Leonardo and Central Italian Art: 1515-1550

The publication of this monograph
has been aided by a grant from the
Samuel H. Kress Foundation

KATHLEEN WEIL GARRIS POSNER

Leonardo and Central Italian Art: 1515-1550

PUBLISHED BY

NEW YORK UNIVERSITY PRESS

for the College Art Association of America

NEW YORK 1974

Monographs on Archaeology and the Fine Arts
sponsored by
THE ARCHAEOLOGICAL INSTITUTE OF AMERICA
and
THE COLLEGE ART ASSOCIATION OF AMERICA
XXVIII
Editor:
Lucy Freeman Sandler

For My Mother and Father

Contents

Preface

This essay grew out of the observation that the references to Leonardo which abound in the late work of Raphael were particularly clear and richly significant in the *Transfiguration,* Raphael's last altarpiece. These examples of Leonardo's artistic legacy suggested a number of interrelated questions about his last sojourn in Rome, about his works and his theoretical ideas and their influence on Raphael and other contemporaries and, ultimately, on developments in Central Italian art after Raphael's death. Vasari's proposition that Leonardo was the father of High Renaissance art has seldom been disputed, nor is there much argument that his heritage was fundamental in shaping the subsequent course of Italian art. There has been less discussion and agreement, however, about the ways in which this formation took place and about what it may have meant to artists in the sixteenth century. In this study, I attempt to distinguish several episodes of Leonardism, both before and after his death, which seem to be more than the ordinary, random references to the classic Leonardesque substructure of Cinquecento art. Instead, these instances appear to be examples of a distinct, purposive, reevaluation of Leonardo's achievements. It was undertaken in the light of the most modern artistic developments in Rome and Florence and had consequences for the emergence of the *maniera.*

In this short, speculative inquiry into the problem of Leonardo's influence in the sixteenth century, I have concentrated on a few key examples in Central Italy, since the artistic sovereignty there of Raphael and Michelangelo has tended to mask the continuing significance of Leonardo—even in their own works—so effectively. There are, of course, other important aspects of Leonardo's artistic authority in the sixteenth century which need to be explored. For instance, the works of Sienese artists like Beccafumi and others can, I think, be illuminated by further consideration of their relation to Leonardo. Even more essential would be the clearer definition of the Leonardesque current in Lombard and Emilian painting, most notably in the art of Correggio. Fortunately, the work of David A. Brown promises to fill this need. Important studies by David Summers on the *figura serpentinata* and on Michelangelo appeared too late to be fully incorporated in this essay, but they seem to come to conclusions that converge with mine by means of other evidence. There seems to be much material for further investigation, as well, in the later Cinquecento use of Leonardesque elements. Finally, a word about Leonardo's historical personality as it is

reflected in his influence on other artists. All my work brought home to me the validity of the growing tendency to see Leonardo, not as a tragically isolated Romantic figure, but as a person directly involved with a broad range of vital issues in sixteenth-century life. I deal only in passing with what I see as Leonardo's confidence that he could actually re-create antique art and transform himself into a new Apelles. Yet, further investigation of Leonardo's activities and behavior would surely strengthen the correlations with attitudes toward the great work of reconciliation, transformation and creation that can be traced through Cinquecento thinking about art, but also about religion, philosophy, science and magic—with the widespread and profound implications that the latter word had for the Renaissance.

The literature of Leonardo studies is so vast and imposing that to write anything at all on the subject is to incur formidable intellectual debts. Without claiming to enlist the prestige of my creditors on my own behalf, I should like to acknowledge how much I gained from Sir Ernst Gombrich's intuitive pages on Leonardo's working methods in *Norm and Form* and on his later theoretical ideas. Sydney Freedberg's fundamental volumes on Cinquecento painting, with their special sensitivity to the interactions between artists, provided both nourishment and challenge. I should like also to mention Konrad Oberhuber's deceptively modest piece on Raphael and Michelangelo in which he argues for the kind of rapprochement between the two artists which I have tried to show in other ways. Readers will see for themselves how much I owe to John Shearman's pioneer article on Leonardo's color and chiaroscuro and also to his other works on Renaissance art. I wish, however, to attest as well to the rare benevolence and willingness to share and to help for which he is so well known.

Indeed, for all its small size, this book owes a great deal to the learned and generous friends who, at various times, read the manuscript, made suggestions and discussed with me the ideas and hypotheses put forward here. For all benefits, my grateful thanks go to B. F. Davidson, S. J. Freedberg, C. L. Frommel, L. H. Heydenreich, H. W. Janson, W. Lotz, K. Oberhuber, D. Posner, J. Shearman and C. H. Smyth.

Valuable time on leave and a grant from New York University's Graduate School of Arts and Science facilitated my work. I should also like to convey special appreciation to Mary M. Davis, Vice-President of the Samuel H. Kress Foundation, which supported my research. Many thanks are due as well to the curators of museums and drawing cabinets for help in obtaining photographs; to James Beck and Bernice Davidson for the same reason, and to D. Redig de Campos and his staff for allowing me to study the *Transfiguration* in the Vatican laboratories; to the American

Academy in Rome and the Bibliotheca Hertziana for their long-standing hospitality and assistance. I have been fortunate indeed to have the help of Lucy Freeman Sandler, editor of the College Art Association Monograph series. This book has been much improved by her perceptive editorial judgment and lively good sense. Thanks are due as well to Harriet F. Senie for her work on the manuscript and proofs. Finally, I wish to express my gratitude to Donald Posner, who confers gifts of sense, insight and encouragement with the perfect simplicity that bespeaks unlimited resources.

PART I

Nell'arte della pittura aggiunse costui alla maniera del colorire ad olio una certa oscurità, donde hanno dato i moderni gran forza e rilievo alle loro figure. (Vasari-Milanesi, Le Vite, IV, 50)

I Leonardo in Rome:
The Genesis of Raphael's
Transfiguration

W HEN LEONARDO CAME TO ROME, where he lived intermit-
tently from late 1513 to 1516,[1] he failed to receive the commissions for
paintings which might have seemed due [2] the man who had launched a
new epoch in Western art. It has also seemed that Leonardo's artistic colleagues in
Rome took little notice of the presence of the founder of the *maniera moderna*.[3]

The traditional picture of Leonardo's Roman sojourn as being artistically nearly
sterile comes, as one would expect, from Vasari's account of it.[4] He says, however,
that Leonardo was brought to Rome after the election of Leo X by Giuliano de'
Medici because of the patron's interest "in philosophy and most of all in alchemy";
that is, not necessarily because of Leonardo's reputation as a painter. In fact, Leonardo
was remarkably busy with scientific, engineering and architectural projects, but
Vasari only describes what he thought were bizarre enigmas, jokes and experiments
which took up Leonardo's time, and he quotes the Pope's dismissive remark, "he'll
never accomplish anything," when Leo finally did commission a painting from

Leonardo. Thus Vasari reintroduces the themes of Leonardo's intellectual instability and unwillingness to produce works of art which are such important traits of his character portrait throughout the *Vita*.

Vasari's interpretation depends on Castiglione's famous reference to Leonardo in the *Libro del Cortegiano:* "he despised the art of which he was the rarest master and turned to the study of philosophy in which he invented such strange ideas (*concetti*) and new chimerical fantasies *(nuove chimere)* that all his mastery of painting will never teach him to depict them." [5] Here the theme of the artist-philosopher (a motif that goes back to antiquity) is already paired with the implicit tragedy of the genius's desertion of his art and his resulting isolation from it. Castiglione had begun to write his book during Leonardo's lifetime and his judgment may well reflect what was thought in Rome at the time.[6] Furthermore, we know almost nothing of the few works of art Leonardo did make in Rome. All these factors have helped to preserve the continuing influence of Vasari's developmental model of early sixteenth-century art in which Raphael and Michelangelo left the art of Leonardo behind and went on without him to create the Roman High Renaissance. Even the most recent accounts of the period reaffirm the traditional opinion that Leonardo was largely superseded and forgotten, that he must have seemed like "an apparition from another era" [7] when he arrived in Rome. The melancholy literary myth of the aging artist rejected and frustrated in Rome probably contains a core of truth. I should like to propose, however, that Leonardo's personal presence and the example of his art took on special meaning for the course of Roman painting precisely during his seemingly barren years in the city.

This is not in itself an entirely new proposal. Vasari, himself, realized that Leonardo's innovations had enabled "modern artists to give great vigor and relief to their figures." [8] Modern critics have also often noted that Raphael, who had already fallen under Leonardo's spell in Florence, went on in Rome to make still more forceful and consistent use of Leonardo's imagery as a source of figural motifs and of principles of narrative and expressive composition.[9] This increased assimilation of Leonardo's art went beyond Florentine habit. It seems, instead, to have been a response to the new Vatican commissions which presented Raphael for the first time with the challenge of painting monumental *historia;* a task for which Leonardo provided the outstanding recent models. Thus references to Leonardo were already evident in the early Stanze, before his arrival in Rome. The *Disputa* (Fig. 12), both in its preparatory studies and in the finished composition, as well as the other frescos of the Stanza della Segnatura, display Raphael's creative recollections of Leonardo's *Adora-*

tion of the Magi (Figs. 4, 9-10).[10] Its lessons also continue to be evident in the heightened, centripetal energies of the *Heliodorus* fresco.

The intensification of interest in Leonardo's art throughout Raphael's Roman years was associated with a more general transformation of his style in the direction of greater activity and expressiveness and was accompanied by a related dramatic darkening in the tonality of his pictures. These developments became especially marked in works beginning 1514-1515, as critics have often pointed out.[11] We see this trend in Raphael's frescos, but the reference to Leonardo's *Adoration* is particularly clear in designs for altarpieces such as Raphael's projects for an *Assumption* preserved in an engraving by the Master of the Die (Fig. 11) and for the planned *Resurrection* that was probably intended for the Chigi Chapel in S. Maria della Pace.[12] The Leonardesque source of Raphael's increasing concern with luministic effects, especially in the later portraits, has also been recognized. Freedberg, in particular, emphasized that Raphael's *Donna Velata* (Fig. 2) and the portrait of Baldassare Castiglione (Fig. 3), with their "quasi-Venetian" approach to light and color, in fact reflect renewed, direct knowledge of the *Mona Lisa* (Fig. 1), which Leonardo apparently brought with him to Rome, and that Leonardo's example had inspired Raphael's investigations into a more optical mode of painting.[13] This specific observation can, however, be applied far more broadly to Raphael's later Roman works, and more general conclusions could be drawn. It seems to be more than a coincidence that Raphael's increasing concern with Leonardesque modes of achieving compositional, expressive, and optical vitality should have coincided with the sojourn in Rome of Leonardo himself.

Furthermore, Leonardo's ideas and then still unpublished writings also reveal a fundamental concern with theoretical attitudes toward the possibilities of modern painting and its relation to the achievements of antiquity that have many close parallels with Raphael's own thoughts and actions in the last years of his life. It would seem that, in all these ways, the renewed presence of the aged Leonardo was influential for Raphael, suggesting to him how the inventions that had done so much to shape his own maturity at an earlier moment could be reformulated with new relevance for the most immediate concerns of Roman painting and for those tendencies in it which proved to be most prophetic for the *maniera*.

A heightened and, I believe, conscious, reexamination of Leonardo's legacy can be demonstrated in most of Raphael's later works, but it was his final altarpiece, the *Transfiguration* (Figs. 5-8), that reveals the most comprehensive and searching meditation on the most modern uses of Leonardo's art, especially as it was formulated

in the *Adoration.* At first glance, the *Transfiguration* resembles Leonardo's painting neither in format nor in subject. For that matter, the intense, localized coloristic and tonal definition of the lower half of Raphael's panel and the brightness of its upper portion contrast with the shadowy harmonies of Leonardo's incomplete underpainting. Nonetheless, it was in the *Transfiguration* that both Leonardo's structural and expressive innovations in the depiction of *historia* and his invention of the *"certa oscurità,"* were restated with such paradigmatic clarity and force that what seemed a culminating act of retrospection on Raphael's part also marked a turning point in the course of Renaissance painting.[14]

Some of Raphael's borrowings from Leonardo in the *Transfiguration* are remarkably literal. This can be seen with greater ease when we compare Figs. 4 and 5, in which the two compositions are visible in more schematized form. Raphael uses St. Philip's lovely pose of stricken wonderment from the *Last Supper* for one of the young Apostles on the left of the *Transfiguration,* and the bearded heads of the older Apostles recall, in a general sense, their Milanese prototypes. The extensive description of foliage and water in the lower part of Raphael's picture also reflects similar passages in the *Madonna of the Rocks* or in the *St. Anne* pictures (Figs. 19, 43).[15] More profuse and important, however, are the references to Leonardo's *Adoration of the Magi.* Individual heads and figures from Leonardo's painting are adopted as well as their location and arrangement in the composition. The most striking examples are the Apostle resembling St. Joseph at the center of the *Transfiguration,* the heads [16] and gesticulating hands along the curving margin of the hillside on the right of the picture, and the grouping of the figures on the left. The gesture of Raphael's Philip-like Apostle had already been developed in the *Adoration,* while the two heads above Leonardo's standing figure on the left reappear in the *Transfiguration* with new emphasis. Even the idea of the upward-pointing poses of Raphael's figures, though not their actual gestures, is found in Leonardo's picture.[17]

Once these references are recognized, it begins to be evident that Raphael's picture can also be understood more generally as reflecting a rethinking of the compositional principles of Leonardo's altarpiece as a whole. It is there that we find the implosive energy of the figures crowding inward from the sides of the painting, reacting with such variety to a dramatic event. There too, for all the differences, is a parallel for Raphael's setting, with its high horizon (now representing Mount Tabor), the deeply curved foreground, blocked off at the back,[18] flattened on top,[19] and allowing a glimpse of a deep, lyrically observed landscape on the right. Leonardo's composition also furnishes a precedent for the conjunction of two different kinds of space, seen from different eye levels and represented by different means in the background and

foreground, without a measurable middle distance to link them. (In both pictures, they are connected by the shape of a tree.) Perhaps most significant of all for Raphael was Leonardo's placement of the foreground figures in an area of darkness that is silhouetted against an upper zone of light in which other events take place. Indeed, in the unfinished state of the *Adoration,* this contrast appeared with a programmatic though unintended distinctness.[20]

As we have seen, recourse to Leonardo's example had been a means to Raphael's formulation of the next phase of his own development [21] on other occasions as well, and the *Adoration* itself had served Raphael as a model in works as diverse as the *Disputa,* the *Spasimo di Sicilia* (Fig. 13) and, perhaps, in the design for an *Assumption.* These and other works by Raphael were also influential in the genesis of the *Transfiguration.*[22] There were, however, also good reasons why Raphael should choose this moment to renew and intensify his study of the older master.[23] The recent memory of Leonardo's presence in Rome could have been directly inspiring and Raphael may actually have visited Florence in late 1515,[24] where he could have renewed his acquaintance with Leonardo's founding masterpiece of the High Renaissance.[25] Moreover, the brilliant copiousness of figures, action and emotion of the *Adoration* and its tonal contrasts would have been particularly meaningful to Raphael in this phase of his development. Not least, the special problems raised by the commission for the *Transfiguration* and the competitive atmosphere in which it was undertaken may have given these impressions uniquely powerful focus.

* * *

Why Raphael combined the scene of Christ's Transfiguration with the story of the boy possessed by an unclean demon is a question that has often been raised.[26] The stories follow each other in the scriptural accounts but there is no clear narrative or causal link between them.[27] The boy is brought to the Apostles to be healed during Christ's absence. The Apostles are unable to exorcize the demon. Christ returns, casts out the malign spirit and chides those present for their lack of faith. Although a variety of iconographical interpretations have been offered to explain the significance of these events in terms of Raphael's picture,[28] there seems to be general agreement that the juxtaposition of the two themes comments in some way on the powerlessness of man in the absence of divine salvific power or of faith in it, and that the sharp tonal contrasts in the picture reflect this idea. While these interpretations imply that Raphael's reasons for presenting the two themes in a single picture were iconographic, there have also been speculations that an attempt to enrich the *historia* of the

painting was a contributing or even a fundamental motive.[29] Drawings published by Oberhuber indicate that there was indeed an early moment when the Transfiguration alone was to be shown in Raphael's picture,[30] but we do not know at what stage the decision was made to represent both events. Nonetheless, once the decision was reached, Leonardo's *Adoration* must have appeared as a compelling example of how two disparate themes and events [31] might be articulated and organized. Earlier works by Raphael may have helped to bring that example to mind. If, as Shearman has argued,[32] Raphael's *Assumption* projects of 1514-1515 are reflected in the engraving of the subject by the Master of the Die, the bipartite scheme of the *Assumption* (which also relies on the *Adoration* and converts it into a vertical format) [33] would have formed an important intermediary step in the development that led to the *Transfiguration*. In this last altarpiece, however, Raphael turned back to Leonardo with a concentration and vigor unequalled in his earlier works.

Leonardo's picture offered Raphael a way to conjoin a nearby human event, full of narrative and dramatic action, with a scene of divine revelation which Scripture describes as being distant, on a mountain top (that is, high in the picture format), previous in narrative sequence to the scene below [34] and which is—by implication—both eternally present and outside the limits of human time and space. The upper scene had, furthermore, to convey its transcendent motivating force and yet to be instantly comprehensible to the spectator as part of a larger totality. Now the subsidiary, light, upper zone of the *Adoration* could be intensified and enlarged to become the—literally—supernatural world of Mount Tabor, transfigured in miraculous brilliance.[35] The dark lower foreground which is the undisputed primary focus of Leonardo's composition could function, instead, as the shadowy abode of the "benighted" Apostles and pilgrims below. Thus the structure and function of Leonardo's formal order could be made explicit and used as the direct metaphorical embodiment of the iconographical and expressive content of Raphael's picture. At the same time, however, Raphael also created a new relation between form and content.

Every constituent part of Leonardo's *Adoration* contributes to the visualization of his ideal of integration and harmony both of form and of meaning. The responsive, surging figures define a pattern in which surface and depth are focused and fused in the Madonna and Child. It is, however, the division of surface into light and dark, into figural zone and landscape field, that makes this total physical and psychological concentration possible. The tonal contrast frees the figures from the strictures of Quattrocento linear perspective space with its inevitable tendency to diminish the figures as they move off into space. Instead, the dark foil allows the drama of human

form and feeling to be presented with unimpaired monumentality and immediacy, close to the picture plane. The deep tonality of the foreground in the *Adoration* also produces a new coherence and vividness of optical experience,[36] while the revelation of figures, visible to the degree that they are touched by light, functions as another expression of the Epiphany that is the picture's subject. The luminous distances that fill the upper part of the panel have a clearly subsidiary meaning, and they are experienced as the ever-widening horizons of the world Leonardo has already created for us.

Raphael broke the delicate equilibrium of Leonardo's synthesis. To begin with, once the central Madonna and Child, which were no longer appropriate, were removed from Leonardo's compositional schema, its whole formal and expressive motivation was disrupted. In the context of Raphael's painting, however, this absence and displacement at the core provides an effective unconscious enrichment of content, since it is precisely the absence of the Prime Mover that gives point to the episode of the possessed boy.[37] Raphael's modification of Leonardo's pictorial structure corresponds to the iconographic meaning of the new subject. As a result of Raphael's obedience to the demands of his subject, however, the transfigured Christ now becomes a second, competing focus in the picture and Leonardo's complex systems of harmonized subordinations to a single goal are now reorganized, by Raphael, into a pattern of simultaneous contrasts that reflect and express the new duality. The "background" in Raphael's picture becomes the scene of the miracle and is no longer subsidiary to the foreground. Surface and depth are no longer seen as functions of each other but symbolize the double reality of the subject. Raphael's landscape breaks through the inclusive curve of the horizon. The foreground figures are large, more active and move in skewed disjunctive patterns as they are seen from a steeper viewpoint that is incommensurate with the space of the upper half of the composition. Even Leonardo's unified embracing tonality in the lower half of the *Adoration* is modified by Raphael to give greater clarity to the foreground figures by allowing them to emerge with full definition against the newly intense darkness behind them.

This description evokes the familiar etiology of mannerism as the concept has traditionally been defined, with its characteristic symptoms of strain, conflict, multiplicity and disintegration. Yet Raphael's *Transfiguration* was surely not done in polemical response to the *Adoration*. Instead, the crucial formal differences between the two works were, in a sense, consequences of the very fact that Raphael took so seriously directives and implications latent in the older master's handling of a cognate problem. All the constituents of Leonardo's *Adoration,* as we have seen, had essen-

tially been means of organizing and communicating physical and psychic forces that were also ever more powerfully realized elements in Raphael's own developing art. In the *Transfiguration*, Raphael's renewed confrontation with the *Adoration* helped to define and to intensify those energies to the point where they were no longer contained within the harmonizing limits that had been set for them by Leonardo himself. Thus the great opening statement of the High Renaissance came to serve in the creation of the very work that was the clearest and most monumental announcement of its end.[38]

II Leonardo's Dark Manner and the *Paragone:* The *Transfiguration* and the *Raising of Lazarus*

HE DARK TONALITY that is so striking a feature of the *Transfiguration* had already begun to gather in some of Raphael's earlier works, especially in the Stanze, as an aspect of his experiments with the organizing power of light. However, the subject of the Transfiguration itself also served as a direct stimulus to his further exploration of this kind of painting. The luministic effects of the picture are so remarkable and varied that it comes as something of a surprise to realize that Raphael shows us the very moment when the dawn is breaking and thus, at least implicitly, represents the Transfiguration as a night scene (see Appendix). There are iconographical explanations for this. Still, Raphael must also have also chosen this setting in order to justify the virtuoso display of different kinds of lighting in the same picture. This consideration would have had some importance

in the special competitive circumstances of the commission where, as we shall see, Raphael was—in fact—challenged to prove his mettle specifically as a painter; that is, as the consummate master of optical effects.

Two further circumstances contributed to the flowering of a Leonardesque, newly dark manner in the *Transfiguration:* its technique and its monumental format. Vasari had implied [39] that Leonardo's dark tonality could be realized fully only in panel painting where an oil technique could be used. After tracing the development of oil painting in his "della pittura," he finds its culmination in Leonardo and Raphael. Two characteristics make the method preferable for the modern painters. Oil makes colors appear softer, more sweet and delicate and makes it possible to achieve a more *"sfumata maniera."* Moreover, the technique itself "imparts such plasticity to the forms that they appear like relief: ready to push out beyond the surface of the panel." [40] As for the format of the painting: the large surface of the *Transfiguration* [41] also allowed a more intense degree of darkness to be spread over a wide area of the composition without the loss of visibility and clarity that would have occurred in a smaller painting. All of these factors combined to make the *Transfiguration* an ideal demonstration piece in which the special possibilities and advantages of a Leonardesque dark manner could be fully realized. It is no wonder that the novelty and importance of the *Transfiguration* specifically as a dark picture was apparent at once, not only to artists but to critics from the early Cinquecento [42] to the present day. [43]

As Vasari had pointed out, Leonardo's *oscurità* provided modern artists like Raphael with a uniquely effective means of giving plasticity *("rilievo")* to painting as well as "the corporeal homogeneity . . . which would rival sculpture." [44] Leonardo himself saw the use of light and shade in the creation of *rilievo* as the cardinal task of painting. [45] As Shearman has suggested, the achievement of "sculptural presence of painted form may well have been among Leonardo's most compelling ambitions, obsessed as he was with the *Paragone.*" Certainly the achievement of convincing plasticity in painting was also an ever more focused ambition of Raphael as well; less in terms of competition among the arts than as part of a search for total pictorial conviction and force of dramatic presentation. Yet, it may be that Raphael turned so decisively to the use of Leonardesque obscurity in the *Transfiguration* as a polemic reaction to a special kind of *paragone* that attended the commission for the altarpiece.

Cardinal Giulio de' Medici seems to have given the double commission for the *Transfiguration* and the *Raising of Lazarus* (Fig. 14) for the Cathedral of Narbonne to Raphael and Sebastiano del Piombo to spur each artist to greater achievement by pitting one against the other. [46] It was well known, too, that in this competition Sebastiano was a surrogate for Michelangelo; [47] that is, for the artist who was to define

painting as excellent only insofar as it approached the quality of sculpture, in as far as it possessed *rilievo*.[48] For Michelangelo this meant, in theory, that painting was at best only a partial, diminished imitation of sculpture. In practice, it meant that painting, like sculpture, was reduced to the representation of finite plastic units (figures), interrelated to some extent by grouping but principally through pose and gesture, and projected into an essentially negative, empty space. Raphael's enthusiastic adoption of a Vincian dark manner, in effect, bespoke allegiance to an opposed theoretical attitude which held that painting was the superior art because of its greater ability to achieve *rilievo* through the use of light and shade. Painting was also to be preferred over sculpture because of its richer resources for the depiction, not only of figures, but of all nature in its visual and poetic totality.

This was certainly also Leonardo's view which he expressed clearly in his *Paragone*.[49] Indeed, later in the sixteenth century, Lomazzo made the fascinating observation that it was specifically Leonardo's dark manner that enabled him to "do everything that nature herself can do." [50] Recently, in the same vein, Gombrich suggested that Leonardo's deliberate "universality" as a painter was a reaction against the Michelangelesque point of view.[51] It is difficult to know how overtly Raphael subscribed to such ideas, but he could have known them through Leonardo and through Baldassare Castiglione, Raphael's great friend whose thoughts and writings seem, in turn, to have been influenced directly by Leonardo's then still unpublished ideas.[52] They shared the belief, born in antiquity and common in the sixteenth century, that painting was the highest art. Castiglione, however, applies this idea specifically to Raphael in the *Libro del Cortegiano* [53] in the well-known passage when the sculptor Giancristoforo Romano is made to say of Raphael "that the excellence you see in his painting is so great that sculpture could never equal his attainments." [54] Indeed when Castiglione makes the conventional listing, based on Philostratus, of the kinds of effects that can be achieved in painting but not in sculpture, he mentions some of the very elements that characterize the poetry of the *Transfiguration* with its *"oscura notte . . . 'l nascere dell'aurora di color di rose"* and the *"cappelli flavi"* of many of the figures.[55] It was these elements in Raphael's art and also Castiglione's praise of them that were to lead Vasari to the idea that Raphael had cultivated an *"ottimo universale"*—the ability to represent nature in all her optical variety—when he discovered, as Vasari puts it, that he could not hope to equal Michelangelo in the depiction of the nude.[56]

Like Leonardo, and perhaps inspired by him,[57] Castiglione also points out that painting triumphs over sculpture because it adds light, shade and foreshortening to outlines and thus achieves the greater degree of *rilievo;* but Castiglione himself does

not yet go beyond this simple association of light and shadow with relief, to an explicit endorsement of dark tonality in general. The nearest one can come to a hint of such an attitude in Castiglione is his praise of black and of grave color that "tends to darkness" as being the best for the dress of a gentleman.[58] The beautiful restrained palette of Raphael's portrait of his friend is certainly a direct fulfillment of this ideal.

A comparison of the *Transfiguration* with the *Raising of Lazarus* may reveal something of the paragonistic difference of approach that the sixteenth century saw in the art of Raphael and Michelangelo. In fact, the present-day distinction between the two works is given an even exaggerated emphasis by the fact that the *Transfiguration* has badly needed cleaning.[59] There are, however, several further clues which, taken together, seem to offer evidence that use of a Leonardesque dark manner was in some sense an issue in the controversy that surrounded the pictures.[60] In a well-known letter to Michelangelo of July 2, 1518, Sebastiano says that Raphael's *St. Michael* (Fig. 15) and the *Holy Family of François I*[er 61] were being sent to France. The paintings had aroused much criticism, Sebastiano was pleased to report, because they looked as though they "had been darkened by smoke or rather like figures of iron which shine all light and all dark." Sebastiano adds that Michelangelo would have found Raphael's pictures reprehensible, going entirely "contrary to your opinion." Presumably Sebastiano believed that Michelangelo would have objected to Raphael's use of intense tonal contrasts as opposed to the clearer modeling and cooler, more abstract colors of Sebastiano's figures in the *Lazarus* done under Michelangelo's aegis.[62] For Sebastiano, the idea of "smoke" *(fumo)* may also have carried the associations with Leonardo's *sfumato* darkness that it does for us today [63] and the letter may reflect the Venetian's awareness of the source of the darkness he criticizes in Raphael. For that matter, the dangers inherent in the wrong use of Leonardo's *oscurità* are reiterated by Vasari at various times.[64]

Sebastiano's letter seems paradoxical, however, in view of the fact that he had developed a dark manner in his own pictures of about 1515-1517.[65] This darkness, which is not of a Venetian kind, evolved partly in response to Raphael and, also, perhaps through direct contact with Leonardo in Rome.[66] We see this most strikingly in the otherwise Michelangelesque Viterbo *Pietà* (Fig. 16), although it is, of course, a night piece.[67] Elaborate precautions were taken to keep the work of each painter secret from the other, but Sebastiano's *Lazarus* and Raphael's *Transfiguration* have genuine concordances that have led students to speculate inconclusively on the problem of mutual influence.[68] It would appear, however, that the two paintings resemble each other in that both betray study of Leonardo's *Adoration*.[69] The ruined architecture in the upper left of Sebastiano's picture is remarkably comparable to that of the Uffizi

painting; the apportionment of light and dark, of figural and nonfigural zones also recalls Leonardo, as does the device of the tree used to link the two areas. The appearance and placement of individual heads and gestures, the dynamic figure groupings and the crowds pouring down into the foreground show that the artist had, in some way, absorbed the lessons of Leonardo's great altarpiece.[70] A variant of the Vincian dark foreground also survives despite the cooler coloration of Sebastiano's painting. (The general darkness of the picture is, however, overemphasized in black and white reproduction.)

Sebastiano's decision to turn to the *Adoration* on this crucial occasion was very probably inspired by Raphael's earlier *Assumption* designs[71] and would have been strengthened as well by the example of the *Spasimo di Sicilia;*[72] a picture which also reflected Raphael's interest in Leonardo's composition. Thus the tendency of Raphael's own most recent works would have suggested to Sebastiano that he too should now look back more directly to Leonardo, especially for those parts of the *Lazarus* composition for which Michelangelo had provided no guide.[73] If, on the other hand, Michelangelo had a more substantial role in the *Lazarus,* as has sometimes been proposed,[74] the competitive rapprochement with both Leonardo and Raphael that is visible in the picture would have considerable implications for our view of Michelangelo's own development. The inception of Sebastiano's darker mode of painting corresponds with the beginning of his closer partnership with the sculptor and with the growing sense of a competition between Michelangelo and Raphael. At the very least, we may say that Sebastiano himself understood that renewed assimilation of Leonardo's art was a formidable resource in the struggle for the mastery of modern painting.[75] Apparently Sebastiano also thought that Michelangelo's ideas should be interpreted in an analogous fashion, if not to the extreme degree he described in his letter to Michelangelo.[76] Michelangelo's own opinion cannot be deduced from these observations[77] but, despite his adherence to sculptural values in painting, he had already been moving toward a more pictorial mode in the last bays of the Sistine Ceiling and, by the 1530s, when he next returned to painting he, like many other painters, evidently made the dark manner his own.[78] It may be that he had ratified the Leonardesque experiments which Sebastiano had, in a sense, performed on his behalf.

III Leonardo's Dark Manner and the Challenge of Antique Painting

CARDINAL GIULIO'S COMMISSION for the Narbonne paintings very probably followed Leonardo's departure from Rome, yet the fact of his recent presence somehow continues to make itself felt beneath the surface of events. As we have seen, Vasari gave a negative interpretation of Leonardo's Roman sojourn.[79] The artist was given rooms in the Belvedere and great things were hoped for, but Leonardo, in Vasari's estimation, frittered away his time on warlock tricks as well as with "strange experiments with oils for painting and for varnishes to preserve *(mantenere)* the finished works." When the Pope did commission a painting, "Leonardo at once began to distill oils and herbs to make the varnish" for the not yet existing picture. It was this trying and inexplicable behavior that called forth the Pontifical complaint,[80] "that man will never do anything since he thinks of the end of the work before the beginning."[81] Vasari reports this remark with the wincing appreciation of a colleague who knows the dangers of exasperating one's patron. This story sounds like the random transmission of a bit of merely anecdotal material, but

the fact that it is one of the very few things Vasari knew about Leonardo's stay or, perhaps, that he thought worth recording, makes one listen more attentively for the reverberations it may have.

We know that Vasari was concerned about problems raised by the technical means being used to achieve the new lucent darkness that he saw in the pictures of Leonardo, Raphael and his school. Vasari comments, for instance, that lamp black "used almost through caprice" in the *Transfiguration* would cause the picture to become still more obscure with time. He makes the same remark about Giulio Romano's *Anima Madonna* (Fig. 17), the darkest of Giulio's Roman works. In each case, Vasari blames the pigments used for the blacks which, he says, will always deteriorate even if they are varnished.[82] Apparently the paramount problem was to create stable dark tones, either directly in the paints or, conceivably, in conjunction with the use of varnish that would not ruin the blacks.[83] In this context, it is possible that Leonardo's experiments with a final varnish which he undertook "instead of beginning at the beginning," represented more than an old man's caprice. The composition of the varnish would, for instance, have had to be settled beforehand if its effect on the pigments beneath was being considered.

The report of a great painter's mysterious experiments with varnish has some familiar and august associations. It was Apelles, says Pliny, who covered his finished pictures with a glaze or varnish *(atramentum)* one of whose functions was to lend moderation or darkness *(austeritas)* to florid colors.[84] Leonardo was being called the modern Apelles during his own time and, although this rhetorical compliment had been applied to artists since Giotto, Vasari's anecdote may somehow preserve for us traces of Leonardo's attempt to follow what he considered ancient example to be.[85] The meaning of the Plinian passage was the subject of intense debate some years ago [86] but I hope it will not rekindle controversy if I emphasize that Leonardo would have known Pliny through Landino's translation, which the painter probably owned.[87] What Pliny meant by his description of the *atramentum* may be open to discussion, but Landino's interpretation of Pliny's text is fairly easy to define in regard to the matters that concern us here. According to Landino, the inimitable *"atramento"* of Apelles was applied thinly to the finished picture. By reflecting light, it increased the splendor (of the colors) in the eyes of the beholder. This coating protected the picture, but its most remarkable characteristic was that it prevented the splendor (brilliance) of the colors from offending the eye by making them appear as though they were being seen from a distance through transparent stone. The same substance exercised a barely perceptible restraint on florid colors.[88]

In an equally well-known passage Pliny explains that Apelles made his *atramentum*

with burnt ivory, and it has been argued that the optical effects Pliny described could have been achieved by suspending burnt ivory in a clear medium or by a varnish tinted in other ways.[89] Certainly later sixteenth-century writers did believe that the secret substance was a varnish, while Gianbattista Adriani, who had also read his Pliny, thought the varnish was *"bruno."* [90] Leonardo himself discusses clear and darker varnishes and was apparently interested, both in theory and in practice, in the visual effect of varnish on the colors beneath.[91] Vasari also tells us that Leonardo's experimental Roman varnish was to be applied to the finished picture. But was he really pondering the mystery of the *atramentum* as he worked in his Belvedere studio? [92] Leonardo describes a way of making a painting "eternal" by affixing a thin sheet of glass to its surface with varnish.[93] This immediately evokes Pliny's account of the *atramentum*. He says it gave the effect of a *"lapis specularis";* literally, a "window stone." Now Vasari explains that modern glass is an "imitation" of antique stone panes made from alabaster or other translucent stone and that glass, too, varies widely in tone. Indeed, Adriani and later Mancini actually translate Pliny's window pane as "glass" and liken its revivifying effect on the painting to that of varnish.[94]

Such a protective coating, even if "clear," would have enhanced the depth and translucence of the painted colors;[95] that is, it would have strengthened qualities uniquely associated with the developing oil technique which Vasari had seen as an essential concomitant of the *maniera moderna*.[96] Landino's translation, however, also emphasizes the veiling effect, like that of distance; that is, the very effect that Leonardo's *sfumato* achieves by other means.[97] In this way, the *atramentum,* too, would have encouraged the desirable union of tones so often mentioned by Vasari [98] and, like the dark tonality of Leonardo's paintings, would have increased the illusion of plasticity by allowing objects to exist in a surrounding, visible, atmospheric space.

Another quality of the *atramentum* of Apelles might be kept in mind: its protective strength. In the *Paragone,* the sculptor claims that his art is the more enduring. The pane of glass used as a varnish and the other ways of glazing and vitrifying mentioned in Leonardo's notebooks [99] show that the point was a telling one. Indeed, after 1500, Leonardo amplified the *Paragone* perhaps, as has been suggested, in response to contact with Michelangelo.[100] Apparently the sculptor's arguments were not forgotten. Pliny had described ancient encaustic techniques as "incorruptible" [101] and Leonardo's contemporaries thought that he had tried unsuccessfully to revive them in his wall and panel painting.[102] The *atramentum* which defended the panel from *"ogni bruttura"* held out a similar promise for modern painting [103] and in this way Leonardo could hope to vanquish the last theoretical pretentions of "the sculptor." An indication of the topicality of this idea in early sixteenth-century Rome is to be

found in the accounts of attempts by Sebastiano and others to paint in oil on stone, "which endures forever." [104]

More tantalizing still, when the *atramentum* is mentioned by Pliny and others, it is defined as "inimitable": a secret lost with the ancient world. Leonardo lived to see his old ally, Bramante, rediscover the ancient way of pouring concrete, Vasari tells us, which made possible the building of the new St. Peter's. Giovanni da Udine also found, through experiment, the antique formula for stucco, thus making true decoration *all'antica* a modern reality.[105] The famous dark secret of Apelles could easily have held a similar fascination for Leonardo, more than ever in the Roman context. The *atramentum* of Apelles was such an ingenious invention because it gave to his pictures what Landino translates as *"una certa austerità."* Does the thought still echo in Vasari's praise of that *certa oscurità* which was Leonardo's special contribution to modern painting? [106]

Whether or not Leonardo's Roman varnish was, in fact, intended to be a new *atramentum,* it may well be that his more fundamental inventions of *sfumato* and dark tonality, which had so few precedents in the art of his time,[107] were also directly inspired by what was understood to be antique example.[108] Pliny had already reported that the painting of Athenion was preferable to that of Nikias because of its *"austerior colore."* Indeed, Pliny saw the use of chiaroscuro as an historical improvement in the art of painting. Alberti had also interpreted Pliny to mean that the best antique painting was—and therefore modern painting should be—basically tonal: that is, based on black and white. Alberti praises the skill in chiaroscuro of the ancient painters and he already describes *sfumato.*[109] However, he did not go on to advocate directly the use of a dark tonality as such. It therefore remained for Leonardo's *oscurità* to satisfy the ambition to paint the surrounding air as Philostratus demands, to "give substance to the shadow out of the shadow itself in order to give full relief upon the flat surface"—that is what Pliny said Pausias had done [110]—and to create the laudable darkness [111] of Apelles and Pausias as it was described by Dolce and others.[112]

In the past, we have usually thought of Leonardo as an artist less involved in the revival of antiquity than his great contemporaries because his own attention seems to have been more closely fixed on the inductive study of nature than on the study of tradition. Yet Leonardo wrote that it was better to imitate the ancients than the moderns, studied ancient ruins in Rome and seems to have owned a codex containing drawings of ancient buildings.[113] Recent scholarship has also become increasingly aware that he was deeply responsive to antique figurative ideas as well.[114] It seems equally significant that Leonardo's life or, more precisely, his actions, had frequent parallels with antique writing about art.[115] His championship of high intellectual and

social status for the artist goes back to Pliny. Ultimately, even Leonardo's tireless investigation of natural phenomena fulfills an antique ideal of the artist-philosopher and can be seen in the light of the idea expressed by Philostratus and others, as well as by Leonardo, that the best painting imitates and understands nature best.[116] Others, most importantly Alberti, had already tried earlier to model their ideas about art on elevated antique ideals of this kind.[117] Alberti cites the inspiring example of a variety of artists mentioned in ancient literature and urges his contemporaries to acquire their fame and renown; a feat that would be all the more glorious since modern painters lack the advantage of models and traditions available to the artists of the past.[118] Leonardo, with the stubbornness of genius, may simply have pushed this humanistic commonplace to the point where it became a genuine program of action.[119] We are fully accustomed to the idea that Leonardo gained and shaped his knowledge about the natural world by means of constant experiment. The same cast of mind could well have led him to "test out" what was known about ancient art and artists. It would have been entirely characteristic of Leonardo to try to reinvent antique art, less by copying its surviving remains, than by attempting to *be* an antique painter. By taking seriously the role of "new Apelles," Leonardo would have been recreating—through experiment—the attitudes, knowledge and techniques that had made the triumph of antique art possible and that would assure his own. Similar kinds of proposals have been made at various times about Ghiberti and Titian while, most recently, it has been shown that Dürer and Giovanni Bellini were seen by contemporaries as behaving like Apelles and Protogenes.[120] Leonardo must surely also have had an important place in the history of this special kind of *imitazione*.[121]

Certainly Raphael, too, had become ever more deeply interested in the lessons of ancient art and we know that he consciously set for himself the problem of bringing modern art into conformity with the highest values and standards of antiquity.[122] In painting, this concern was expressed in a variety of ways, ranging from the use of a studiously correct archeological vocabulary of form and decoration to experiments with antique modes and subject matter. In the *Transfiguration,* this can perhaps be seen in the romantic landscape passage [123] and, in quite another style but with similar intent, in the statuary rhetoric of the famous kneeling woman in the foreground.[124] The new dark manner, with its coloristic *austeritas*,[125] may well also have been another coefficient of that heightened fidelity to what was known, through literature, of antique taste and practice. It is significant that Castiglione emphasizes the fact that much more could be known of antique art through literary descriptions of it than from its few surviving remains; by the same token, Giovio describes Raphael's color in specifically Plinian terms and praises its *austeritas*.[126]

Raphael was, of course, also familiar with Alberti's ideas and could have arrived quite independently at the idea that dark tonality was an attribute of the best antique painting; but since *oscurità* is so closely associated with Leonardo in the *Transfiguration* and in other works, it is more likely that Leonardo's ideas and practice in Rome confirmed Raphael's notions on this subject. The dramatic night illumination of the *Liberation of Peter* was conceived before Leonardo's arrival and probably reflects Raphael's independent desire to emulate the antique, but it is worth remembering that Leonardo wrote instructions on the painting of night scenes and that he was himself thought to have painted them.[127] Quite apart from his contribution to the development of this special genre of dark painting,[128] the evidence of Leonardo's last surviving picture, the much restored *St. John the Baptist* (Fig. 18),[129] indicates that he continued to extend the general possibilities of his dark manner.[130] Castiglione, too, with his interest in antique art and theory, and his connections with Leonardo, could easily have stimulated Raphael's decision to explore the dark mode further in paintings like the *Transfiguration*.[131] However, Leonardo's most recent practice, as well as the earlier works he had brought with him to Rome, would have provided the most convincing possible demonstration of what a modern dark manner could be.

IV Leonardo's Legacy in the Raphael School and the Fate of the Dark Manner

THE ASSOCIATION OF Leonardesque motifs, compositional principles and light with a deliberately antique style continues in Raphael's latest pictorial ideas in the Sala di Costantino.[132] The original decision to execute the murals in a medium other than fresco recalls Leonardo's experiments of this sort and implies a similar attempt to make qualities of easel painting available to mural decoration. The *Battle of the Milvian Bridge* certainly satisfies Leonardo's written prescriptions for painting battles.[133] More specifically, as has often been noted, the mural is a virtuoso variation and development *all'antica* on the theme of the *Battle of Anghiari,* of its expressive mode and, indeed, of its central motif.[134] The critical reassessment of Leonardo's compositional and tonal inventions that we have seen in the *Transfiguration* also occurs in other late Raphaelesque works; most notably those

executed by Giulio Romano. The degree of Raphael's responsibility in some of these pictures may remain controversial, but their relationship to Leonardo is a constant and important factor in all of them. This suggests—at the very least—that recourse to Leonardo was known to Giulio as a conscious principle of Raphael's artistic procedure. The *Perla* (Fig. 20) and the *Anima Madonna,* for instance, are reissues in more current coin of the values of Leonardo's *St. Anne.* This is also true in varying degrees of the other *Madonnas* of the Roman period painted both before and after Raphael's death.[135] In these works, the formal invention is presented in a sooty obscurity that goes beyond Leonardo's own intention and is, in fact, also a further intensification of Raphael's dark mode as it had been set forth in the *Transfiguration*[136] not many years earlier. One may presume, however, that this darkness was a development of Raphael's own ideas since it is also found in works like Raphael's own *St. Michael* as well as the *Holy Family of François I er:* pictures sent to the same patron during Raphael's lifetime and represented as being works of his own hand.

A still more personal aspect of Giulio's version of the dark manner is revealed in the Genoa *St. Stephen* (Fig. 21), where he strives to make over the *Transfiguration.* Although he retains the fundamental division of light and dark, the Leonardesque structure of Raphael's painting has been largely dispersed; partly as a result of Giulio's differing stylistic intent and partly because he also recalls Raphael's own cartoon for the *Stoning of St. Stephen,* a composition which had been a source for the *Transfiguration* as well.[137] This dispersal is also evident in the splattered, dappled treatment of color and light. Leonardo's method of providing coherent *rilievo* is now freed from its original function and works independently, even dissonantly, as an element among others.[138] Indeed, in comparison with Giulio's painting, Raphael's *Transfiguration* now looks more like the culmination of what Leonardo had begun in the *Adoration* than like a disruptive analysis of it. Nonetheless, Giulio's exploitation of the fragmented constituents of Raphael's picture still points back to Leonardo. Giulio's hectic figures are still the counterparts of Leonardo's worshippers but their gestures, no longer vehicles of pure expression, are now made to serve specific narrative ends as the saint's tormentors prepare to stone him. The grimaces of the mob are developed from the experiments of Leonardo's physiognomical sketches and it may be that such models also lie behind the faces in the scene of the possessed boy in the *Transfiguration.*[139] The ruinous landscape background of the *St. Stephen* still finds its ultimate precedent in the *Adoration.*[140] Once again, and now more distinctly than in Raphael's own work, aspects of Leonardo's artistic synthesis were being reinterpreted in the creation of a style that was in many respects its opposite. Raphael's example, but most particularly Giulio's interpretation of it, was to make Leonardesque dark

tonality a hallmark of the modern manner and to assure its propagation within the dominant tradition of Central Italian painting.

Giulio's version of Raphael's late Vincian mode had still communicated an aspect of its original mystery and its potential for poetic violence. This was also true of the art of the most radical if more narrowly limited and consistent practitioner of Raphaelesque chiaroscuro, Polidoro da Caravaggio. I do not suggest that he was directly moved by Leonardo's example in Rome,[141] but he did carry to new heights both pictorial and emotional elements made possible by Leonardo's invention of darkened totality. Polidoro's *oscurità,* although fully grounded in Raphael, Peruzzi and Giulio,[142] is especially interesting in our context since it provides an unequivocal demonstration that a dark mode was considered an integral aspect of a style which was deliberately *all'antica.*[143] In his facade decorations, darkness became a necessary factor of what was, in both senses of the term, a relief style. In the S. Silvestro landscapes, their strong antique reference and atmospheric glamour may also have been associated with an oil mural technique [144] which, as we have seen, had also on other occasions been a characteristic of "modernly ancient" painting.[145] Indeed, Polidoro's re-creation of antique landscape in modern style was, itself, the kind of innovation that we saw in the making of the dark manner. In drawings like the *Entombment* in the Louvre (Fig. 22), the unified, lyrical animation of all elements of landscape and figures, the emphasis on a sketchy, "open" technique of chiaroscuro drawing, and the special fervent tenor of Polidoro's response to the antique also suggest a distant kinship with an aspect of Leonardo's creativity. This affinity would have allowed Polidoro to respond with particular sensitivity to echoes of Leonardo's art in Raphael's work.

The active function of Vincian prototypes, generally, in Raphael's art was also understood in a clear if not very profound way by the Raphael shop as represented by Penni in the years after the master's death. In the *Adoration of the Magi* designed for the Scuola Nuova tapestries (Fig. 23), Raphael's schemes for *Assumptions* and recollections of the *Transfiguration* are enriched by renewed direct reference to Leonardo's *Adoration.*[146] Leonardo's version of the subject is cited as though it were Raphael's own. It is reused just as Raphael's own compositions are reused: it is given declamatory emphasis to affirm the legitimacy of the tapestry designs as genuine if posthumous statements of Raphael's artistic intentions.

Raphael's Leonardesque heritage was also claimed by the young Parmigianino, who "imitated Raphael in everything, but especially in painting." [147] Parmigianino's last picture done in Rome, the *Vision of St. Jerome* (Fig. 24),[148] may indicate that he too understood something of Leonardo's role in the fashioning of the most modern art.[149]

The picture seems like a conscious demonstration of the method that Vasari says was Raphael's own road to perfection as a painter:[150] he studied the best masters new and old, selecting the best from each in the creation of a new manner of his own. Although Parmigianino's London picture unites citations from Michelangelo, Raphael and Correggio [151], the basic compositional scheme is actually still derived from works such as the *Transfiguration*,[152] as is the presentation of forms and the dusky dramatic illumination of the picture. In the same way as each of the other figures in the composition refers to one of the founding masters of the *maniera moderna*, Parmigianino's *Baptist* refers, at least indirectly, to Leonardo.[153] The dark mode of illumination may also allude to Leonardo, all the more so since Parmigianino had become acquainted with this sort of *oscurità* before his arrival in Rome. When he arrived there, Parmigianino would have learned Raphael's most recent precepts in a milieu dominated by Giulio, whose interpretation of them extrapolated and emphasized Leonardo's contribution. Although Parmigianino was receptive to this version of the dark mode he was, of course, primarily responsive to the elements of deliberate monumentalized *grazia* in the art of Rome. His interpretation of those elements in the London picture and in later works such as the *Madonna of St. Zachary,* however, suggests that the mystery and languor of his figures still tend to reflect the Leonardesque nuance in Raphael and Giulio.[154] This mood or inclination which persists in Parmigianino's art was fortified and given its special coloration by his prior encounter with Correggio, in whom similar characteristics were derived from the same sources.[155] Thus once again, but now less directly, Leonardo's achievements could nourish the development of what would become aesthetic ideals of the *maniera.*[156]

In Rome, Raphael's artistic convergence with Leonardo and the creation of a dark manner were conscious actions even though they were taken as an integral part of Raphael's artistic development as a whole. Furthermore, Raphael's authority was so clear and powerful that his demonstrations of the new uses of Leonardo's art could be absorbed directly by his followers. Elsewhere, the situation was quite different for a variety of reasons. Painting in Siena, to say nothing of Emilia and Lombardy, presents particularly interesting developments of the dark manner. It was in Florence, however, that the problem was uniquely significant and complex.

The direct inspiration of Leonardo's art had been felt continuously in Florence and its elements were, at an early moment, assimilated into the indigenous styles of Fra Bartolommeo and Andrea del Sarto.[157] The result was that *sfumato* and chiaroscuro lost their exclusive identification with Leonardo and dark tonality came, in some instances, to lose its original primary function as a means of creating *rilievo.* Pedretti's

researches [158] seek to establish Leonardo's presence in Florence at various times between 1513 to 1516. Pedretti, however, suggests that he was concerned only with architectural projects there. His presence is not, moreover, necessary in order to explain the darkening chiaroscuro in the works of Fra Bartolommeo and Sarto during this period. Nonetheless, it would certainly have revived and stimulated interest in the meaning of Leonardo's own accomplishments as a painter.

Leonardesque elements seem to have been significant in the genesis of Pontormo's *Visdomini* altar (Fig. 25),[159] although it was completed only in 1518 when Leonardo had already been in France for more than a year. In the fruitful absence of Leonardo, Fra Bartolommeo and possibly also of Andrea del Sarto,[160] Pontormo made his first monumental statement of post-classical style in Florence. It is interesting that the painting also marks his first unequivocal use of a Leonardesque dark manner.[161] This mode had been available to him for some time through his own brief apprenticeship to Leonardo, through Florentine example, and through Raphael's version of it in the *Madonna dell'Impannata* (Fig. 26) [162]–if, indeed, Pontormo had not already visited Rome before painting the picture.[163] In any event, Pontormo's emphatic choice of a Leonardesque *maniera oscura* on this occasion is an indication that he saw chiaroscuro–as Raphael had done–as newly significant for the formulation of a modern style. It may be argued [164] that Pontormo now used a dark mode as Giulio was to do: to break up three-dimensional forms and compositional structures into disjunctive surface patterns. Historically speaking, certainly, Pontormo appears to have used the dark manner in a way that contradicted the original intentions of its inventor. From the viewpoint of 1518, however, it may rather have seemed that Pontormo was continuing and developing the classical use of chiaroscuro and *sfumato* as creators of *rilievo* [165] through pictorial, optical means. Indeed, by setting his elongated, spatially compressed, isolated and abstracted figures in fitful darkness, Pontormo gave them a plausible existence in a common atmosphere if not in a measurable space.[166] Furthermore, the dusky *sfumato* also functions to provide a psychological tonality that recalls Leonardo and which is also still expressed in the haunted faces of Pontormo's creatures.[167]

This expressive use of the dark manner may help to explain something about its long afterlife in *maniera* painting which, in other ways, was often opposed to Leonardesque principles. *Maniera* artists, more characteristically, came to define forms in a brilliant "flat light" [168] that could bleach colors and that alluded to the aesthetics of antique relief sculpture. Yet, in works like Vasari's *Allegory of the Conception* (Fig. 27) or Bronzino's *Resurrection,*[169] the dark tonality, welling out of the background, is still used as an alternative way of creating the convincing sense of

rilievo which Smyth has shown was essential to the style.[170] Why did artists like Vasari use a dark mode on some occasions and not on others, especially when other conventions of the *maniera* seemed to reject its premises?

Sometimes, of course, the subject matter itself *(Nativities* are an example) invited treatment as a night scene. It is also likely that the impetus from antique description of night pieces and the performance of Raphael and others in this genre, as in the dark mode generally, helped to perpetuate a taste for such settings and lighting. Another explanation for darkness in a picture can sometimes be found in a *maniera* artist's use of a specific late-Raphaelesque prototype (Fig. 28).[171] Furthermore, writers like Lomazzo show that dark pictures were thought proper in certain architectural settings (such as crypts) and that the Aristotelian psychology of dark and light was also in the painter's mind.[172] Most important of all, Lomazzo preserves and develops the Leonardesque idea that light (and thus its absence) is a vital expressive element. It is not surprising that a very general survey of the dark manner in the later Central Italian Cinquecento points to a special association between intense chiaroscuro effects and religious subject matter. As Freedberg showed,[173] *maniera* formal conventions and ideals did not lend themselves to the direct transmission of traditional religious feeling, and it may be that a mode of atmospheric darkness, with its classic association with expressive immediacy and verisimilitude, was sometimes used to impart these characteristics to sacred images. Finally, the metaphorical connection between optical darkness and mystery, both sacred and secular, may also have been involved.[174]

In Pontormo's career, the dark mode was shortly to reappear. He had almost certainly visited Rome by 1520 where his experiments with a dark manner would have been strongly reinforced by the experience of Raphael's own newly Vincian *oscurità*.[175] In the bucolic and courtly setting of Poggio a Caiano, Pontormo had, in fact, decisively rejected *tenebroso* modes. However, in the very different, penitential setting of the Certosa, he used them to great effect. Pontormo's concern with night scenes and dramatic illumination at the Certosa, which Vasari praises so highly,[176] may also have been inspired by what was going on in the circle of Castiglione and Raphael; an ambient from which Leonardo's influence is not to be excluded. In the later twenties, Pontormo again turned to Leonardo's example. In a work like the *St. Anne* altar (Fig. 44), the theme itself invited a treatment reminiscent of Leonardo and Fra Bartolommeo. In this period, however, Pontormo as well as other Florentine artists also began to look at Leonardo in a new way and for reasons that had little to do with the dark manner.

PART II

. . . ed era in quell'ingegno infuso tanta grazia da Dio ed una demostrazione sì terribile accordata con l'intelletto e memoria . . . (Vasari-Milanesi, Le Vite, *IV, 20)*

v Leonardo and Michelangelo: The Medici Chapel

THE USE OF a dark mode of painting for the creation of *rilievo* and expression was the most striking legacy of Leonardo to later Cinquecento painting, but there was a second important if less easily definable way in which Leonardo's art provided an example and an impetus in the creation of postclassical styles in Central Italy. This was the supernal grace of line, pose, color and expression which Leonardo's contemporaries thought so desirable and which Vasari and others seem to equate with Grace from God. For Vasari, Raphael was Leonardo's most direct successor in this respect and, historically, the most influential source of *grazia* or *venustà* for later painters. Yet, as these qualities were sought increasingly, Leonardo's earlier achievements could also be seen as newly significant and accessible under this aspect. Indeed, as has often been pointed out, Leonardo's commitment to the demonstration of beautiful style as a goal of art was a significant factor in the creation of the *maniera*.[177] At the same time, Leonardo's appreciation of the unclassical aspects of antique art must also have created a link with similar perceptions by the younger generation.[178]

31

Of the artists who turned anew to Leonardo because of the abstract grace of his forms, Michelangelo's situation is perhaps the most controversial and interesting. Like Raphael, Michelangelo had wrestled in his earliest Florentine years with the meaning of Leonardo's artistic inventions. Unlike Raphael, however, Michelangelo's struggle seemingly culminated in his opposition to much of the older artist's achievement. Michelangelo's early debt to the specifically pictorial qualities of Leonardo's art was, however, greater than is usually allowed and I believe it forms the background against which certain other later developments in Michelangelo's career may be seen.

The unfinished *Battle of the Centaurs* (Fig. 29) occupies a place in the history of relief sculpture that is in some ways remarkably similar to that of Leonardo's *Adoration*. Michelangelo's figures are no longer placed in front of the relief plane but emerge from the depths of the block with unprecedented freedom,[179] as though the stone were no more dense than the dusky atmosphere that surrounds Leonardo's gesticulating figures. Although we know that contemporaries thought the relief had been completed, it is likely that Michelangelo intended to carry it to a higher degree of finish.[180] Yet, even if the figures were ultimately to be more fully revealed, it may be that Michelangelo's new mode of approach to relief sculpture was, in fact, a plastic equivalent for the new *sfumato*[181] and, like it, was adopted to enhance the *rilievo* of the figures.[182] Speaking more generally, it seems to me that Michelangelo's instinctive and uniquely powerful awareness of the three-dimensionality of forms was initially nourished by Leonardo's invention of the optical means by which the existence of objects in surrounding space could be represented in drawing and painting. Indeed Michelangelo's remarkable dependence on drawing and his practice of carving inward from the front surface of the stone in deepening layers of relief[183] testify that his perception of depth was originally organized by means of its projection in two dimensions.[184] Although these characteristics were to remain constant throughout Michelangelo's career, both in painting and sculpture, his early creation for himself of the role of sculptor implied, at least initially, a rejection of painting as Leonardo had newly defined it.[185]

This polarity was only intensified by the kinds of commissions that filled the sculptor's next years[186] and Vasari says that, during the time before Leonardo left for France, relations between the two artists were unfriendly.[187] Furthermore, Michelangelo's artistic personality and methods never allowed him to absorb the essence of another's style in the comprehensive way that was characteristic of Raphael. Nonetheless, we have seen that there had been tentative indications in painting that a rapprochement in the interests of the two artists had taken place when they were in

Rome. Earlier, there seems to have been reciprocal influence in the development of the motif of the *Slaves* for the *Julius Tomb*.[188] In the second decade, however, critics have noted both a growing atmospheric quality and a more deliberate grace in Michelangelo's drawings and in some of his sculpture.[189] The rapt, curving smoothness of the so-called *Dying Slave* of ca. 1513 (Fig. 30), for example, comes closer to Leonardo's ideals of grace as revealed, for instance, in the standing *Leda* (Fig. 31), than any earlier work by the sculptor. It is as though Michelangelo, too, had begun to experiment [190]—if only intermittently—with a mode of *venustà* as a counterpoise to his more dominant *terribilità*.[191] It cannot be proved that this tendency was linked to a new study of Leonardo since there were some precedents for it in Michelangelo's own earlier works.[192] There is some provocative visual evidence, however, that Leonardo seems again to have been on the sculptor's mind when he moved back to Florence and at a time when his style underwent an important change.

As in Raphael's *Transfiguration,* recourse to Leonardo can be observed most easily in terms of a specific artistic problem: the design of the *Night* (Fig. 37) in the Medici Chapel. Despite the vast differences in medium and artistic vision, a comparison of the head of the sculpture (Fig. 36) with Leonardo's studies for the head of the standing *Leda* (Fig. 35) [193] seems to show where Michelangelo's thoughts were turning.[194] The path that would have led Michelangelo to this association of ideas was a short one. Once he had decided to model his allegorical figure on an antique *Leda* relief (Fig. 34),[195] it would have been entirely natural to look also at the other famous and exemplary representations of the Leda theme.[196] This is all the more likely since both Leonardo's versions of the *Leda* (Figs. 31-33) provided the smoothness and elegant torsions not present in the prototype but which were at least partly sanctioned by antiquity.[197] It was these features of Leonardo's pose that seem to have led Michelangelo to exploit its possibilities in the Medici Chapel.

Aside from the reference in the head of the *Night,* however, there is only a veiled resemblance to a *Leda* pose (Fig. 33). This restraint conforms with the iconographical requirements of the sculpture.[198] It was only in the necessarily youthful figure of the *Dawn* (Figs. 38 and 40), that the full stylistic import of Leonardo's versions of the *Leda* could be fully expressed.[199] There, the studied artifice of Leonardo's graceful, lengthened shapes and suave surfaces could contribute most [200] to the creation of the new formal language that marks such an important and influential aspect of Michelangelo's style in the twenties and early thirties. A comparison of the profile of the *Dawn* with the head of St. Philip in the *Last Supper* shows still another aspect of the painter's legacy to the sculptor (Figs. 38, 39).[201]

When Michelangelo turned again to the theme of the reclining female nude,

around 1530, some of the same elements were associated with each other once more. Michelangelo's design for the reclining *Leda* derived again from the antique *Leda* relief and from the Medici *Night* itself.[202] This new image may also have been in some sense a renewed competitive response to Leonardo's rendition of the same theme. The sculptor had, after all, once before set himself an analogous task, in his versions of Leonardo's *St. Anne*,[203] which had culminated in the polemical anti-Leonardo statement of the *Doni Tondo*. Moreover, the *David-Apollo* (which Heydenreich calls "almost the brother in stone" of the Vincian *Leda*),[204] done in the same period as the *Leda* cartoon, is a further sign of Michelangelo's desire to come to terms with Leonardo's statements of this figural subject. Certainly contemporaries seem to have accepted Michelangelo's *Leda* as the new paradigm he must have intended it to be. The coldly sensuous elegance of the reclining figure became as much a formal exemplar as the vivid legato grace of Leonardo's standing and kneeling *Ledas* had been in the past.[205]

One of the ways in which the sculptor's new ideal went far beyond the example of the past, as represented by Leonardo, was in the new licence of proportion which Vasari also stresses in his account of the Medici Chapel architecture.[206] He and Vincenzo Danti believed that Michelangelo's elongated figural canon was the demonstration of a new grace and rightness based on internal subjective criteria of judgment.[207] However, Dolce had already noticed, in another context, that the vogue for *"colli lunghi"* and slim proportions was based on the example of Roman sculpture.[208] I think this was probably also true for Michelangelo figures. Furthermore, the awareness of Vitruvius and Pliny that the era of perfection in antique sculpture had been marked by elegant proportions [209] must also have been influential. On another level, the changing appearance of Michelangelo's figures may be related to the commission for which they were made.

The use of a *pietra serena* articulation of the Medici Chapel was dictated from the beginning by the requirement that the New Sacristy of S. Lorenzo resemble the Old.[210] Michelangelo responded to the patterns of the Brunelleschian tradition by inserting a carved marble wall architecture into the dark stone framework, exploiting its slim proportions and linear precision [211] with unprecedented poetic intensity. Michelangelo's figural sculpture had, with few exceptions, been conceived in close connection with a sustaining or enframing architecture (Fig. 41). In the early versions of the *Julius Tomb,* therefore, the figures shared the High Renaissance proportionality of the architecture. Thus it seems, in retrospect, inevitable that an artist who saw such explicit metaphorical relation between architecture and the human figure would also make the canon of the figures of the Medici Chapel accord

with the anormative proportions and elegant linearity [212] of his new mode of architecture. The idea that the architecture should resemble that of the Old Sacristy carried with it allusions to the past glories of the early Medici era in Florence and to the continuing identity of Florentine traditions and interests with those of the imperiled Medici dynasty in the period after the Medici restoration.[213]

Although the style of the sculpture which was developed for the chapel cannot, itself, be shown to be determined by such public propagandistic aims, its elongated, refined forms, like those of the architecture that accompany it,[214] pay homage to continuing values of Florentine taste.[215] That taste had been formed in the Quattrocento and the conservative, even archaising, aspect of the New Sacristy commission invited Michelangelo to reaffirm these values in modern terms. Comparable links with the past can also be found in contemporary Florentine figurative art, for instance in Sarto's circle.[216] It would seem, however, that Leonardo, who had transmuted native concepts of linear grace into a fully modern idiom of great prestige, also presented an important source for Michelangelo's own newly Florentine style. Where the Roman Raphael had turned to Leonardo as a means of giving still greater pictorial intensity and drama to his style, Michelangelo now sought, instead, those elements of *venustà* and elegant comeliness which were less essential to his own vision [217] but which were becoming increasingly important in the language of modern art as the "stylish style" took shape.[218]

It would be a distortion to assert that Leonardo was the dominant element in the formation of Michelangelo's new manner. Indeed, I believe that recent observations that there was a new response in Michelangelo's art to Raphael, beginning in the later teens, are essentially correct.[219] In part, these stylistic similarities may be due to parallels as well as to genuine convergences but they could have been stimulated by the cultivated Medician milieu in which both artists worked. This elevated patronage as well as Raphael's example [220] would have contributed to the creation of an aesthetic climate in which Michelangelo, too, could incorporate elements of Leonardo's style.[221]

VI Leonardo
and Florentine Mannerism:
Three Examples

THE INSISTENT GRACE of form and outline of Leonardo's *disegno,* to which Michelangelo seems to have been sensitive, also took on considerable relevance for other, younger, Florentines. It cannot always be shown that these artists followed Michelangelo's example in their renewed interest in Leonardo during the late twenties and early thirties, but they did use Leonardo much as he did: in highly selective and limited ways. Sometimes they looked to Leonardo for an elegant turn of formal phrase; sometimes, more functionally, as the classic source of specific characteristics of style. Here again, Pontormo seems to have been especially responsive to the new role Leonardo's example could play. More than other artists of his time, Pontormo pursued the implications of Leonardo's long *legato* outlines. He must have seen in them both a potential for a still greater lengthening of the linear phrase and of the form it describes, as well as the possibilities for expressive energy of that line, independent of the form it depicts.[222] At the same time, Pontormo seems to have been struck by a perfectly genuine aspect of the appearance of Leonardo's

painting which had, however, been invisible or irrelevant to High Renaissance eyes. Partly because of their dynamic contours, partly because of chiaroscuro contrasts, Leonardo's painted figures often seem detached silhouettes against the background foil [223]—despite his goal of tonal unity. Moreover, in works like the Louvre *St. Anne* (Fig. 43),[224] the volumetric forms do not suggest the weightiness their large size implies. These characteristics offered Pontormo a way in which ample forms, describing an apparent plasticity, could be projected against a surface rather than into depth and thus transformed into a haunting and decorative beauty that converged with ideals of the *maniera*. These features can be seen not only in Pontormo's *St. Anne* altar and in the Hannover *St. Jerome* [225] (Figs. 42, 44), where the subject matter could inspire new interest in Leonardo's treatment of the theme, but in works like the Capponi *Entombment* [226] where there are no motival associations with Leonardo.[227]

The sculptor, Baccio Bandinelli, was another of the younger Florentines on whom Leonardo had profound and enduring effect. Bandinelli's deep artistic involvement with Leonardo has yet to be thoroughly studied and its sources were manifold. Bandinelli was first apprenticed to Gianfrancesco Rustici,[228] who was the foremost translator of Leonardesque ideals into sculpture in Florence. Rustici was more interested in the atmospheric quality and expressive violence in Leonardo than Bandinelli was to be. In fact, Rustici's bronze group on the Florentine Baptistry (Fig. 45) might qualify as an adaptation of Leonardo's dark manner into sculpture. Leonardo had apparently known Bandinelli's father, and Vasari states repeatedly that Leonardo worked directly with Rustici.[229] Leonardo and Bandinelli most probably met in this way. Vasari also believed that it was Leonardo who encouraged and focused the young artist's interests; praising his drawings, urging him to venerate Donatello and to make reliefs. These three concerns do indeed continue to dominate Bandinelli's interests even more than those of contemporary sculptors. Like Michelangelo, Bandinelli would have learned from Leonardo the supremacy of *disegno* and the notion that drawing was not only a technique to prepare a work of art but a fundamental means of thinking and cognition. It may even be that Leonardo's theoretical preference for reliefs as opposed to sculpture in the round, because they more closely resembled painting,[230] helps to account for Bandinelli's unusual and persistent commitment to this form.[231] It is also of interest to our understanding of both artists that Leonardo inspired Baccio to carve his first work: an antique female head modeled on an example in the Medici collection. This information comes from Vasari,[232] who apparently saw nothing uncharacteristic of Leonardo in this suggestion.

Bandinelli's first attempt at sculpture has been lost, but most of his early works in

other media speak in a distinct if somewhat halting Vincian accent. His earliest prints, such as the *Cleopatra,* engraved by Agostino Veneziano in 1515 (Fig. 46), show a boldly pictorial approach to the modeling of the figure and the use of a dark Leonardesque foil for the background. The *Cleopatra* is also remarkable for its complex double *contrapposto* which Baccio would have known from Leonardo's *Leda* but which had also been ratified by Raphael's use of the *Leda* theme in the *Galatea* fresco in the Farnesina.[233] Bandinelli had become acquainted with the art of Raphael and his school in Rome as early as 1514, and was there again in 1517 [234] when the renewed interest in Leonardo was at its height there. Indeed, what little we know of Bandinelli's painting in the teens also shows it to be doctrinaire to the point of awkwardness in its advocacy of Vincian darkness. Characteristically, however, Bandinelli seeks to combine Leonardo with the antique. The foreground of Baccio's *Leda,* painted about 1517 (Fig. 47),[235] reverses and adapts the newly discovered *Laocoon* group.[236] Thus the smiling Leda is seated on a carved pedestal which is partly covered by drapery as in the statue, and the serpent's bite is transformed into the swan's kiss.[237] In his painting Bandinelli faced the challenge that Rustici had confronted in his sculpture: the integration of the dark manner into sculptural form. Leonardo had claimed primacy for painting, in the *Paragone,* on the ground that painters create and control their own light within the picture, whereas sculpture is dependent on outside sources of illumination.[238] In a sense, Rustici's sculpture seeks to mitigate this deficiency by modeling shapes and surfaces that catch light and unify the forms with the surrounding atmosphere. In Bandinelli's painting, on the other hand, despite all the dramatic, mottled contrasts of light and darkness, an inherent separation between plastic form and the light that plays upon it is maintained. This may be a reaction to a parallel clarification and schematization of Leonardo's dark manner that is visible in Roman painting of the same moment. Yet, Bandinelli's smooth sealed forms and the ambiguous treatment of the *Leda* theme in terms of statuary are certainly also related to his ambitions as a sculptor.

A comparable orientation can be detected in a remarkable pen drawing by Bandinelli (Fig. 48) which should, perhaps, be dated somewhat earlier than the painting.[239] The sculptor copies Leonardo's *Angel of the Annunciation,* which Vasari had seen in the Medici collection and which is known to us in several versions.[240] The image is closely related to Rustici's *Baptist,* and Leonardo seems already to have experimented with the motif in the period when the young sculptor first made his acquaintance. It is possible that Raphael was also involved with Bandinelli's interest in the image, although the uncertain date of the Leonardesque prototype and of Baccio's drawing leave the matter in doubt. However, the figure of the blond,

pointing youth in the foreground of the *Disputa* (Fig. 12) also conveys Raphael's knowledge of Leonardo's examples and is, in some ways, closer to Baccio's interpretation.

Bandinelli's drawing confirms Vasari's account of the artist's early formation and displays the imitative insistence and skill which are so crucial to Baccio's artistic personality. His *Angel,* however, is far more than a clever copy. It is a concentrated search for the concrete, plastic equivalents for the fleeting play of light and shade that defines Leonardo's surfaces. Bandinelli was famous for his chalk drawings from his earliest youth.[241] That more flexible and pictorial technique would have seemed the appropriate means to record the delicate *sfumato* of the original. Baccio's choice of the pen and his representation of shadow by webs of cross-hatching are not fortuitous. They are the technical means, used also by Michelangelo, to achieve the stabilization and clarification of form that initiates the conversion of a painted image into sculpture. This was a fundamental aim of Bandinelli's draughtsmanship throughout his career. This transformation also entailed, for the sculptor, a related reduction of Leonardo's rich formal and expressive language to its dominant values of elegance and *grazia.* We see this tendency clearly in the polished figures in Bandinelli's relief of the *Birth of the Virgin* for the Santa Casa di Loreto (Figs. 49-50).[242] There the sculptor obeys selected directives inherent in Leonardo's art when he exploits Vincian motifs for their tense curving shapes, their continuity of form and perfection of finish. In Baccio's somewhat ruthless hands, sweeping Leonardesque rhythms were reduced to formulae of grace, caught up into a rigorous system of style whose structure was indebted to Raphael but, still more, to the example of antique relief [243] and which was to endure for the rest of the sculptor's career. Yet even this antiquarian tendency was also consonant with Leonardo's partial sanction of imitation of the ancients. Thus Bandinelli was one of the first artists of the younger generation to see in Leonardo a source not only of canonical tradition, but of intimations prophetic of the *maniera.* At the same time, the conservatism of Bandinelli's mature style preserved its Leonardesque components and helped to perpetuate their influence in the later Cinquecento.

It is worth remembering, however, that Bandinelli's earliest experiments with a graceful manner were contemporary with his use of a deliberately *antigrazioso* mode, developed in close association with Rosso Fiorentino. Leonardo's heritage, however, also had significance for this aspect of Bandinelli's art. This is particularly evident in the least *manieroso* and graceful of Bandinelli's works, the *Hercules and Cacus* (Fig. 51), finished in 1534 and placed as a counterpart to Michelangelo's *David* in front of the Palazzo Vecchio. The colossal *Hercules* group was intended to challenge and super-

sede Michelangelo's masterpiece, both as a statement of politics and of artistic principle. [244] The two heroes were traditional symbols of the Florentine state and of its republican traditions. Commissioned by Duke Cosimo in the period after the siege of Florence, Bandinelli's *Hercules* became, instead, the embodiment of Medici hegemony in Florence. This fact helps to explain some of the violence of the criticism launched against Bandinelli's statue. At the same time, however, critics were also responding to the artistic polemics projected by the *Hercules and Cacus*. Michelangelo's *David* represented the culmination of the entire antique and modern tradition of the standing *contrapposto* figure for the early sixteenth century. Instead of competing in the same mode, Bandinelli rejected it decisively by placing his *Hercules* in a tense arrogant stance in which the figure's weight was equally distributed on both legs. This highly unusual pose, as well as the compact proportions of the figure and the anatomical patterns of the torso, was directly related to drawings by Leonardo of a *Hercules* which, in turn, seem to have developed out of studies for figures related to the *Battle of Anghiari* (such as Fig. 52).[245] Furthermore, Vasari's report that Bandinelli found the modelling of his group *"troppo dolce"* when it was first exhibited,[246] may suggest that this aspect of the sculpture was also originally Leonardesque. Bandinelli's crouching *Cacus,* however, is adapted from the famous antique *Knife Grinder,*[247] while the often criticized brutality of Bandinelli's interpretation of figures and pose also have precedents in later antique art. In the *Hercules and Cacus,* Bandinelli attempted to outdo Michelangelo's achievement by presenting a conscious alternative to it.[248] In doing so, he adopted the same artistic attitudes that had guided his earliest experiments. He championed a degree of fidelity to antique prototypes which would have seemed to Michelangelo like a betrayal of his own individuality. At the same time, Bandinelli selected a Leonardesque image for its "anti-Michelangelesque" potential, imitated it closely and transformed it into sculptural terms.

Many more examples could be cited of this kind of creative retrospection in the sixteenth century, but perhaps the most typical meaning of Leonardo's second Florentine incarnation can be seen in Bronzino's famous Uffizi portrait of Eleonora di Toledo (Fig. 53).[249] The painting is often singled out as the epitome of the high Tuscan *maniera*,[250] whose cold iconic brilliance seems the negation of everything Leonardo stood for. Yet, the means Bronzino chose to transmute the human person of his noble subject into its ineffable timeless surrogate were subtly to infuse the secret perfections of the Mona Lisa's visage into the individual lineaments of the Duchessa's face (Figs. 54-56).[251] In the *Eleonora,* however, the Mona Lisa's pose becomes one of ceremonial presentation; the warm breast a silken shield; the soft clothes, a peacock armor and the ambiguous smile is extinguished in the precise

definition of the sitter's sullen dignity. Most striking of all, perhaps, Bronzino turns the deep misty heavens that open behind the Mona Lisa like the country of her imagination into a hard, blue empyrean, pure and daunting as Byzantine gold.[252]

The *Mona Lisa* had long since acquired an exemplary authority akin to that of the antique and this, in itself, would have made the picture a good model for a great portrait of State. Even visual quotation of the *Mona Lisa* was a kind of classic citation since Raphael had used this source in portraits of his own. Raphael's act of homage, however, was meant as a still fuller statement of Leonardo's own intention to create a vivid humanity in terms of burgeoning *rilievo* and splendor of optical effect. The appearance of Bronzino's picture reveals, however, that he saw the *Mona Lisa,* instead, as a symbol whose meaning was beauty itself: the embodied *grazia* that defined the perfection of art. The means to that perfection was now a vision of *disegno* that no longer perceived painting as "a composition of light and shade combined with all the various kinds . . . of colors," in Leonardo's words;[253] but rather as the simulacrum in paint of illuminated sculpture.

This was by no means the only occasion on which Bronzino made specific use of Leonardo's example. Indeed, it might be said that the linear definition of idealized form and the related, peculiar psychological impenetrability and ambiguity so often noted in Bronzino's portraits take up the special mode of portraiture represented by Leonardo's *Ginevra de' Benci* and really found only in Leonardo. Nevertheless, Bronzino also brings us to the limits of our investigation. In North Italy, Lomazzo enriched later art theory by reintroducing Leonardesque ideas; the Leonardesque pictorial tradition may have been newly fruitful in the time of Caravaggio.[254] In Central Italy, however, it becomes increasingly difficult as the century progresses to distinguish a genuine current of Leonardesque revival from those aspects of his art that had been fully absorbed and integrated into the Florentine and Roman pictorial heritage. Indeed, the very qualities which would have recommended Leonardo's painting to Bronzino were soon to become targets for criticism. For the next century, Leonardo's *oscurità* seemed to betray an incomplete mastery of the problems of painting while the clarity and vigor of his contours were seen as a still unabated, primitive harshness that remained for later artists to overcome.[255] Leonardo had become the reincarnation of Protogenes who had not known when to lift his brush from the painting. He was no longer a Renaissance Apelles triumphant.

APPENDIX Luministic Imagery in the Iconography of the *Transfiguration*

VARIOUS PROPOSALS have been made in the past about the religious and political meaning of Raphael's picture. Some of these proposals take note of the unprecedented combination of the shining vision on Mount Tabor with the episode of the boy possessed by a demon—a scene which takes place in the valley below.[1] Critics have been equally struck by the tonal contrasts between the two halves of the composition and by the importance of luministic elements in the painting as a whole.

Vasari had already described Christ's brilliant garments in the picture as being "the color of snow," and, by quoting this gospel formulation (Mark IX:3), showed that he understood Raphael's representation to refer directly to Scripture.[2] The visualization of the biblical metaphor in Raphael's painting also helps to communicate the

prefiguration of the Resurrection and of salvation, both of which are always inherent in the meaning of the Transfiguration. At his Resurrection, for instance, Christ's countenance once more becomes "like lightening and His raiment white as snow" (Matthew XXVIII:3). The spiritual significance of the light of the Transfiguration is expressed most clearly of all in a biblical source outside the gospels. St. Peter in his second Epistle interprets the Transfiguration, saying of it, "Ye do well to attend, as to a light that shineth in a dark place, until the day dawn and the day star arise in your hearts" (Epistles 2 Peter 1:16-19).[3] As I have already suggested, Raphael's painting illustrates this passage with remarkable fidelity since the dawn does, in fact, rise and the transfigured Christ shines forth above the darkness in celestial splendor.[4]

All these diverse biblical sources can, however, also be found gathered together in the liturgy for the Feast of the Transfiguration, August sixth, which celebrates Christ's appearance in garments of supernal whiteness, surrounded by a glory of divine light. Several authors have also noted that two deacons are represented in the upper left of Raphael's painting, and these have been identified as saints whose commemoration falls on the same day as that of the Transfiguration. Attempts have been made to explain the curious iconography of the painting on this basis, despite the fact that the liturgy nowhere refers to the episode of the possessed boy.[5] Nonetheless, a closer examination of the text and meaning of the liturgy and, particularly, of its rich luministic imagery yields a number of concordances with the striking contrasts both of tonality and meaning between the two halves of Raphael's picture.

Throughout the Mass, evocations of brilliant, coruscating light are summoned to describe the Transfiguration, and certainly this imagery itself could have encouraged Raphael to conceive of this picture in unusually dramatic, luministic terms. At the same time, of course, the effusion of light described in the liturgy has traditional symbolic meanings with which Raphael would have been entirely familiar. We have already seen how the Mass interprets the Transfiguration as "a light that shineth in a dark place." Peter uses this expression in the context of an exhortation to the faithful to await Christ's Second Coming and their Salvation. This is also what is metaphorically implied by the relation of the episode of the possessed boy to the Transfiguration, both in the gospel accounts and in the painting: the pilgrims and the Apostles must also await the return of the Savior before the child can be healed. Indeed, Christ Himself insists on this point while chiding those who wait for Him with lack of faith (Matthew XVII:16-22; Mark IX:16-29; Luke IX:10-41).

In the Mass, as well, the passage from Peter, with its emphasis on an inner illumination that will come into the hearts of the faithful, is placed in a context of

liturgical purgation and purification. This theme is stated explicitly in the Secret where the priest says, ". . . by the splendor of His brightness cleanse us from the stains of our sins." The interpretation of the Transfiguration as a brilliant symbol of passage from darkness into light, whose meaning is purification and healing, also recurs in the Mass for the Second Sunday in Lent, in which the theme of Salvation is closely associated with the Resurrection of Christ which was prefigured by the theophany on Mount Tabor. At the same time, the need for secrecy is stressed in the Office: "Tell the vision which you have seen to no man, till the son of man be risen from the dead" (Matthew XVII:9). This command, which is echoed also in the other gospel accounts, is also consistent with the often noted compositional isolation from each other of the two narrative episodes in the painting.

The Office for the Feast of the Transfiguration also provides further prayers which couple luministic imagery with metaphors of healing and salvation. In the breviary, the Petrine citation from the Mass is balanced by a *capitulum* from St. Paul's Epistle to the Philippians: "We look to the Saviour, Lord Jesus Christ, who will reform the body of our lowness made like the body of his Glory (*corpori claritatis suae*)." [6] This is certainly also the exact sense of the juxtaposition of the Transfiguration with the episode of the boy possessed by an unclean spirit.

Even if we accept the notion that Raphael's painting is really linked to the liturgical feast, this does not tell us why Cardinal Giulio de' Medici should have chosen this subject for a painting. Although scholars have speculated on this very point, none of the various theories that have been advanced have found general acceptance. There is still another source, however, which seems to confirm the symbolic meaning of the Transfiguration as it is interpreted in the liturgy and which may thus illuminate the intent of the commission.

Luministic imagery, metaphors of healing and the juxtaposition of the possessed boy with the Transfiguration, are all found together in the Sermons of St. Augustine on the Gospel of St. Matthew *(Sermones* LXXVIII-XXX). Augustine says that the shining robe of Christ, whiter than snow, represents the purification and healing of the Church. [7] The healing of the possessed youth is another example of Christ's divine physicianship. The Transfiguration, however, is also an announcement of the Passion and of the Resurrection. In the same way, the possessed boy is the figure of sinful humanity redeemed by Christ. "The sick slew the physician but the physician being slain healed the frantic patient" *(Sermo* XXX). The metaphor of Christ as physician recurs throughout this group of sermons and, indeed, the concept of *"Christus medicus"* is important to Augustinian thinking in general, and it is an idea that had broad currency during the reign of Leo X. [8] In his new book on Raphael's tapestries

for the Sistine Chapel, John Shearman has shown how these works, and others, celebrate the double theme of *Christus medicus* who heals man and the Church of sin, and of the Pope as *"alter Deus in terris"* who heals their ills and brings peace and unity to the world by dispensing the *"medicina Dei."* Although what Shearman calls the "medical metaphor" was a traditional one, and had already been applied to Julius II, it seemed uniquely appropriate to the Medici Papacy. The significant word play on the family name and mission was optimistically applied to the new Pontiff, whose virtuous habits, as well as his promise to bring peace to the Christian world, made him seem to his contemporaries like a veritable earthly Messiah.[9] Raphael's painting would appear to be still another visual embodiment of this "medical metaphor" and, for political and religious reasons, would have made an especially appropriate gift by the Cardinal de' Medici to his new See of Narbonne.

If this line of inquiry is pursued further, Raphael's painting can be understood, as well, as championing the unique authority and power of the Pope: the *Primatus Petri,* one of the dominant issues of the era of the Lateral Council. Shearman, for instance, points out that the passage *"Hic est filius meus dilectus in quo mihi complacui,"* illustrated by the Sistine wall fresco of Christ's Baptism, would also have referred to the tapestry hanging below: the *Charge to Peter,* a subject which affirms Christ's choice of Peter as the foundation of the Church.[10] These words, first spoken by God the Father at Christ's Baptism, are heard again issuing from the shining cloud that surrounds Christ at the climax of the Transfiguration with the added exhortation "hear ye him" (Matthew XVII:5). Both patristic and liturgical texts on the Transfiguration emphasize this moment, above all others, as the revelation of Christ's unequivocal primacy and authority. For the Pope, as *"alter Deus in terris,"* the Transfiguration ratifies his supremacy as well.

St. Peter's role during the Transfiguration may also be interpreted as referring to the *Primatus Papae.* With James and John, Peter was chosen to bear personal witness to the revelation of Christ's Godhead. Indeed, it is possible that the affirmation of papal primacy is also reflected in Raphael's unique interpretation of the episode of the possessed boy. The remarkable thing about it is that the healing of the child does *not* take place. The scene shows the helplessness, even of the Apostles, in Christ's absence. The cure can be effected only by the great *Medicus* himself. In the same way, only Christ's vicar, the Pope, can bring peace and unity to the world and healing to the Church.[11] The same theme can, of course, be found in the intended companion piece to Raphael's painting: Sebastiano's *Raising of Lazarus.* Here, too, is a Resurrection-like miracle, accomplished to show the power of faith, and as a demonstration of

Christ's unique power and authority as a healer. The implications of such an interpretation lead far beyond the scope of this study.[12] Here we can only suggest that when Raphael's painting, with its contrasts both of illumination and content, is seen as an image of *Christus medicus* and of the *Medicina Dei,* it is no longer eccentric or inexplicable, but takes its place as an integral part of the widely disseminated and understood "mythology of Leo's pontificate."[13]

Notes

PART I

N.B. A condensed and somewhat modified version of the material on Raphael's *Transfiguration* was published in the *Art Quarterly*, XXXV, 1972, 343-374.

1. This was at least Leonardo's second trip to Rome; he had probably been there in 1502-1503 (C. Pedretti, *A Chronology of Leonardo da Vinci's Architectural Studies after 1510*, Geneva, 1962, 61, 64); G. Poggi, *Leonardo da Vinci: la vita di Giorgio Vasari nuovamente commentata*, Florence, 1919, 41-43. Leonardo traveled from Milan via Florence to Rome. Rooms had been prepared for him at the Vatican by the first of December, 1513, and he may already have been in Rome by that time. (He was probably still in Florence on October 20.) Since he saw Bramante in Rome (see below, n.3), Leonardo must have been in Rome before March, 1514 when the architect died. The first dated notice of Leonardo's presence in Rome is for July 7, 1514. Leonardo was established in Rome until the autumn of 1516 although he was absent at times during this period. (See Pedretti, *Chronology*, 79-81, 107-112, for Leonardo's peregrinations as well as for his architectural activities.) For Leonardo's other projects during this period and related bibliography, see also C.L. Frommel, "Leonardo fratello della confraternità della Pietà dei Fiorentini a Roma," *Raccolta Vinciana*, XX, 1964, 369-373. Leonardo's activities were widespread and intense, ranging from a project, sponsored by Giuliano de' Medici, to drain the Pontine marshes, to concern with dissections, the building of St. Peter's and the design of mirrors, machines, instruments and maps.

2. G. Vasari, *Le Vite de' più eccellenti pittori, scultori ed architettori*, ed., G. Milanesi, Florence, 1878-1885, IV, 47, for paintings made by Leonardo during his Roman stay.

3. The only contemporary record of contact between Leonardo and his most famous contemporaries in Rome mentions Bramante but Raphael and other architects may have had some direct knowledge of Leonardo's scientific activities (Pedretti, *Chronology*, 33, 81, 157-162). See also C. L. Frommel, *Baldassare Peruzzi als Maler und Zeichner*, Beiheft, *Römisches Jahrbuch für Kunstgeschichte*, II, 1967-1968, 83, n. 371.)

4. Vasari-Milanesi, *Vite*, IV, 46-47.

5. "Un altro de' primi pittori del mondo [Leonardo] sprezza quell'arte dove è rarissimo, ed essi posto ad imparar filosofia; nella quale ha così strani concetti e nuove chimere, che esso con tutta la sua pittura non sapria depingerle." (V. Cian, ed., *Il Cortegiano del Conte Baldesar Castiglione*, Florence, 1929, II, XXXIX, 197-198, line 31. Cf. Vasari-Milanesi, *Vite*, IV, 18, 22.)

6. V. Cian, "Baldassar Castiglione e Leonardo," in M. Cermenati, ed., *Per il IV centenario della morte di Leonardo da Vinci*, Bergamo, 1919, 102. P. Giovio, "Leonardi Vincii Vita," in G. Tiraboschi, ed., *Storia della letteratura italiana*, Rome 1785, IX, 120, writing ca. 1527, also says that Leonardo carried few works to completion because of his other interests. The idea is taken up by the Anonimo Magliabechiano (C. Frey, ed., *Il Codice Magliabechiano*, Berlin 1892, 110), and by Dolce (M.W. Roskill, *Dolce's "Aretino" and Venetian Art Theory of the Cinquecento*, New York, 1968, 181). However, as Mancini understood, these comments were not entirely negative but rather gave evidence of Leonardo's "furor poetico e pittoresco ... per amator e contemplator dell'arte e così gl'ascrive a virtù e non a vitio." (A. Marucchi, L. Salerno, eds., G. Mancini, *Considerazioni sulla pittura* [1614-1630], Rome, 1956, I, 190.)

For the history of attitudes toward Leonardo's character and art, see L. Venturi, *La Critica e l'arte di Leonardo da Vinci,* Bologna, 1919, 93-165.

7. F. Hartt, *History of Italian Renaissance Art,* New York, 1969, 410. Most recently, however, Chastel has given a stimulating interpretation of a "Léonard engagé" and stresses his influence in Florence in the early sixteenth century but also, posthumously, on the ideas of Vasari (A. Chastel, "Les notes de Léonard de Vinci sur la peinture d'après le nouveau manuscrit de Madrid," *Revue de l'Art,* XV, 1972, 16).

8. Vasari's interpretation was expanded by later writers. Lomazzo, who was so strongly influenced by Leonardo's teachings, actually wrote a poem praising Leonardo's chiaroscuro (E. Solmi, "Ricordi della vita e delle opere di Leonardo da Vinci raccolti degli scritti di Gio. Paolo Lomazzo," *Archivio storico lombardo,* XXIV, 1907, 324). Elsewhere, Lomazzo also insists repeatedly on the darkness of Leonardo's style and on its historical importance. Leonardo and those who followed his rule "sono stati reputati degni del nome di pittore, perchè sono stati cotanto parchi nel dare il chiaro, che non altrimenti che gemma preziosa l'hanno distribuito nelle sue figure. Talchè sono riuscite di tanta dolcezza, e rilievo, e così piene d'artificio e considerazione, secondo la natura della cosa finta; e la ordinazione della superficie, che più non ne può mostrare il naturale." (G. P. Lomazzo, *Trattato dell'arte della pittura* [1584], Rome 1844, I, 406.) Lomazzo also speaks of Leonardo's "nobil furia di colorito esprimendo in loro [great men and small] e gli andamenti suoi, dandogli le ombre, e i lumi variatamente, con veli sopra veli . . . Leonardo nel dar il lume mostra che habbi temuto sempre di nondarlo troppo chiaro, per riseruarlo a miglior loco e ha cercato di far molto intenso lo scuro, per ritrovar li suoi estremi. Onde con tal arte ha conseguito nelle faccie e corpi che ha fatti veramente mirabili, tutto quello che può far la natura. Et in questa parte è stato superiore a tutti, tal che in una parola possiam dire che'l lume di Leonardo sia divino." (G.P. Lomazzo, *Idea del tempio della pittura* [1590], Hildesheim, 1965, 50-51.)

9. Vasari-Milanesi, *Vite,* IV, 27, 372. For a summary of modern views see S.J. Freedberg, *Painting of the High Renaissance in Rome and Florence,* Cambridge, Mass., 1961, 157-158, 162-166, 181, 185, 335; J. Pope-Hennessy, *Raphael,* London, 1971, 61, 64, 219 *et passim;* L. Becherucci, A. Forlani-Tempesti *et al., Raffaello,* Novara, 1968, I, *passim,* emphasize the importance of Leonardo most consistently. For studies of Leonardo's role in individual works by Raphael see for instance, G. Hoogewerf, "Raffael en Leonardo da Vinci," *Medeelingen van het Nederlandsch Historisch Instituut te Rome,* III, 4, 1947, 27-40; K. Oberhuber, "Die Fresken der Stanza dell'Incendio im Werk Raffaels," *Jahrbuch der Kunsthistorischen Sammlungen in Wien,* LVIII, 1962, 23-72; C.G. Stridbeck, *Raphael Studies II: Raphael and Tradition,* Stockholm 1963, 60, 79. Many of Raphael's *Madonnas* are ultimately based on Leonardo, not only in their compositional structure and affective relationships, but in the creation of an atmospheric totality realized in terms of light. Some early works, indeed, already show a Leonardesque darkness in their background indoor settings. However, see Pope-Hennessy, *Raphael,* 188-189, 285-286, nn. 18, 19, 27, 28 for the problem of repainting. In Raphael's Roman works he still remembered Leonardo's lessons in the orchestration of dramatic, coherent narrative action expressed through dynamic figures whose gestures express both their inner motivation and their relation to the event depicted. Raphael had assimilated Leonardo's art to the point that it was entirely his own and remained continuously available to him.

10. Pope-Hennessy, *Raphael,* 64. This impression is strengthened by the common ancestry of the compositions of Leonardo and Raphael in those of Donatello.

11. For example, see Freedberg, *High Renaissance,* 265-266 ff., and in his *Painting in Italy 1500-1600,* Harmondsworth, 1971, 39.

12. See J. Shearman, "The Chigi Chapel in S. Maria del Popolo," *Journal of the Warburg and Courtauld Institutes,* XXIV, 1961, 143-152, 155-158; an *Assumption* by Cola dell'Amatrice in the Vatican Pinacoteca, signed and dated 1515, is clearly influenced by the Raphaelesque *Assumption* and provides a *terminus ante quem* for the design. For the *Resurrection,* see M. Hirst, "The Chigi Chapel in S. Maria della Pace," *Journal of the Warburg and Courtauld Institutes,* XXIV, 1961, 171-174. See also Becherucci and

Forlani-Tempesti in Becherucci *et al.*, *Raffaello*, I, 171-172, II, 401-404. It is possible that Leonardo may also have studied both themes since there are school works representing these subjects and an *Assumption* is mentioned in the Codex Atlanticus (ca. 1481). See L.H. Heydenreich, *Leonardo da Vinci*, New York, 1954, I, 181, 183. A drawing at Windsor of an *Assumption* attributed to Cesare da Sesto (K. Clark, C. Pedretti, *Leonardo da Vinci Drawings at Windsor Castle*, London, 1968, no. 056) shows a close relationship to the Raphaelesque engraving and to the Monteluce *Coronation* and presumably implies knowledge of them. This is true also of a Brera *Assumption* given to Marco d'Oggiono. It is impossible to say whether Raphael could have known any studies by Leonardo or his circle for these subjects.

13. Freedberg, *High Renaissance*, 181, 333-336, 372. The assumption that the *Mona Lisa* accompanied Leonardo to Rome is based on visual similarities to portraits by Raphael and Sebastiano. More recently, E.H. Gombrich, "The Form of Movement in Water and Air," in C.D. O'Malley, ed., *Leonardo's Legacy*, Berkeley and Los Angeles, 1969, 203, and Forlani-Tempesti in Becherucci *et al.*, *Raffaello*, II, 397, have also briefly expressed the belief that Leonardo's Roman presence must have had direct results for his contemporaries. Freedberg, *High Renaissance*, 151, notes that Peruzzi also passed through a phase of Leonardesque illumination in 1513-1515, which may be related to Leonardo's presence in Rome. Frommel, *Peruzzi*, 83, observes direct absorption of Leonardesque types ca. 1516. Peruzzi's reception of Leonardo may also have had consequences for Polidoro. See below, n. 142.

14. For a comparative survey of earlier assessments of the *Transfiguration* see H. Lütgens, *Raffaels 'Transfiguration' in der Kunstliteratur der letzten Vier Jahrhunderte* (Diss.), Göttingen, 1929. J. Strzygowski, *Das Werden des Barock bei Raphael und Correggio*, Strassburg, 1898, was the first to note the importance of Leonardesque elements in the *Transfiguration*, but he made comparisons only with the *Last Supper* as a source for types and gestures in Raphael's picture (Lütgens, *Transfiguration*, 17). The more recent literature on the work, beginning with O. Bock von Wülfingen, *Raffael, Die Verklärung Christi*, (Neubearbeitung des 1946 erschienenen Kunstbriefes, Werkmonografien zur bildenden Kunst, no. 9) Stuttgart, 1956, adds little to earlier observations on Leonardo's influence. No more than passing allusion to Leonardo in this context is made in such postwar monographs as S. Ortolani, *Raffaello*, Bergamo [1942], 1948, 73; O. Fischel, *Raphael*, tr. B. Rackham, London, 1948, 285, 287. A Bertini, "La 'Trasfigurazione' e l'ultima evoluzione della pittura di Raffaello," *Critica d'arte*, VIII, 1961, 1-19, and G. L. Mellini, "In margine alla 'Trasfigurazione' di Raffaello," *Critica d'arte*, X, 1963, 39-53, however, give far more extensive inventories of Leonardesque characteristics and motifs in the picture and a fuller appreciation of their significance. They also point to their source in the *Adoration*. Subsequent Raphael literature does not take up the question specifically, although H. von Einem, in his thoughtful study, "Die 'Verklärung Christi' und die 'Heilung des Besessenen' von Raffael," *Abhandlungen der Akademie der Wissenschaften und der Literatur in Mainz*, Wiesbaden, 1966, 307, mentions Leonardo's influence on Raphael's poses depicting expression and motion. Becherucci, in Becherucci *et al.*, *Raffaello*, I, 191, however, states succinctly that the radical illumination of the *Transfiguration* is based on that of the *Adoration* and she is, throughout her text, specially sensitive to Leonardesque elements in the Roman Raphael. For the general history and bibliography of the *Transfiguration*, see L. Dussler, *Raffael: Kritisches Verzeichnis der Gemälde, Wandbilder und Bildteppiche*, Munich, 1966, 67.

15. The passage of water with reflections at the lower left of the *Transfiguration* also seems to be a response to these pictures. However, see below, n. 55.

16. Vasari-Milanesi, *Vite*, IV, 27, 372, may also have recognized Raphael's debt to Leonardo's *Adoration* since he singles out the "teste belle" as major elements in both pictures.

17. The St. Philip-like pose is studied separately in drawings in the Louvre and at Oxford (K. Oberhuber, "Vorzeichnungen zu Raffaels 'Transfiguration'," *Jahrbuch der Berliner Museen*, n.f., IV, 1962, 134, n. 42, 136. Also see these sources for the attribution of these sheets.) The gesture of Raphael's Apostle, seated in the middle, echoes that of the Leonardesque angel in the *Adoration* to the left of the tree. Leonardo's kneeling adoring Magus seems a point of departure for the very different kneeling woman

in the *Transfiguration*. Even the figures of the three Apostles on the mountain derive from the prostrate Magus on the left of the *Adoration* and the figure on the right who raises his hand to his forehead. Drawings for the *Transfiguration* reveal an even stronger Leonardesque imprint than the finished painting.

18. The hill, which represents Mount Tabor is, however, a traditional feature of *Transfigurations* and appears in versions of the theme that inspired Raphael's handling. See Lütgens, *Transfiguration,* 15-17; Stridbeck, *Raphael Studies,* 7, and von Einem, "Verklärung," 304-309, 316, for sources of the Transfiguration motif in Western and Byzantine art. To these examples one may add Genga's *Transfiguration* in Siena (B. Berenson, *Italian Pictures of the Renaissance: Central Italian and North Italian Schools,* London, 1968, III, pl. 1843).

19. J. Shearman, "Leonardo's Colour and Chiaroscuro," *Zeitschrift für Kunstgeschichte,* XXV, 1962, 24, 43, n. 29, identifies Leonardo's dark "foil" *(campo)* as a "half-built choir" or, perhaps, as the Virgin's cloth of honor. Certainly it passes behind some of the figures. In what is thought to be Filippino's version of the Scopeto altar in the Uffizi, however, only rocks and a hillside are represented.

20. Pope-Hennessy, *Raphael,* 64, also sees Leonardo's underpainting as the source of Raphael's wash drawing technique in the drawings for the *Disputa*. For the technique and condition of the *Adoration* see P. Sanpaolesi, "I Dipinti di Leonardo negli Uffizi," in A. Marazza, ed., *Leonardo: Saggi e ricerche,* Rome, 1954, 40-46.

21. It is possible that this tendency was specially marked on those occasions when Raphael found himself in direct competition with Michelangelo, as in the early Stanze and the Cartoons as well as in the *Transfiguration*.

22. The degree to which the *Adoration* underlies the *Disputa* was again recently stressed by Oberhuber, Lecture, the Frick Collection, December, 1971. For the *Spasimo,* see Freedberg, *Painting in Italy,* 70, n. 75. Forlani-Tempesti, in Becherucci *et al., Raffaello,* II, 397, rightly stresses direct contact with Leonardo in Raphael's *Assumption* designs.

23. Significantly, the *Madonna di Foligno,* which itself prefigures the *Transfiguration,* also quotes directly from the Madonna of the *Adoration* (H. Wölfflin, *Classic Art,* London, 1953, 20) and uses the kneeling figure on the left for the St. Francis as well as the Vincian pointing gesture for the Baptist.

24. The presumption for this trip rests on Vasari's account and a later letter by Bandinelli. See J. S. Ackerman, *The Architecture of Michelangelo,* 2nd ed., London, 1964, II, 3. Whether or not Raphael actually saw the *Adoration* again, his use of elements from the picture during his just preceding Roman years shows what a clear image he still had of Leonardo's painting. Probably, there were sketches or copies of the work in the Raphael Shop.

25. Other artists also turned to the *Adoration* at this time, among them Sarto, *Preaching of the Baptist,* 1515 (J. Shearman, *Andrea del Sarto,* Oxford, 1965, 31); Rosso, *Memento Mori,* 1517 (Freedberg, *High Renaissance,* 544); Pontormo, *Joseph in Egypt,* 1518 (K. Forster, *Pontormo,* Munich, 1966, 30).

26. A summary of earlier attitudes toward the aesthetic problem posed by the combination of the two themes is given by Lütgens, *Transfiguration,* 22-45. For more recent interpretations: Bock von Wülfingen, *Verklärung,* 14-16, 18; von Einem, "Verklärung," 315; Freedberg, *Painting in Italy,* 218, Pope-Hennessy, *Raphael,* 72-75.

27. The healing of the possessed boy follows all three scriptural accounts of the Transfiguration: Matthew XVII:1-21, Mark IX:2-29, Luke IX:28-44. A comparative analysis of the scriptural passages may be found in Lütgens, *Transfiguration,* 32-34.

28. Summarized in von Einem, "Verklärung," 300-303, 312, 315. See also F. Hartt, "Power and the Individual in Mannerist Art," *The Renaissance and Mannerism: Acts of the Twentieth International Congress of the History of Art,* Princeton, 1963, 227.

29. See Lütgens, *Transfiguration,* 43; Bock von Wülfingen, *Verklärung,* 14, 18; von Einem, "Verklärung," 315-317, 321-323; Freedberg, *High Renaissance,* 358; Freedberg, *Painting in Italy,* 48. If, as von Einem proposes, Raphael's original subject was the Healing alone, the theme would have been visually and

iconographically more congruent with the Raising of Lazarus. However it seems unlikely that this important commission would have specified one of the least often represented miracles and one which is otherwise always associated with the Transfiguration.

30. Oberhuber, "Transfiguration," 116-143. The status of these drawings as *modelli* or reflections of *modelli* for the *Transfiguration,* rather than as subsequent school varients of Raphael's composition, is doubted by von Einem, "Verklärung," 317-319, but is accepted by Dussler, *Raffael,* 67, Forlani-Tempesti, in Becherucci *et al., Raffaello,* II, 429 and by Pope-Hennessy, *Raphael,* 72.

31. Leonardesque motifs begin to show up in studies for the *Transfiguration* that post-date the decision to couple the two narrative themes. It is also interesting that the surviving auxiliary cartoons of individual heads are often closer to their counterparts in Leonardo's *Adoration* than are their final versions in Raphael's painting. This is especially true of two studies in the British Museum (P. Pouncey, J. A. Gere, *Italian Drawings in the Department of Prints and Drawings in the British Museum: Raphael and His Circle,* London, 1962, 33, 34). The relevant drawings are illustrated in Oberhuber, "Transfiguration." See also Dussler, *Raffael,* 67; Forlani-Tempesti in Becherucci *et al., Raffaello,* II, 416-429. Raphael was working away from the prototype, first exploring it then integrating it fully into his own style and the requirements of his picture. A similar treatment of a Leonardesque theme can be observed in Raphael's preliminary studies for the *Madonna di Foligno* (Pouncey, Gere, *Raphael,* no. 25, pl. 30).

32. See above, note 12.

33. Raphael's *Resurrection* projects would have had the same effect although we cannot tell if they were dependent on the *Adoration* as well. The situation is still more complicated since we must assume that Leonardo brought to Rome not only his paintings, but drawings for projects as well. Cesare da Sesto's earlier presence in Rome may possibly also have had some influence.

34. For a sensitive description of the relation between the scriptural text and Raphael's painting, see Bock von Wülfingen, *Verklärung,* 9-14.

35. E. Müntz, *Raphael,* Paris, 1881, 561, also saw the scriptural passage as the source of Raphael's light effects. The incandescent cloud surrounding Christ is described in all three gospels and God the Father speaks from its midst. W. Schöne, *Raffael,* Berlin-Darmstadt, 1958, 20, believes the cloud of light represents the Holy Ghost, thus making the representation a Trinity, as Vasari says. (see Appendix, also, von Einem, "Verklärung," 301-303.)

36. Shearman, "Colour," 30, 41, gives a fine exposition of this aspect of Leonardo's achievement.

37. Goethe's famous description of the *Transfiguration* emphasizes this point (H. von Einem, ed., *Goethes Italienische Reise,* 5th ed., Hamburg, 1961, 346). Von Einem, "Verklärung," 325, senses this absence so powerfully that he hypothesizes a missing Christ figure at the center of Raphael's "original" composition.

38. For the place of the *Transfiguration* in the development of Raphael's style, see Freedberg, *High Renaissance,* 361.

39. Vasari-Milanesi, *Vite,* IV, 50, also Lomazzo, *Tempio,* 49.

40. Vasari-Milanesi, *Vite,* I, 185. Although the dark manner was developed as part of an oil technique, Leonardo seems to have been confronting the problem of integrating its effects into mural technique by his catastrophic use of a mixed medium in the *Battle of Anghiari* (P. Giovio, "Leonardi Vincii Vita," in G. Tiraboschi, *Storia,* 121; Vasari-Milanesi, *Vite,* IV, 43. Also below, n. 102). Raphael, on the other hand, had considerable success in translating dark tonal effects into fresco through the extensive use of *al secco* additions. Indeed, the Sala di Costantino was to be decorated with oil murals (J. Shearman, "Raphael's Unexecuted Projects for the Stanze," in G. Kaufmann, W. Sauerländer, eds., *Walter Friedlaender zum 90. Geburtstag,* Berlin, 1965, 177-180). Sebastiano urged the use of an oil technique for wall painting whenever possible, and this kind of technique ultimately became very popular in the later part of the century (Vasari-Milanesi, *Vite,* I, 188), and the boundaries between effects achieved in fresco and oil became blurred. In Raphael's time, however, the flat colors and

surfaces of fresco were still to some extent limiting factors in the representation of translucent darkness. This was even more true of the Tapestry Cartoons which were bound by medium and, perhaps, by the location for which they were intended, to a relatively clear, bright gamut of color.

41. The *Transfiguration* measures 405 x 278 cm., yet Leonardo's *Adoration* (243 cm.) is only 35 cm. narrower. It is possible that the large size of Leonardo's work was another factor in his use of a new dark manner.

42. P. Giovio, "Raphaelis Urbinatis Vita" (shortly before 1527) in G. Tiraboschi, *Storia,* IX (aggiunta), 122-124. In this extremely compressed account, Giovio gives particular emphasis to the *Transfiguration* and to Raphael's dark mode. "Sed ars ei plurimum favit in ea fabula, quam Clemens Pontifex in Janiculo ad aram Petri Montorii dedicavit, inea enim cum admiratione visitur puer a Cacademone vexatus, qui revolutis, et rigentibus oculis, commotae mentis habitum refert. Caeterum in toto picturae genere numquam ejus operi venustas defuit, quam gratiam interpretantur; quamquam in educendis membrorum toris aliquando nimius faverit, quum vim artis supra naturam ambitiosus ostendere conaretur. Optices quoque placitis in dimensionibus distantiisque non semper adamussim observans visus est; verum in ducendis lineis, quae commissuras colorum quasi margines terminarent, et in mitiganda, commiscendaquae vividiorum pigmentorum austeritate jucundissimus artifex ante alia id praestanter contendit, quod unum in Bonarota defuerat, scilicet ut picturis erudite delineatis etiam colorum oleo comistorum lucidus al inviolabilis ornatus accederet."

Vasari-Milanesi, *Vite,* IV, 371-372, 378, gives a sensitive description of the *Transfiguration,* calling it Raphael's greatest picture and emphasizing the luministic effects of the upper part of the painting. However, he notes and criticizes the special darkness of the picture which he attributes to the mistaken use of printer's lamp black mixed in the colors. "E se non avesse in questa opera, quasi per capriccio, adoperato il nero di fumo da stampatori; il quale, come più volte si è detto, di sua natura diventa sempre col tempo più scuro, ed offende gli altri colori, coi quali è mescolato; credo che quell' opera sarebbe ancor fresca come quando egli la fece, dove oggi pare piuttosto tinta che altrimenti" (IV, 378). Here Vasari attributes the darkness of the picture to condition; yet, in his *Vita* of Leonardo, the earlier master's dark manner is described in the same terms: ". . . cercava neri che ombrassino . . . ed infine riusciva questo modo tanto tinto, che non vi rimanendo chiaro, avevon più forma di cose fatte per contraffare una notte . . ." (IV, 26). Elsewhere, however, Vasari praises the chiaroscuro mode of the *Transfiguration* in tones reminiscent of Giovio. ". . . il fare che elle [the figures] si perdino alcuna volta nello scuro, ed alcuna volta venghino innanzi col chiaro . . ." (IV, 375). Moreover, Vasari seems to understand quite clearly the Leonardesque origin of Raphael's darkness. "Raffaello se gli è avvicinato [to Leonardo] bene più che nessuno altro pittore, e massimamente nella grazia de'colori" (IV, 374), and in the *Proemio* on technique: "Ed in questo modo si debbe nel lavorare metter gli scuri dove meno offendino e faccino divisione, per cavar fuori le figure; come si vede nelle pitture di Raffaello da Urbino e di altri pittori eccellenti che hanno tenuto questa maniera" (I, 181).

Modern commentators have been equally aware of the unusual dark tonality of the *Transfiguration* and have also been divided on its merits. While J. D. Passavant, *Raffael von Urbino und sein Vater Giovanni Santi,* Leipzig, 1939, II, 357, for instance, observes that the picture has the strongest chiaroscuro of Raphael's works, J. A. Crowe and G. B. Cavalcaselle, *Raffaello* (1882), Florence, 1891, III, 247, quote Vasari on the darkness of the picture, suggesting that the excessive blacks were added only after Raphael's death as a quicker way of finishing the picture. In the more recent literature, the painting's darkness is usually taken for granted.

43. Whatever the justice of Vasari's report that the *Transfiguration* had been ruined by darkening, the later vicissitudes of the picture have certainly darkened it far beyond Raphael's intention. For the history of the condition of the picture, G. Male, "La 'Transfiguration' de Raphael: quelques documents sur son séjour à Paris (1789-1815)," *Atti della Pontificia Accademia Romana di Archeologia: Rendiconti,* xxxiii, 1960-1961, 225-236; Pope-Hennessy, *Raphael,* 16-17, 261, n. 33. (Copies of the work are listed by Dussler, *Raffael,* 69.) Test patches also indicate an earlier, superficial cleaning. A thorough restoration

of the picture is, however, now under way. I wish to thank Dr. D. Redig de Campos and his staff for having allowed me to inspect the picture in the Vatican laboratories, for discussing the painting and its condition with me, and for his suggestion that the later mosaic copy in St. Peter's would provide a good idea of the original tonality. The darkness of the foreground seems original. It also already appears in early prints after the *Transfiguration*.

44. Shearman, "Colour," 30.

45. "The first task of painting is that the objects it represents should appear in relief...." (A. P. McMahon, tr. and ed., *Treatise on Painting by Leonardo da Vinci,* Princeton, 1956, I, 62, no. 103, also 63, no. 107.)

46. Pope-Hennessy, *Raphael,* 71-72.

47. Roskill, *Dolce's "Aretino,"* 95; Vasari-Milanesi, *Vite,* V, 567-568; E. Battisti, "La critica di Michelangelo prima del Vasari," *Rinascimento,* V, 1954, 115-123.

48. See Michelangelo's letter to Varchi published by P. Barocchi, ed., *Trattati d'arte del Cinquecento,* Florence, 1960, I, 82.

49. See, for example, McMahon, *Treatise,* I, 4, no. 10; 32, no. 47; 41, no. 55. On the "universality" of the painter, 60, no. 95.

50. Lomazzo, *Tempio,* 51.

51. Gombrich, "Water and Air," 201-203.

52. V. Cian, "Nel mondo del Castiglione," *Archivio storico lombardo,* N.S., VII, 1942, 70-79; V. Cian, *Un illustre nunzio pontificio del Rinascimento: Baldassar Castiglione,* Vatican City, 1951, 13. F. Ertl, *Baldassare Castigliones Beziehungen und Verhältnis zu den Bildenden Künsten* (Diss.), Munich, 1933, 56, notes that the two men had most probably met in Milan as well as in Rome. Ertl analyzes the probable influence of Leonardo's ideas on Castiglione, distinguishing those common sources which might also account for some of the similarities between the two thinkers. The definition of painting, the high place accorded the painter in society, and the primacy of *rilievo* in painting are among the most important of these ideas held in common; however, C. Pedretti, *Leonardo da Vinci on Painting: A Lost Book (Libro A),* Berkeley, Los Angeles, 1964, 55, n. 58, notes the special correspondence of Leonardo's later ideas in the *Paragone* with those of the *Cortegiano.* (See also, Cian, ed., *Il Cortegiano,* 92, 124-125.) I should like to suggest that Matteo Bandello, the famous author of *novelle,* could have served as a link between Castiglione and Leonardo. Bandello knew Castiglione and his family extremely well (Cian, *illustre nunzio,* 162-163; F. Flora, ed., *Tutte le opere di Matteo Bandello,* 3rd ed., Verona, 1952, I, xv-xvi); he gave the well-known eye-witness reports of Leonardo's behavior and conversations in Milan in 1497 (Flora, ed., *Bandello,* I, 646-647) and adopted Leonardo as the artist *par excellence* in his stories. For instance, a description of the most luxurious imaginable chamber includes paintings on the walls by Leonardo (Flora, ed., *Bandello,* I, 53). Also see below, n. 119.

53. Cian, *illustre nunzio,* 65-67, 135. The composition of the work began in the mid-teens; the manuscript was complete by 1518 and ready for press in 1524, although it was published only in 1528.

54. "... che la eccelenza, che voi conoscete in lui nella pittura, sia tanto suprema che la marmoria non possa giungere a quel grado." (Cian, ed., *Il Cortegiano,* I, l, 125.)

55. Cian, ed., *Il Cortegiano,* I, li, 126-127. This list is ultimately derived from Philostratus who also mentions the "look of a man who is mad" as a subject particularly appropriate to painting. This might have been a factor in Raphael's decision to include the scene of the possessed boy in the *Transfiguration*. Mention of the representation of water, "springs," in Philostratus, is also interesting in this context. (A. Fairbanks, tr., *Philostratus, Imagines,* London, 1931, 3-5, 11-13.) Both Philostratus and Castiglione list effects such as the "flashing of armour" which are striking in the *Stanza dell'Incendio.*

56. Vasari-Milanesi, *Vite,* IV, 376; see S. Alpers, "Ekphrasis and Aesthetic Attitudes in Vasari's Lives," *Journal of the Warburg and Courtauld Institutes,* XXIII, 1960, 209 ff., for the theoretical background of this distinction; also, see n. 51, above, for Gombrich's suggestion that such considerations underlie Leonardo's drawings of the Deluge. Interestingly, Vasari cites the *Transfiguration* as the supreme

example of the *"modo mezzano"* that Raphael assumed in order not to compete with Michelangelo (Vasari-Milanesi, *Vite,* IV, 376-377).

57. McMahon, *Treatise,* 34, no. 48; Cian ed., *Il Cortegiano,* I, l, li, 124-127.

58. Cian, ed., *Il Cortegiano,* II, xxvii, 177.

59. For the condition of the *Transfiguration,* see above, n. 43. For the condition of the *Lazarus* and the history of its cleaning in 1967, see C. Gould, *National Gallery Catalogues: The Sixteenth Century Venetian School,* London, 1959, 76-80; *The National Gallery Report,* January, 1967-December, 1968, 41-42, 45-47, notes "the picture is, pretty certainly, even now darker than the painter intended." The tonality of the picture has, however, been heightened in the course of restoration. See "Die Auferweckung des Lazarus von Sebastiano del Piombo," *Maltechnik,* LXXIV, 1968, no. 3, 65-70.

60. That Raphael's superior colorism was thought to be at issue generally in this contest with Michelangelo by means of Sebastiano, is shown in Vasari's life of the Venetian (Vasari-Milanesi, *Vite,* V, 568). See above, n. 47, also J. Shearman, *Mannerism,* Harmondsworth, 1967, 46-47, who rightly sees Raphael's painting as a competitive statement of "what was possible in art."

61. The condition of these two "dark" pictures is discussed by Pope-Hennessy *(Raphael,* 261, n. 34). For the problem of Giulio's participation in the two pictures, compare Dussler, *Raffael,* 60, and Freedberg, *Painting in Italy,* 47, 471, n. 50. It is conceivable that the special darkness of the painting was meant to appeal to the tastes of the French king as they had been schooled by his court painter, Leonardo. For the history of the paintings, see J. Cox Rearick, *La Collection de François I^er^,* Paris, 1972, 30-31.

62. ". . . che credo non vi possete imaginar cossa più contrario a la openione vostra de quello havaresti visto in simel opera. Io non vi dirò altro, che pareno figure che siane state al fumo overo figure di ferro che luceno, tutte chiare et tutte nere . . ." (V. Golzio, *Raffaello nei documenti, nelle testimonianze dei contemporanei, e nella letteratura del suo secolo,* Rome, 1936, 70-71). Sebastiano's meaning is clarified by Vasari-Milanese, *Vite,* I, 180-181, in his "Della Pittura": "Così nella pittura si debbono adoperare i colori con tanta unione, che è non si lasci uno scuro et un chiaro sì spiacevolmente ombrato, e lumeggiato, che e' si faccia una discordanza. . . . Conciossiachè il troppo acceso offende il disegno, e lo abbacinato, smorto abbagliato e troppo dolce, pare una cosa spenta, vecchia ed affumicata: ma lo unito che tenga in fra lo acceso e lo abbagliato, è perfettissimo. . . . Debbonsi perdere negli scuri certe parti delle figure, e nella lontananza della istoria." For Sebastiano's colors in the *Raising of Lazarus,* see C. Gould, *The Raising of Lazarus by Sebastiano del Piombo,* London, 1967, 11, and above, n. 59.

63. Leonardo's own use of terms involving "smoke" are listed by E. H. Gombrich, "Blurred Images and the Unvarnished Truth," *The British Journal of Aesthetics,* II, 1962, 171 ff.

64. See, for example, Vasari-Milanesi, *Vite,* I, 180, IV, 373-374, 376-377. Vasari also realizes that Leonardo and Raphael resemble each other in their use of color.

65. For significant similarities of technique between Leonardo and Sebastiano, including the use of dark varnish, C. Brandi, "The Restoration of the Pietà of Sebastiano del Piombo," *Museum,* III, 1950, IV, 1951, 207, 211. The relation of these pictures by Sebastiano to Roman art was discussed by Freedberg, *Painting in Italy,* 69, also by M. Hirst, in "Michelangelo and Sebastiano del Piombo," a lecture at the Institute of Fine Arts, N.Y., March, 1972. The Leningrad *Entombment,* although perhaps not a night piece, seems also to be a dark picture. For the distinction between this dark manner, which I believe to be founded on Leonardo and Raphael, and its Venetian counterpart, see Freedberg, *High Renaissance,* 373, 379, 386.

66. Freedberg, *High Renaissance,* 372, pl. 475, also sees this contact in the reflection of the *Mona Lisa* in Sebastiano's Budapest *Portrait of a Youth* of about 1515-1516.

67. Marcantonio's engraving after a very Viterbo-like *Pietà* (B. 34) is datable around 1511-1512 and so precedes Michelangelo's idea and probably influenced him and Sebastiano (K. Oberhuber, "Raphael und Michelangelo," *Stil und Überlieferung in der Kunst des Abendlandes: Acts of the Twenty-First International Congress of the History of Art, 1964,* Berlin, 1967, II, 164).

68. See, for example, von Einem, "Verklärung," 316, n. 1, 320; Freedberg, *Painting in Italy,* 70, 384-385. The first mention of the *Transfiguration* occurs in a letter by Leonardo Sellaio to Michelangelo of 19 January, 1517, but the commission can reasonably be supposed to go back to late 1516. For the full range of documents relating to the double commission to Raphael and Sebastiano see L. Dussler, *Sebastiano del Piombo,* Basel, 1942, 201-203; Dussler, *Raffael,* 67. As C. Gould, *The Raising of Lazarus by Sebastiano del Piombo,* London, 1967, 12, points out, the wording of the letter indicates that Raphael's commission may have preceded that of Sebastiano (. . . "vi scrissi come Bastiano aveva tolto a fare quella tavola . . . ora mi pare che Raffaello sottosopra il mondo perchè lui nonlla faca [sic] per non venire a paraghoni" Dussler, *Sebastiano,* doc. no. 10). This would make sense only if Raphael already had the commission. On July 2, 1518, Sebastiano wrote to Michelangelo in Florence saying that Raphael had not yet begun to paint (Dussler, *Sebastiano,* doc. no. 13). This does not necessarily mean, however, that the design was not yet complete. Von Einem, "Verklärung," 320-322, proposes that the *Transfiguration* begun in 1518 was a *second* version which had been preceded by a design for a *Christ Healing the Possessed Boy.* The fact is, we do not know whether Raphael arrived at his design before or after Sebastiano began work (by September, 1517: Dussler, *Sebastiano,* doc. no. 12). It seems more likely that Raphael would have given thought to the problem soon after taking on a commission of this importance, rather than leaving it in abeyance for a year and a half.

 The *Transfiguration* became an important source for other pictures of the period. However, none of these works give us a *terminus ante quem* for the completion of Raphael's *Transfiguration* design in quotable form. A *Resurrection* by Genga of about 1519 in Rome, reflects Raphael's *Resurrection* projects of around 1514 (Hirst, "S. M. della Pace," 172, Pl. 29e; Freedberg, *Painting in Italy,* 490, n. 99) but may also already echo the design of the *Transfiguration.* Correggio's S. Giovanni Evangelista Ceiling and especially the figure of Christ (1521) also seems to incorporate the experience of Raphael's altarpiece. For the problem of Correggio's trip to Rome and its possible date as early as 1518, Freedberg, *Painting in Italy,* 180-182, 188, 492, n. 22. The relation between the two works is made clear in a print after Raffaellino da Reggio (B. XV. 244 .ii) which shows the Christ of the *Transfiguration* set in a *tondo* with clouds alla Correggio. A print of about 1520 shows the final design of Raphael's picture with all the figures in the nude and may thus transmit a finished preliminary drawing (Shearman, *Mannerism,* 48). See above n. 12 for the problematic relation of the *Transfiguration* to *Assumption* and *Coronation* projects by Raphael. For other works influenced by the *Transfiguration,* see von Einem, "Verklärung," 316, n. 1.

69. Freedberg, *High Renaissance,* 385, saw a similar "programmatic" intention in both works to achieve diversity of characterization.

70. In Sebastiano's picture one may also note the St. Joseph-like head, the figure with the bent elbow at the base of the tree on the right, as well as the first kneeling figure on the left and the pair of men on the left, all of whom derive from the *Adoration.* Also, see below, n. 72.

71. Shearman, "S. M. del Popolo," 156.

72. Freedberg, *High Renaissance,* 383-384; Oberhuber, "Raphael und Michelangelo," 162; Freedberg, *Painting in Italy,* 70. It should be noted, however, that the *Lazarus* contains references to the *Adoration* which are not transmitted by means of the *Spasimo* or by the *Assumption* design recorded by the Master of the Die.

73. Sebastiano's desire to best Raphael at his own game may be seen in the Venetian's own *Transfiguration* for the Borgherini Chapel, which reuses not only the upper part of Raphael's composition, but the figure of Raphael's *St. Andrew,* as well as the motif of the dawning light. On the significance of the date given Sebastiano's picture for the date of completion of Raphael's design, see R. Pallucchini, *Sebastiano Viniziano,* Milan, 1944, 52, 54; von Einem, "Verklärung," 318, n. 2., Freedberg, *Painting in Italy,* 70-71. Michelangelo's seeming response to Raphael's composition is discussed by J. Q. van Regteren Altena, "Zu Michelangelos Zeichnungen," *Stil und Überlieferung,* II, 177.

74. J. Wilde, *Italian Drawings in the Department of Prints and Drawings in the British Museum: Michelangelo and his Studio,* London, 1953, 30-31, was the original advocate of Michelangelo's role in Sebastiano's picture. Oberhuber, "Raphael und Michelangelo," 163, gives the most extreme statement of this position and the bibliography of this controversy. For the latter, see also Freedberg, *Painting in Italy,* 473-474, n. 74. The most restrictive view was taken by C. de Tolnay, *Michelangelo,* Princeton, 1948, III, 90, who, however, also notes the relationship of the style of the *Lazarus* to Michelangelo's later painting. The problems attendant on the attribution of the relevant drawings were summarized by Pouncey, Gere, *Raphael,* 163-164. Thereafter, S. J. Freedberg, " 'Drawings *for* Sebastiano' or 'Drawings *by* Sebastiano': the Problem Reconsidered," *Art Bulletin,* XLV, 1963, 253ff; A. Perrig, "Gedanken zu dem kritischen Katalog der Michelangelo Zeichnungen," *Zeitschrift für Kunstgeschichte,* XXVIII, 1965, 359 and von Einem, "Verklärung," 321, n. 2, tended to reaffirm Sebastiano's authorship of the disputed drawings. However, see Freedberg, *Painting in Italy,* 474, n. 74.

75. The Venetian evaluation of Leonardo as "Michelangelo's equal in everything," is put forward by Dolce in Roskill, *Dolce's "Aretino,"* 181. Leonardo was by no means thought passé; he was problematical only because of his difficulties in producing works of art.

76. Lomazzo, *Trattato,* 405-406, makes precisely this distinction between Michelangelo's use of light and that of Leonardo and Raphael. Sebastiano's report that he found his own treatment of figures and drapery in the *Lazarus* superior to Raphael's Tapestry Cartoons, Dussler, *Sebastiano,* 205, doc. 43, also suggests that these were the qualities he and Michelangelo cared about most.

77. Michelangelo's ambivalence toward the use of dark tonality may be associated with his general avoidance of oil painting, indeed of panel painting (with the exception of the *Doni Tondo* and the *Leda).* The quarrel with Sebastiano over the medium of the *Last Judgment* (Vasari-Milanesi, *Vite,* V, 584) may also have been an indication that Michelangelo distrusted or was unfamiliar with mural painting media other than fresco. Leonardo's example would also have been a discouragement.

78. Shearman, "Colour," 40, 46, n. 79, sees a rapprochement of Michelangelo's later color with that of Leonardo, especially in Michelangelo's *Leda* and, certainly, Pontormo's versions of Michelangelo's other pictures use a dark manner. Drawings of the *Resurrection* by Michelangelo also indicate a darkened background. Oberhuber, "Raphael und Michelangelo," 164, follows Tolnay in relating the tonality of the *Last Judgment* to Raphael's late *oscurità.*

79. Vasari-Milanesi, *Vite,* IV, 47. Compare Pedretti, *Chronology,* 129, 130 and Ackerman, *Michelangelo,* cat. 3-4, for the meaning of this problematic passage.

80. Although it is usually thought that Leo X was not a particularly beneficent patron to Leonardo, Vasari went to considerable lengths to show otherwise. In his fresco of *Leo's Consistory of 1517* in the Quartiere di Leone X in the Palazzo Vecchio, Vasari shows Leonardo together with Michelangelo against a passage of Roman cityscape. In the *Raggionamenti sopra le inventioni da lui dipinte in Firenze, etc.,* Florence, 1588, Giornata III, 127, Vasari says, "In questa storia . . . ci sono tutti i ritratti loro di naturale per mostrar fra questa storia la magnificenza di Leone." (C. Pedretti, *Documenti e memorie riguardanti Leonardo da Vinci a Bologna e in Emilia,* Bologna, 1953, 111-113; Pedretti, *Chronology,* 111-112.) Pedretti notes that neither Leonardo nor Giuliano de' Medici (who is also depicted) would have been in Rome on June 1, 1517 when the Consistory took place. For that matter, Michelangelo would also have been absent. It is equally curious that Raphael, who was in Rome, is not shown but he is also excluded from other purely Florentine listings of great artists. See E. Maurer, "Pontormo und Michelangelo," *Stil und Überlieferung,* II, 141.

81. "Oimè! costui non è per far nulla, da che comincia a pensare alla fine innanzi il principio dell'opera." (Vasari-Milanesi, *Vite,* IV, 47.)

82. Vasari-Milanesi, *Vite,* IV, 26, 378, V, 533. C. Eastlake, *Methods and Materials of Painting of the Great Schools and Masters* (1869), New York, 1960, II, 74. However, Leonardo and artists influenced by him both in Florence and Siena also seem to have used lamp black.

83. The technical and visual problems of varnish used on oil paintings as seen in the 16th century are summarized by Mancini, *Considerazioni,* I, 23. "... oltrechè, se non vi si ha gran cura, queste in poco tempo diventan sordide, non godibili, nè quelle che erano quando furono fatte e, quello che importa più; non possono dall'occhio in qualsivoglia position essere godute, ricercando lume e reflessione determinata per la vernice che se la dà sopra."

84. K. Jex-Blake, E. Sellers, *The Elder Pliny's Chapters on the History of Art,* London, 1896, 132-133, 159 and nn. 5-9, (Pliny, XXXV, 7). C. Grayson, tr. and ed., *Leon Battista Alberti On Painting and On Sculpture,* London, 1972, 86-89. See also Shearman, "Colour," 41, 47, on the possible influence of Pliny's *atramentum* as a directive to Renaissance painters to tone down "over-vivid colour."

85. Leonardo was given this title even before the beginning of the century by Luca Pacioli and later by Sabba da Castiglione (Shearman, "Colour," 41, 47, 90, n. 5). The same epithet is found in Vasari-Milanesi, *Vite,* IV, 11, and in the epigrams quoted by him. By 1500, Leonardo was also compared favorably with Phidias and Praxiteles in the dedication to Leonardo by the anonymous Milanese author of the *Antiquarie prospettiche romane.* Of course other artists, beginning in the Trecento, were also compared to Apelles. For the history of this idea, M. Baxandall, *Giotto and the Orators,* Oxford, 1971.

86. For the problem of the constitution and use of the *atramentum,* see the series of articles by Gombrich, Kurz, Ruhemann, *et al.,* in the *Burlington Magazine,* XCI, CIII, CIV, CV, 1949, 1962-1963, and in the *British Journal of Aesthetics,* I, 1961, no. 4, 231-237, II, 1962, no. 2, 171-178. The questions arising from the interpretation of Pliny's text are summarized by E. H. Gombrich, "Controversial Methods and Methods of Controversy," *Burlington Magazine,* CV, March, 1963, 90-94. Pliny's passage certainly indicates that the *atramentum* was to lend *austeritas* to the colors; that is, to tone them down whether by darkening them or by making the surface slightly matte (Gombrich, "Controversial Methods," 91, n. 10). See also Shearman, "Colour," 41, 47, n. 91, for the coloristic function of Leonardo's dark tonality and for a suggestion of its possible roots in Pliny. (I have not seen Shearman's unpublished thesis on early sixteenth-century color and I have been unable to consult M. Rzepinska, *Historia Koloru w dziejach malarstura europejskiego,* Cracow, 1970).

87. Although Leonardo's manuscript notation does not say so, G. D'Adda, *Leonardo da Vinci e la sua libreria,* Milan, 1873, believed that Leonardo owned the first edition of Cristoforo Landino's *Historia naturale di C. Plinio Secondo tradocta di Lingua Latina in Fiorentina,* Venice, 1476. (See also G. Richter, *The Literary Works of Leonardo da Vinci,* London, 1939,II, 366.) E. Solmi, "Le fonti dei manoscritti di Leonardo da Vinci," *Giornale storico della letteratura italiana,* suppl. 10-11, 1908, 235, makes no suggestion about the edition of Landino's Pliny that Leonardo might have owned. However, G. Favaro, "Plinio ed Leonardo," in Cermenati, ed., *Per il IV centenario,* 135, states that the artist owned Landino's edition of 1501. (I have been able to consult only the editions of 1476, 1481 and 1516 which are identical in the portions of the text discussed here.) Leonardo made notes on other parts of Pliny's Chapter XXXV on the history of art, as well. He would, of course, have been able to read the Latin text as well as Landino's translation.

88. "Ma una cosa nessuno pote imitare. Imperoche i[n] piastraua lopere sue gia finite con si sottile atramento che quello per reflexione de lumi exitava lo splendore a glocchi & conseruaua la pictura dalla poluere & da ogni bruttura. Ma con grande ingegno accioche losplendore de colori non offendesi gli occhi perche chosi era come guatarla [guardarla] dalla lungi per pietra trasparente. Onde la medesima cosa daua occultamente una certa austerita a colori floridi." (C. Landino, tr., *Historia Naturalis,* Venice, 1476, unpaged.) This interpretation differs in small but not insignificant ways from other translations and interpretations. See E. Gombrich, "Dark Varnishes: Variations on a Theme from Pliny," *Burlington Magazine,* CIV, February, 1962, 51; Gombrich, "Controversial Methods," 90, 91. Landino's translation simply Italianizes the more puzzling terms such *atramentum* and *colores floridi.* However, he must have thought that their meaning was clarified by Pliny's chapter on "Colori naturali et artificiosi"

(*Historia naturale,* XXV, 6), which begins "colori sono austeri o floridi. Luno e laltro interviene o da natura o da mistura." Pliny then goes on to name the austere and florid colors and to explain the making and use of *atramentum.* There are various methods for making good blacks *(atramentum)* but Apelles used burned ivory. (K. C. Bailey, tr. and ed., *The Elder Pliny's Chapters on Chemical Subjects,* London, 1932, 85-87, and Gombrich, "Controversial Methods," 90-91, for the interpretation of these texts.) W. Lepik-Kopaczynska, *Die Antike Malerei,* Berlin, 1963, 70, explains that antique painters used a final coating containing burned ivory *(elephantinum)* to tone down the *colores floridi* which she interprets as colored glazes on top of opaque colors *(colores austeri).* The *elephantinum* was suspended in a transparent medium; she suggests egg white or wax. It is interesting to note that Pliny says *atramentum* was also used to darken a light ground *before* painting. Nor does Pliny distinguish between blacks used for painting and those in the famous coating used by Apelles. See also W. Lepik-Kopaczynska, "Colores floridi und austeri in der antiken Kunst," *Jahrbuch des Deutschen Archaeologischen Institutes,* LXXIII, 1958, 79-99 (especially 88-89), and *Apelles der berühmteste Maler der Antike,* Berlin, 1962, 2-19, for a more extended discussion.

89. See, for example, Gombrich, "Controversial Methods," 52, and other articles in the *Burlington Magazine,* cited above, n. 86.

90. G. B. Adriani, "A Giorgio Vasari," Vasari-Milanesi, *Vite,* I, 38: "Trovò nell'arte molte cose e molto utili, le quali giovarono molto a quelli che dipoi le appararono. Questo non si trovò giammai dopo lui chi lo sapesse adoperare; e questo fu un color bruno, o vernice che si debba chiamare, il quale egli sottilmente distendeva sopra l'opere già finite; il quale con la sua riverberazione destava la chiarezza in alcuni dei colori e li difendeva dalla polvere, e non appariva se non da chi ben presso il mirava; e ciò faceva con isquisita ragione, acciocchè la chiarezza d'alcuni accesi colori meno offendesse la vista di chi da lontano, come per vetro, li riguardasse, temperando ciò col più e col meno, secondo giudicava convenirsi." Adriani takes his account from Landino's Pliny too (P. Barocchi, ed., G. Vasari, *La Vita di Michelangelo nelle redazioni del 1550 e del 1568,* Milan, 1964, Commento, 234), thus his text is a valuable indication of how the *atramentum* was understood in the sixteenth century. Although he does not speak of a varnish, Dolce (1557), in Roskill, *Dolce's "Aretino,"* 153, 299, states that "il bruno si legge essere stato frequentato da Apelle" as part of a discussion of chiaroscuro and dark tonality. G. B. Armenini, *De' veri precetti della pittura,* Ravenna, 1578, 74, 122, 128-129, 132-133, says, "dicono alcuni che Apelle usasse nel fine delle opere sue un liquor come vernice, col quale egli rauiuaua tutti i colori ricoprendoli col più, e col meno secondo che di quelli egli vedeua di bisogno." Then comes a discussion of varnishes over oil colors ending with the lament that "molti pocchi se ne curino a i tempi nostri." The recipes that follow seem to be for varnishes that range from a yellowish tone to those that are clear and brilliant. However, when discussing Leonardo, whom Armenini closely identifies with Zeuxis and Apelles, he mentions the use in *al secco* technique of "aquarelle di nero e lacca fina [lake] insieme," tints used to veil the finished work and to strengthen the colors. He also reiterates that varnishes and the use of varnish in the medium, unifies the tones and the picture surface. Lomazzo, *Tempio* (1590), 49, during a discussion which includes both antique painters and Leonardo, mentions ancient varnishes along with those used by Bramante and Mantegna. Two of their works (owned by L.) were covered with "una certa acqua viscosa," which Lomazzo removed to make the pictures look like new again; presumably brighter. Without entering here into the problem of actual practice in the Cinquecento, one may note that C. Brandi, "Restoration of the *Pietà,*" 208-209, states that Sebastiano used a dark varnish at a time when his technique was also otherwise related to Leonardo. (See above, n. 65.) R. Borghini, *Il Riposo,* Florence, 1584, 278, also describes the *atramentum:* "Solo in una cosa non si trovò mai chi lo sapessi imitare, cioè in una vernice, che egli sopra l'opere già finite distendea, la quale con la sua trasparentia, e virtù destava i morti colori, e tutti insieme, acciò che l'uno più dell'altro la vista non offendesse, gli univa, e dalla polvere difendea." While Borghini does not speak of darkness, he now stresses the union of tones that the varnish imparts. For the subsequent history of the

atramentum, see J. Plesters, "Dark Varnishes—Some Further Comments," *Burlington Magazine,* CIV, November, 1962, 454-455.

91. Eastlake, *Methods and Materials,* II, 33ff, 97-98, 100-104, 108-110, 114-117, 121, for variety in the tints of Leonardo's varnishes. Eastlake notes that Leonardo usually made his browns purplish to counteract the yellow tone of the varnish and he affirms that while Leonardo tried to develop clear, unchanging varnishes, he also used "mellower tints and glazings with substantial varnishes . . . reserved for the final operation." M. Hours, "Notes sur l'étude de la peinture de Léonard de Vinci au Laboratoire du Musée du Louvre," *L'Art et la Pensée de Léonard de Vinci: Études d'Art,* nos. 8, 10, Paris-Alger, 1953-1954, 209, and in "Étude analytique des tableaux de Léonard de Vinci au laboratoire du Musée du Louvre," in Marazza ed., *Leonardo: Saggi e ricerche,* 15-26, as well as M. Rudel, "La technique picturale de Léonard de Vinci," *L'Art et la Pensée de Léonard de Vinci,* 297-299, established that Leonardo did use a final oil varnish to increase the translucent quality of the pigments. Leonardo, in his treatise (McMahon, *Treatise,* 176; Pedretti, *Libro A,* cat. 30), discusses the effect of colors seen through glass tinted yellow or other colors. Some colors will be improved, others impaired (with a yellow glass, blue, black and white are impaired). Leonardo mentions "clear varnishes" (McMahon, *Treatise,* 200), while he praises an amber-colored varnish made from cypress oil (McMahon, *Treatise,* 364, 635, 636). Also see Sampaolesi (cited above, n. 20), for Leonardo's use of varnish. For the earlier use of dark varnish, still derived from the tradition of the antique *atramentum,* see Eastlake, *Methods and Materials,* I, 252, and C. Brandi, "The Cleaning of Pictures in relation to Patina, Varnish and Glazes," *Burlington Magazine,* XCI, July, 1949, 183-188.

92. The general truth of Vasari's report of Leonardo's interest in technical problems of painting while he was in Rome is revealed by Leonardo's notes on "Giovanni Francese" in the Codex Atlanticus (Solmi, "Fonti," 179). Eastlake, *Methods and Materials,* II, 101-102, believed that Vasari's mention of herbs distilled by Leonardo refers to lavender used in making spike oil. He doubts that Leonardo was using it in a coating varnish. Borghini, *Il Riposo,* 221, however, speaks of *"olio di spigo"* used in a varnish made to dry in the shade (thus preserving the colors and support of the picture).

93. McMahon, *Treatise,* 200, no. 557, Cod. Urbinas, f. 161-161v.

94. Vasari-Milanesi, *Vite,* I, 204-205; Mancini, *Considerazioni,* I, 145 (ca. 1614-1621). The simile of translucent stone or glass seems to imply that all-over varnishes were known before the seventeenth century, *pace,* O. Kurz, "Time the Painter," *Burlington Magazine,* CV, March, 1963, 96. It may be added that the *Raising of Lazarus* was fully varnished when completed (Dussler, *Sebastiano,* 203, doc. 24).

95. See, for example, J. Plesters, "Dark Varnishes," 453; S. Rees Jones, "The Cleaning Controversy: Further Comments," *Burlington Magazine,* CV, March, 1963, 97-98.

96. Vasari's comments both on pictures and in his "della pittura" show his awareness that the transition to oil painting, an enterprise in which Leonardo pioneered, was far from complete. Varnishes, colored or clear, had traditionally been used on tempera pictures. It was, on one occasion, Vasari's hope that, in murals at least, an oil medium mixed with varnish might obviate final varnishing altogether (Vasari-Milanesi, *Vite,* I, 187). At the same time, as Kurz ("Time the Painter," 96, n. 17) points out, Vasari praised Giovanni Caroto who restricted his varnishes to the dark pigments and thus avoided dimming the picture as a whole [!] (Vasari-Milanesi, *Vite,* V, 287). Mancini had also been concerned with this problem (see above, n. 83) and, in his *Considerazioni,* I, 315, he picks out Raphael's *Transfiguration* and Giulio's *Anima Madonna*—the very pictures Vasari saw as technically problematic—as the earliest monuments of oil technique. Interestingly, he attributes the importation of oil painting to Dürer, an idea that is significant in view of Leonardo's use of northern techniques (see below, n. 112).

97. Eastlake, *Methods and Materials,* I, 103-104, in fact, identifies the thin brown glazes with which he believed Leonardo had finished his works, with *sfumato* itself and he cites Lomazzo's beautiful

description of "veli sopra veli" as the essence of Leonardo's technique (see above, n. 8). Lomazzo also emphasizes Leonardo's fear of making pictures too bright.

98. See above, n. 90 for Borghini's attribution of this quality to the *atramentum.*

99. McMahon, *Treatise,* 52.

100. K. Clark, *Leonardo da Vinci, An Account of his Development as an Artist,* London, 1952, 83; Pedretti, *Libro A,* 55, 122-124.

101. Jex-Blake, Sellers, *Pliny,* (XXXV, 149), 151, 172-173.

102. ". . . et di plinio cavò quello stuccho [sic] con il quale coloriva ma non l'intese bene." Frey, *Il Codice Magliabechiano,* 114, 115, 371, suggests that Rustici was the writer's informant. The passage is also cited in Favaro, "Plinio," 134, who rightly notes that this is a distorted reference to one of Pliny's descriptions of an especially durable encaustic. Although Pliny was uncertain of the identity of the inventor of encaustic painting, he praises Pausias and others for having been particularly expert in its use. Interestingly enough, other sixteenth-century descriptions of Leonardo's technical experiments in the *Battle of Anghiari* suggest that the traitorous material that ruined the mural was walnut oil (Giovio, "Leonardi Vincii Vita," 120), while in C. Frey, *Il Libro di Antonio Billi,* Berlin, 1892, 52, the base is identified as linseed oil. The Anonimo Magliabechiano himself gives another version of the story in which the mural was painted "con vernice" (Frey, *Il Codice Magliabechiano,* 111-112). It may be significant that this confusion was possible. Vasari-Milanesi, *Vite,* IV, 43, blames the *mistura* used on the walls rather than the painting medium. He assumes that Leonardo wanted to paint in oils on the wall. On the problem of Pliny's recipes for encaustic, see Jex-Blake, Sellers, *Pliny,* (XXXV, 149), 172-173. See also, C. Pedretti, *Leonardo da Vinci inedito,* Florence, 1968, 68-75.

103. See Lomazzo, *Tempio,* 49: "Leonardo ha colorito quasi tutte l'opere sue ad oglio, laqual maniera de colorire fu ritrovata prima di Giovanni da Bruggia, essendo certa cosa che gli antichi non la conobbero. E però si legge che il gran Protogene da Cauno coperse quattro volte una sua pittura acciochè, cadendo una, restasse l'altra. Il simile fece Apelle nella sua tanta laudata Venere che durò fin al tempo di Augusto." See below, n. 112.

104. Vasari-Milanesi, *Vite,* I, 189, 190, V, 580. The idea was already expressed in 1530 by V. Soranza writing to Pietro Aretino from Rome (M. Chiarini, "Pittura su pietra," *Antichità Viva,* IX, 1970, no. 2, 29-37). Chiarini stresses that both Sebastiano and Vasari, who also used the technique, used the dark surface of the slate to intensify effects of light.

105. Vasari-Milanesi, *Vite,* IV, 165; VI, 552.

106. Vasari was, of course, familiar with Pliny's statement even before Adriani's adaptation of it from the original text or from Landino's translation.

107. Shearman, "Colour," 38, 40, for early adumbrations.

108. Shearman, "Colour," 41, in a stimulating sentence also raises the possibility that Leonardo's color style was inspired by the literature of antiquity. See below, n. 120.

109. Jex-Blake, Sellers, *Pliny,* 159; Grayson, *Alberti,* 88-91. See also Shearman, "Colour," 41, 47.

110. Fairbanks, *Philostratus,* 5; Jex-Blake, Sellers, *Pliny,* (XXXV, 127) 152-153: "Again, while all others put in the highlights in white and paint the less salient parts in dark colour, he [Pausias] painted the whole ox black and gave substance to the shadow out of the shadow itself, showing great art in giving all his figures full relief upon the flat surface." Adriani's version of Pliny's text is particularly evocative. To obtain *rilievo,* "egli lo dipinse tutto di color bruno, e del medesimo fece apparir l'ombre del corpo" (Vasari-Milanesi, *Vite,* I, 44). It may be noted that the same Pausias who invented the dark manner also invented foreshortening. The association of darkness with relief was present from the beginning.

111. Dolce, in Roskill, *Dolce's "Aretino,"* 153, 299; Adriani in Vasari-Milanesi, *Vite,* I, 38. Lomazzo, *Tempio,* 42, 149-150, who repeatedly praises Leonardo's darkness, relates it directly to Pliny (above, n. 110). Leonardo's greatest achievement used by his followers was "dar i lumi suoi lochi con quella maestria che usò già l'antico pittore da Cauno." M. Barasch, "Licht und Farbe in der Italienischen Kunsttheorie

des Cinquecento," *Rinascimento,* XI, 1960, no. 2, 233, notes Alberti's derivation of the concept of *rilievo* to be achieved by means of light and shade from Pliny's description of Nikias and Zeuxis.

112. Shearman, "Colour," 47, n. 91, supports the suggestion that ancient ideas could influence Renaissance style with the evidence of Fazio's statement in the mid-fifteenth century, *(De viriis illustribus)* that Jan van Eyck had learned from Pliny. In fact, opinion was divided on this subject. Paolo Pino ("Dialogo di Pittura" [1548] in Barocchi, ed., *Trattati,* I, 124), who is close to Leonardo in many of his ideas, agreed that there had been oil painting in antiquity; but his source is Vitruvius who actually describes a kind of encaustic (Barocchi, ed., *Trattati,* I, 124, n. 5). For the oil technique of antiquity, see Lepik-Ko-paczynska, *Die Antike Malerei,* 25. Generally, Cinquecento writers see oil painting as a modern invention from the north of Europe, usually attributed to Jan van Eyck.

 Since it was sometimes believed that Eyckian technique was founded on antique ideas, it is especially interesting to note the degree to which Leonardo's practice was similar to that of Flemish painting. (See, Rudel, "Technique picturale," 299-300, 304-308, Solmi, "Fonti," 179, and, most recently, Chastel, "Les notes de Léonard," 23, 24).

113. Pedretti, *Chronology,* 79.

114. See, for example, Solmi, "Fonti," 341 and, more recently and more profoundly, K. Clark, "Leonardo and the Antique," in O'Malley, ed., *Leonardo's Legacy,* 1-34. I have benefited from Craig Smyth's verbal references to antique resonances in works by Leonardo. For a summary of Leonardo's *Romanità* in architecture, see L. H. Heydenreich, "Leonardo and Bramante; Genius in Architecture," in O'Malley, ed., *Leonardo's Legacy,* 142-148.

115. It is not always easy to tell when biographers are interpreting a Renaissance artist in the light of the ancients and when the artist himself is trying to imitate or rival their feats. Yet, there were a striking number of works, deeds and sayings by Leonardo that corresponded to examples given by Pliny and by other antique writers. These correspondences are of many kinds and only a few can be mentioned here. On the most obvious level, there is Leonardo's choice of antique subject matter. Like Timomachus, for instance, he painted a Gorgon (Medusa) (Jex-Blake, Sellers, *Pliny,* 161; Vasari-Milanesi, *Vite,* IV, 24, 25). Giovanni Gaddi thought that Leonardo's drawings of Neptune rivaled the word-painting of Virgil *(Vite,* IV, 25), and the theme was probably undertaken in this spirit, since it was done for Antonio Segni, the recipient also of Botticelli's *Calumny of Apelles* (Clark, Pedretti, *Windsor Drawings,* cat. no. 12570). Leonardo, like Apelles, became supreme as a painter of horses. Biographers from Giovio ("Leonardi Vincii Vita," 121), through Vasari *(Vite,* IV, 42) and Lomazzo *(Tempio,* 55) may have invented the comparison. However, the very idea of painting a cavalry battle itself evokes the memory of Euphranor who won fame in this way *(Pliny,* 154). Indeed the battle scene that combined Leonardo's example with that of the antique became a special pictorial challenge for artists like Giulio Romano and Vasari. (See also Vasari's descriptions of battles in the *Vite,* IV, 42, and in his letter to B. Varchi in Barocchi, ed., *Trattati,* I, 63.) Shearman, *Mannerism,* 50, interprets Giorgione's *Tempesta* as an attempt to rival Apelles' ability to "paint the unpaintable" *(Pliny,* 133, 145). Surely Leonardo's descriptions and drawings of storms, deluges and cataclysms can be seen in the same light. Indeed the idea of painting landscape as an independent genre could also be gleaned from Pliny. (See E. H. Gombrich, "The Renaissance Theory of Art and the Rise of Landscape," in *Norm and Form,* London, 1966, 111-114. Recently, V. Hoffmann, in "Leonardos Ausmalung der Sala delle Assi im Castello Sforzesco," *Mitteilungen des Kunsthistorischen Institutes in Florenz,* XVI, 1972, proposed that Leonardo was trying to re-create the Vale of Tempe. I should also like to suggest that the beautifully subtle expression of kinship in the faces of the Virgin and St. Anne in the National Gallery cartoon, may have been inspired by Pliny's account of Nikias who painted a young man and his aged father so that we admire the marked resemblance although the difference in ages is not lost *(Pliny,* 95). Parrhasius discovered—as Lomazzo paraphrased Pliny—"la simmetria nella pittura, le argutie del volto, l'eleganza del capello, la venustà della bocca e finalmente l'arte di levar i dintorni delle figure co[n] i colori

(Tempio, 15-16)." This is an apt description not only of the "Mona Lisa smile" but of Leonardo's special achievements as well. I do not suggest that Leonardo set up and followed a Plinian program with any consistency or rigor but rather that the writings of the ancients could be inspiring ratifications and encouragement. It may not be possible to establish that there was a relation between Leonardo's unceasing quest for grace of form and feeling and his consciousness that grace *"quam Graeci charita vocant"* was, according to Pliny *(Pliny,* 121, n. 7), the dominating characteristic of the art of Apelles and its unique achievement. There may also be a dimension of what might be called Dedalic play, as well as interest in magic, in Vasari's story of the artificial monster which Leonardo created out of the strange lizard brought to him by a Roman vine-dresser *(Vite,* IV, 46). We are told by Philostratus (Fairbanks, *Philostratus,* 65), that Dedalus made statues that could walk, and even speak and although there is a very old tradition for the kind of mechanical lion that Leonardo made for the King of France (Heydenreich, *Leonardo,* 191), one may wonder whether Leonardo's desire to use this mode was not also kindled by antique example. In that example, Hermetic writings and traditions would also have been included. On another level, the ambition of Leonardo as well as of other Renaissance artists to write treatises, conforms to the example of Apelles and others mentioned by Pliny *(Pliny,* 121). See also Lomazzo, *Tempio,* 16-17, who discusses modern writers on art as successors to the ancients. These Renaissance literary and theoretical aspirations were, of course, part of the larger campaign to raise the status of art and artists. Still another kind of expression of Leonardo's desire to reincarnate the antique might be seen in his attempts to fashion his own image, in portraits, after that of Aristotle. His contemporaries were also willing to represent him in the guise of an antique philosopher. See, L. Planiscig, "Leonardos Porträte und Aristoteles," *Festschrift für Julius Schlosser,* Vienna, 1927, 137-144; also G. Nicodemi, "Il volto di Leonardo," in *Leonardo,* Novara, 1956, 9-16. Leonardo's role as the artist-philosopher is discussed below.

116. Fairbanks, *Philostratus,* 3; McMahon, *Treatise,* no. 433, 161; R. W. Lee, *Ut Pictura Poesis* (1940), New York, 1967, 10-13, for the historical setting of Leonardo's idea. Leonardo's assumption of the role of philosopher seems to have twin sources. On the one hand, Leonardo draws a comparison between the artist and the orator (E. MacCurdy, *The Notebooks of Leonardo da Vinci,* New York, 1955, 912). Once this simile is made, the artist also becomes responsible for the demands which Quintilian says that Cicero makes on the orator: namely, that he be conversant with "all the workings of nature" and that he form "his character on the precepts of philosophy and the dictates of reason." (H. E. Butler, ed. and tr., *The Institutio oratoria of Quintilian,* London-New York, 1963, IV, 383-385 (Book XII, ii, 4); also, I, 363 (Book II, xxi, 14-15). Quintilian, however, warns against an exaggerated philosophical learning since the orator must remain a man of action. (See also Grayson, *Alberti,* 94-99.) On the other hand, there was available to Leonardo a direct example in Pliny of the antique artist as philosopher. Metodorus was both the best painter and the best philosopher in the Athens of his day *(Pliny,* 159). See Cian, ed., *Il Cortegiano,* I, lii, 129, and Frey, *Il Codice Magliabechiano,* 37, for the Anonimo's version of this account, as well as B. Varchi's "Disputa seconda," in Barocchi, ed., *Trattati,* I, 36. Pamphilos was also trained in every branch of learning, especially arithmetic and geometry and refused to take less than a talent for his work *(Pliny,* 119); an idea echoed in Leonardo's statement to the bankers of Piero Soderini in Florence: "Io non sono dipintore da quattrini" (Vasari-Milanesi, *Vite,* IV, 44-45). As so often, it is Lomazzo *(Tempio,* 37-38) who gives an especially clear and Leonardesque statement of the artist-philosopher ideal. "Il vero pittore dovrebbe essere tutto filosofo, per poter ben penetrare la natura delle cose, e con ragione dare a ciascheduna la quantità dei lumi che gli si deve." The path from Leonardo's philosophical attitudes to his conception of the artist as Magus is a short one. He said that he despised necromancy (McMahon, *Treatise,* no. 686) but his underlying belief that the artist behaves in imitation of the forces of nature and that he is like God the Creator, allies his thinking with that of late fifteenth-century neo-platonic and Hermetic thinkers. See F. Yates "The Hermetic Tradition in Renaissance Science," in C. Singleton, *Art, Science and History in the Renaissance,* Baltimore, 1967, 255-274, especially 261.

117. For the direct relationship between the ideas of Alberti and Leonardo, see Chastel, "Les notes de Léonard," 28, and note 73, for bibliography, as well as Shearman, "Colour," 36-37.

118. "Sed non multum interest aut primos pictores aut picturae inventores tenuisse, quandoquidem non historiam picturae, ut Plinius, sed artem novissime recenseamus. De qua hac aetate nulla sciptorum veterum monumenta, quae ipse viderim, extant." (In M. Vitruvii Pollionis, *De Architectura Libri Decem,* Amsterdam, 1649, II, 14.) The first Italian edition (*La Pittura di Leonbattista Alberti* [tr. Lodovico Domenichi], Venice, 1547, f19v) makes this "... noi no[n] raccontiamo l'historia de la pittura, come plinio, ma l'arte. De laquale al tempo nostro non si ritrova memoria alcuna de gli antichi scrittori, ch'io habbia visto." Alberti seems to be making a distinction between the history of art (Pliny) and discussion of the art of painting itself, a subject about which ancient writers left no trace. (These readings differ significantly from that given by Grayson, *Alberti,* 62-3, 6; see L. Mallè, ed., *L. B. Alberti: Della Pittura,* Florence, 1950, 78.) However, Alberti's ambition to begin anew in this respect itself recalls the wording of Philostratus (Fairbanks, *Philostratus,* 5): "The present discussion, however, is not to deal with painters nor yet with their lives; rather we propose to describe examples of painting in the form of addresses which we have composed for the young (etc.)" Alberti does not, of course, give ekphrases until book III, but the tone is similar. See also the opening phrase of his Book II. Alberti goes on to relay reports of ancient writing on art and cites many encouraging examples from Pliny throughout the treatise. See also Grayson, *Alberti,* 32-33, 64-67. Alberti certainly does not dismiss Pliny but sees him as one source to be used in the new enterprise of modern art. See also, Mallè, *Alberti,* 81: "... sia ad chi inprima cerca gloriarsi di pittura questa una cura grande ad aquistare fama e nome, quale vedete li antiqui avere agiunta."

119. See Baxandall, *Giotto,* 63-64, for the history of this idea. As Shearman, "Colour," 47, n. 5, had noted, Leonardo's conversation with the Cardinal of Gurk in 1497 in Milan which is reported by Bandello presumably reflects Leonardo's own desire to see the pictures praised by ancient writers in order to compare them with what the moderns had accomplished. It is worth pointing out, however, that Bandello also goes on to recount a story which he says Leonardo told on this very occasion, when he was honored by the Cardinal, to show those present the honor paid to painters in "quei buoni tempi antichi." Leonardo's tale begins with Pliny's familiar episode of Apelles and Campaspe and then introduces the modern parallel of Filippo Lippi, who was saved from slavery when his pirate captors admired his art (Flora, ed., *Bandello,* I, 646-650). Although Bandello's story seems to be apocryphal—it already appears in Vasari's 1550 *Vita* of Lippi—Bandello's circumstantial account of Leonardo's actions and words elsewhere in the *Novelle* and in letters could suggest that the author thought he was reflecting Leonardo's own ideas. For the problem of Bandello's reliability, see N. Sapegno, "M. Bandello," in *Dizionario biografico deli italiani,* V, Rome, 1963, 667-673.

120. E. Panofsky, "Nebulae in Pariete," *Journal of the Warburg and Courtauld Institutes,* XIV, 1951, nos. 1-2, 34-41; R. W. Kennedy, "Apelles Redivivus," *Essays in Memory of Karl Lehmann,* New York, 1964, 160-167, who also points out that Titian's idea of himself as Apelles may have been inspired by Leonardo; see also, most recently, D. Rosand, "Ut Pictor Poeta: Meaning in Titian's Poesie," *New Literary History,* III, 1971-1972, 527-546. See C. Dempsey, "Euanthes Redivivus," *Journal of the Warburg and Courtauld Institutes,* XXX, 1967, 422 ff., and A. Smith, "Dürer and Bellini, Apelles and Protogenes," *Burlington Magazine,* CXIV, May, 1972, 326-328. For earlier behavior *all'antica,* see E. H. Gombrich, "The Renaissance Conception of Artistic Progress," *Norm and Form,* 3-7. The same author, in *Art and Illusion,* New York, 1960, 137-138, 221, and in "Blurred Images," 172, 178, shows that Daniele Barbaro (1556) saw Leonardo's *sfumato* in terms of Pliny's description of the subtle outlines made by Parrhasius. Alberti's description of *sfumato* also follows on his description of chiaroscuro painting in antiquity (Grayson, *Alberti,* 88-89). A. Chastel, *The Studios and Styles of the Renaissance,* English ed., London, 1966, 325, believes rightly, I think, that Pliny's praise of Apelles for the variety of things he could paint was taken as a direct challenge by Leonardo and the Venetians.

121. Poliziano, who had a formative influence on the young Leonardo, was among those who stressed that

imitation does not mean copying but "retrovar natura." Presumably this means to seek not only the appearances but the underlying laws of nature. See G. Castelfranco, "Momenti della recente critica Vinciana," *Leonardo: Saggi e ricerche,* 443. For the conceit of transforming oneself into the author being imitated, see E. Battisti, "Il Concetto d'imitazione nel Cinquecento da Raffaello a Michelangelo," *Commentari,* VII, 1965, 95. A comparable idea is probably implied by Raphael's depiction of modern poets in the *Parnassus* (P. De'Vecchi, *L'Opera Completa di Raffaello,* Milan, 1966, 103-104, for a summary of this question). J. Sparrow, "Latin Verse of the High Renaissance," in E. Jacobs, *et al., Italian Renaissance Studies: A Tribute to the Late Cecilia M. Ady,* London, 1960, 363-364, mentions the humanist fantasy by Flaminio Strada (1617) in which Castiglione and others each impersonate their own favorite Classic author.

122. We see this, not only in Raphael's painting, but stated in the famous letter to Leo X on the architecture of Rome (Golzio, *Raffaello,* 85). For the authorship of the letter, see Cian, "Nel mondo del Castiglione," 78-79; F. Castignoli, "Raffaello e le antichità di Roma," in Becherucci *et al., Raffaello,* II, 584, n. 16.

123. For the possible antique sources of Raphael's landscape, see M. Dvořák, *Geschichte der Italienischen Kunst im Zeitalter der Renaissance,* Munich, 1927-1929, II, 123 ff., noted in C. H. Smyth, *Mannerism and "Maniera",* Locust Valley, N. Y., 1962, 61, n. 103; Freedberg, *High Renaissance,* 133, and in his *Painting in Italy,* 147. In the *Transfiguration,* the landscape seems to represent Rome.

124. Giulio's marmorial manner is itself a literal-minded obedience to an aspect of Raphael's own directive to pursue the antique. For the possible coarsening effect of antique example on modern style, see Smyth, *Mannerism,* 80, n. 179. The kneeling figure in the *Transfiguration* is, however, developed out of cognate poses in the *Heliodorus* and the *Sistine Madonna.* The latter painting also provides a source for the *Transfiguration* Christ.

125. This was also noted by Shearman, "Colour," 41.

126. For the passage in Giovio, see above, n. 42. For Castiglione, Cian, ed., *Il Cortegiano,* I, lii, 127-128.

127. McMahon, *Treatise,* 117, no. 284. Sabba da Castiglione *(Ricordi,* Venice, 1554, f. 51v), calls Leonardo the inventor of large figures "tolte dall'ombre delle lucerne" (in Poggi, *Leonardo,* 29). Although Vasari does not mention specific pictures, he says that Leonardo's darkness made his paintings look like "cose fatte per contraffare una notte" (Vasari-Milanesi, *Vite,* IV, 26). By the end of the sixteenth century, Leonardo was also thought to be responsible for the painting of night scenes. F. Bocchi, M. G. Cinelli, *Le Bellezze della Città di Fiorenza,* Florence [1591], 1677, 308: ("in the house of the Cavaliere Vasari, in Borgo S. Croce), vi è una notte su lavagna di Leonardo da Vinci meravigliosa".

128. M. Hirst, "S. M. della Pace," 172-173, also emphasizes Raphael's unusual interest in night scenes in the second decade—especially in the unexecuted *Resurrection*—and connects it with the antique and the influence of Dürer on Raphael. However Leonardo's presence can also have been an important factor. For an appreciation of the possible Northern constituent in Leonardo's tonal style, Shearman, "Colour," 37.

129. Dating of the picture has varied widely with the balance of opinion considering it as a Roman work (L. D. Ettlinger, A. Ottina della Chiesa, *L'Opera completa di Leonardo da Vinci,* Milan-New York, 1967, 110, no. 37). Raphael's *Madonna di Foligno (ca.* 1512) as well as the *Madonna dell'Impannata* contain the *Baptist* motif (Freedberg, *High Renaissance,* 186). It seems to me, however, that the Foligno *Baptist* depends less surely on Leonardo's design than on the still earlier *Baptist* in Fra Bartolommeo's destroyed *Assumption,* formerly in Berlin. (Freedberg, *High Renaissance,* I, 586 as 1508-1509, II, Pl. 46; H. von Gabelentz, *Fra Bartolommeo und die Florentiner Renaissance,* Leipzig, 1922, I, 148, as 1507-1508.) Clark, Pedretti, *Windsor Drawings,* liii, suggest that a drawing datable in 1509 is for the Baptist's hand. There is no reason to suppose, however, that Leonardo did not continue to rework the pictorial idea at a later date. He had the picture in France in 1517. The theme of the raised pointing hand, although not the gesture across the body, was also available through the *Laocoon* after 1506 and is already prefigured in quattrocento *Baptists,* for example, in the *St. Lucy Altar,* as well as in a Schongauer

print and in Mantegna's *Trivulsio Madonna*. Also see below, n. 153. Raised pointing hands also occur in Leonardo's *Adoration* and in drawings. See also Tolnay, *Michelangelo,* III, 90, for the history of the motif.

130. M. Rzepinska, "Light and Shadow in the Late Writing of Leonardo da Vinci," *Raccolta Vinciana,* XIX, 1962, 259, 265, points out that it was only about 1505 that Leonardo transferred his study of dusky lighting and shade outdoors. Chastel, "Les notes de Léonard," 21-25, also discusses Leonardo's growing interest in gentler tonal transitions and more unified luministic effects. Leonardo's new attitude toward light in landscape could well have interested Raphael although he, on the whole, tended to emphasize the dramatic contrasts potential in the dark manner.

131. Castiglione's name is linked with Raphael's *Galatea* and, of course, with his portrait. Castiglione was also on close terms with Giulio Romano. It was the Count who negotiated the final payments for the *Transfiguration,* who made Giulio his agent in the collecting of antiques and who brought the painter to the Gonzaga court in Mantua.

132. For the degree of Raphael's responsibility for the *Sala di Costantino* and for its technique, see Shearman, "Unexecuted Projects," 177-180, Freedberg, *Painting in Italy,* 133-135.

133. F. Hartt, *Giulio Romano,* New Haven, 1958, I, 48.

134. McMahon, *Treatise,* 115-117. Hartt, *Giulio Romano,* 48, calls attention to the Leonardesque source and Freedberg, *High Renaissance,* 162, 572, rightly notes the dependence of the composition on the *Attila* fresco which, in turn, derives from the *Battle of Anghiari.* Sketches by Leonardo such as Windsor 12360 for the Trivulsio Monument may also have played a role. A slightly later drawing, Windsor 12332 (the so-called "pazzia bestialissima") would have been even more inspiring because of its reference to the antique (Clark, Pedretti, *Windsor Drawings,* 30, 47). In turn, an early drawing by Raphael in Oxford (K. T. Parker, *Catalogue of the Collection of Drawings in the Ashmolean Museum,* Oxford, 1956, II, 281, no. 535, Pl. XCCV), which records a phase of the design for the *Battle of Anghiari,* shows how closely Raphael studied Leonardo's ideas and preserved them so that they could be used again later. See also J. Wilde, "Michelangelo and Leonardo," *Burlington Magazine,* XCV, 1953, 65-77.

135. Vasari thought the *Perla* to be by Raphael himself (Hartt, *Giulio Romano,* 53). See Freedberg, *High Renaissance,* 366-368 and 339, where he notes a "slight morbidity" in the *Bindo Altoviti* which recalls Leonardo. (For the attribution, Freedberg, *Painting in Italy,* 471, n. 49.) The nude *Fornarina* in the National Gallery in Rome (for the attribution see De'Vecchi, *Raffaello,* no. 147, 119) appears similar in type to half-length nudes from the Leonardo circle (Ettlinger, Ottina della Chiesa, *Leonardo,* n. 104).

 The *Madonna of François Iᵉʳ* adopts the pose used both in the *St. Philip* of the *Last Supper* and in the *Transfiguration* as well as a dark Leonardesque tonality. The Leonardo-like elements in the *Madonna della Gatta* need no description. Even in Mantua, the patterns of the falling rocks in Giulio's *Sala dei Giganti* recall the cataclysms in Leonardo's drawings: see K. Clark, *Landscape Painting,* (1949), New York, 1950, 47; Gombrich, "Water and Air," 203. A. Chastel, *The Crisis of the Renaissance,* Geneva, 1968, 93, also sees that these "terrible scenes which were to become rife in Italian and all European art do not derive solely from Raphael's studio and the Roman taste for powerful effects." Another source for the *Sala dei Giganti,* in Correggio, is pointed out by Freedberg, *Painting in Italy,* 489, n. 84, 492-3, notes 23, 32. The *Perla* is also interesting for its "aurora molto lodata" (Vasari-Milanesi, *Vite,* IV, 351). The dawn must have an iconographical meaning comparable to the sunrise in the *Transfiguration.* See the Appendix. For formal relationships in the illumination of the two pictures, see Freedberg, *High Renaissance,* 366.

136. The extent of Giulio's participation in the lower half of the painting has long been a matter of controversy (see J. Vogel, "Zu Raffaels *Transfiguration,*" *Monatshefte für Kunstwissenschaft,* 1920, 298-305; F. Hartt, *Giulio Romano,* 34, n. 40; von Einem, "Verklärung" 303, and Dussler, *Raffael,* 69). The question also bears on the degree to which Raphael was responsible for the dark tonality of the lower part of the picture. The date of Giulio's intervention is of equal significance. If his part in the

work dates from Raphael's lifetime, we may assume that Giulio was acting in conformity with the master's desires. If, however, Giulio finished the picture after Raphael's death, he could have attempted "improvements" in accord with his personal preference for *oscurità* which is so clearly expressed in his own works of 1520-1524. Further debate on these questions should await the results of the cleaning now under way at the Vatican. In the meantime, the balance of external evidence favors attributing maximum responsibility for the dark tonality of the painting to Raphael himself. The painting was sufficiently finished to be exhibited at Raphael's death, then at the Vatican and in the Cancelleria. Documentary evidence is inconclusive since payments to Giulio continued until 1526, when he had left Rome and when the picture had already hung for three years in S. Pietro in Montorio. Vasari insisted repeatedly *(Vite,* IV, pp. 371-372, 378), that the work was finished by Raphael and that it had been undertaken in order to display his personal virtuosity and thus to correct his errors in the Farnesina *Loggie,* where assistants had been allowed to execute his designs. The tonality of other later pictures by Raphael, such as the Louvre *St. Michael* (authentic) and the *Holy Family of François I^er* (Giulio on R.'s design), indicate that he favored a dark tonality whether or not he was personally the executor of the work. Even if Giulio's intervention in the *Transfiguration* after Raphael's death was substantial, he would hardly have completed the already famous picture—which was still destined for the original patron—in a way that went counter to Raphael's wishes. Even if Giulio had darkened the picture, he would have had reason to believe that he was acting as the executor of Raphael's artistic will.

137. All these compositions have a common ancestry in Cavallini's fresco of the Stoning of Stephen in S. Paolo f. l. m. (See Stridbeck, *Raphael Studies,* II, 70, Figs. 43, 44; also Hartt, *Giulio Romano,* 55-56.)

138. Vasari-Milanesi, *Vite,* V, 532, carefully follows the account of the *Golden Legend* in his description of Giulio's picture. This source gives no indication of the time of day when the martyrdom took place yet Giulio presents the picture as a violent contrast of light effects, suitable for a night scene.

139. See Raphael's drawing of a screaming Medusa's head for the shield of Minerva in the *School of Athens* (Parker, *Ashmolean,* no. 550; Pope-Hennessy, *Raphael,* Fig. 87).

140. Probably by way of Giulio's adaptation of such landscape elements from Sebastiano's *Raising of Lazarus.* See also Hartt, *Giulio Romano,* 40.

141. The date of Polidoro's arrival in Rome is problematic. If, as A. Marabottini, *Polidoro da Caravaggio,* Rome, 1969, 7, 9, 249, n. 3, suggests, he had arrived as early as 1515, he could theoretically still have encountered Leonardo's direct influence. Polidoro appears to have been so unformed, artistically, when he came to Rome that it is unlikely he would have ventured far outside Raphael's close circle where, however, Leonardesque currents were very strong.

142. R. Turner, "Two Landscapes in Renaissance Rome," *Art Bulletin,* XLIII, 1961, n. 4, 279-280; E. Borea, "Vicenda di Polidoro da Caravaggio," *Arte antica e moderna,* XIII-XVI, 1961, no. 24, 24, n. 2; Freedberg, *Painting in Italy,* 147; Marabottini, *Polidoro,* 11-12, 14, 21, 143, follow Vasari to stress the formative importance of Peruzzi generally and in the S. Silvestro landscapes in particular. This would have been another channel by which Leonardo's ideas would have reached the young painter in Rome (see above n. 13). The same is true of Sebastiano, whom Turner, Borea and Marabottini adduce as influential for the young Polidoro. The role of the Florentine Maturino remains obscure.

143. Vasari-Milanesi, *Vite,* I, 190, says chiaroscuro painting derived from copying sculpture. Chiaroscuro drawing was, however, also a Leonardesque specialty as Vasari had pointed out (Vasari-Milanesi, *Vite,* IV, 20). Also see above, n. 20.

144. For the technique and the possible use of varnish on the murals, see Turner, "Two Landscapes," 276, n. 5. Since then the pictures have been cleaned and, according to Creighton Gilbert who was kind enough to inspect them for me, the paintings now have a chalky surface and a considerably lighter tonality.

145. Freedberg, *Painting in Italy,* 147.

146. E. Müntz, *Les Tapisseries de Raphael,* Paris, 1897, 34-44; Freedberg, *Painting in Italy,* 138, 486. Perino's

grisaille *Passage of the Red Sea* makes use of a partially similar complex of Raphaelesque ideas. See, B. Davidson, "Early Drawings by Perino del Vaga," I, *Master Drawings,* I, no. 4, 1963, 21, Fig. 1, who mentions the relation to Sebastiano's *Lazarus.* However, see also the *Assumption* engraving by the Master of the Die. There is no direct recourse to Leonardo in Perino's design.

147. Vasari-Milanesi, *Vite,* V, 223-224.

148. Dated 1526-1527. Recently extensively cataloged by M. Fagiolo dell'Arco, *Il Parmigianino: un saggio sull'ermetismo nel Cinquecento,* Rome, 1970, 265-266, 490.

149. Parmigianino had already become acquainted with the meaning of Leonardo's art as well as that of Rome about 1519, indirectly, by means of his contact with Correggio and, indeed, a work like the Prado *Holy Family* already shows an incipient Leonardesque dark manner (S. J. Freedberg, *Parmigianino, his Works in Painting,* Cambridge, Mass., 1950, 37-38, 56). Freedberg takes up Vasari's comment that the picture was "a showpiece for the Roman audience before whom Francesco intended to appear." This too suggests that Parmigianino already knew that a dark manner was in fashion there. Clement VII, who had a *Madonna* by Leonardo in his bedroom—as well as a painting by Sebastiano—may also have played a role in fostering this taste. Parmigianino's pre-Roman contacts with Roman style are summarized in Freedberg, *Painting in Italy,* 142-143.

150. Vasari-Milanesi, *Vite,* IV, 11. Indeed, as Freedberg, *Parmigianino,* 72, points out, Francesco's "feat of synthesizing various influences into a stylistically consistent and essentially original whole is itself a Raphaelesque characteristic."

151. The Bruges *Madonna* and Correggio's *Antiope* (Freedberg, *Parmigianino,* 70, 71), and the *Madonna del Cardellino* (J. Shearman, "*Maniera* as an Aesthetic Ideal," in *Studies in Western Art: Acts of the Twentieth International Congress of the History of Art,* Princeton, 1963, II, 219).

152. Freedberg, *Parmigianino,* 71, gives the picture's sources as Raphael's *Madonna di Foligno* (itself an ancestor of the *Transfiguration)* and Correggio's *Madonna of St. Sebastian in Dresden* which is a variant of the Foligno altar. In the *Vision of St. Jerome,* however, the Baptist's pose and his place in the picture cite the cognate figure in the *Transfiguration* and the *Stoning of St. Stephen,* while the rocky ledge echoes Raphael's Narbonne altarpiece as does Parmigianino's organization of light.

153. Freedberg, *Parmigianino,* 70-71, had traced the gesture of the Baptist in the *Vision of St. Jerome* to Correggio's Baptist in the Dresden altar of 1514-1515, noting that Correggio's figure, in turn, was based on the Baptist in the *Madonna di Foligno.* It seems to me, however, that Correggio's figure is, in important respects, closer to the pose, illumination and expression of Leonardo's Louvre *Baptist* (see above, n. 129) than to Raphael's interpretation of it. This suggests that Correggio had seen Leonardo's picture or a study related to it. Parmigianino's Baptist in the London picture is, on the other hand, closer to Raphael than to Correggio's or, indeed, Leonardo's versions. The fact that Parmigianino's Baptist, which was based on Raphaelesque prototypes, should emphasize their Leonardesque source, may suggest again that Parmigianino recognized this component in the style of Raphael and Giulio Romano. It is interesting to note that Leonardesque elements appear late in the preparatory sketches for the London *Vision of St. Jerome.* As in the genesis of the *Transfiguration,* they seem conscious additions. For mystical and philosophical connections between the Baptist images of Parmigianino and Leonardo, see Fagiolo dell'Arco, *Parmigianino,* 490. Similar comments could, of course be made about the Raphael school *Baptist* in the Louvre. Some evidence that Parmigianino was also more directly interested in Leonardo's compositions is provided by a drawing from the Roman period after one of the infants from Leonardo's *Leda* (A. E. Popham, *Catalogue of the Drawings of Parmigianino,* New Haven, 1971, I, no. 214).

154. Giulio had left for Mantua in October, 1524. However, Freedberg, *Parmigianino,* 66, 72, 183, draws attention to the Giulio-like character of Parmigianino's few landscape backgrounds while, later, he comments on the Raphaelesque regularity of form and feature in Parmigianino's *St. Zachery Madonna.* Fagiolo dell'Arco, *Parmigianino,* 505, n. 276, notes that the picture is a "studio di crepuscolo."

155. Leonardo's role in Correggio's development and the problem of Correggio's probable trip to Rome are

summarized by Freedberg, *Painting in Italy,* 178-181. See also, D. Brown, "Correggio's 'Virgin and Child with the Infant St. John,' " *Museum Studies,* no. 7, Chicago, 1972, 7-33.

156. Shearman, *Maniera,* 219, for an analysis of the historic place of Parmigianino's *Vision of St. Jerome.*

157. The role of the Frate in the history of the dark manner can hardly be overemphasized. It should be stressed that his absorption of Leonardo's idea extended, significantly, to his use of broad, dark, underpainting of the kind found in Leonardo's *Adoration.* This can be seen in his *St. Anne Altar* but even more dramatically in the *Adam and Eve* in Philadelphia (B. Sweeney, *The Johnson Collection: Catalogue of Italian Paintings,* Philadelphia, 1966, no. 78). Vasari-Milanesi, *Vite,* IV, 377, is specially aware that Fra Bartolommeo "usasse troppo gli scuri per dar maggior rilievo." See also Shearman, "Colour," 38; Freedberg, *High Renaissance,* 196-197. For the crucial relation of Sarto's color to Leonardo, see Shearman's brilliant essay in his *Andrea del Sarto,* I, 131-148.

158. Pedretti, *Chronology,* 107-141.

159. Forster, *Pontormo,* 30, 66, 72, 160, analyses Leonardo's importance for Pontormo. He sees Leonardo's *Adoration* as a source for Pontormo's 1518 *Joseph in Egypt* and discusses the Leonardesque component in the new style of this work. See also, Freedberg, *High Renaissance,* 529, for Leonardesque traits in the *Cosimo* portrait of the same year.

160. Sarto left Florence in early June, 1518, and returned before the end of 1519 (Shearman, *Andrea del Sarto,* 4). Freedberg, *High Renaissance,* 463-465, 467-469, thinks Sarto may have seen the *Visdomini Altar* before leaving for France. He also notes that Sarto's French *Caritas* "anticipates . . . the *Medici Madonna.*" Perhaps this is another indication of a leaning toward Leonardo which is characteristic of the later Sarto more generally. Freedberg, *Andrea del Sarto,* Cambridge, Mass., 1963, I, 47-51, points out that Sarto could have seen Leonardo in France and would have known Raphael's *St. Michael* as well as Leonardo's *St. Anne* and other works. Shearman, *Andrea del Sarto,* 76-77, tends to give less significance to Sarto's French sojourn although he notes the same contacts.

161. Freedberg, *High Renaissance,* 517. Forster, *Pontormo,* 37, also sees the gathering of a Leonardesque *tenebroso* in works by a variety of Florentine painters in 1515-1518. J. Cox Rearick, *The Drawings of Pontormo,* Cambridge, Mass., 1964, 127, notes that Pontormo's first use of black chalk with white heightening, a mode of "strong contrasts in *chiaroscuro* analogous to those of the painting," in studies for the *Visdomini Altar.* This seems a further indication that the artist himself saw the picture as a new departure in the treatment of light.

162. Freedberg, *High Renaissance,* 448-452, emphasizes the role of the *Madonna dell'Impannata* in Florence after 1514. See also, Freedberg, *Painting in Italy,* 470, n. 35; Dussler, *Raffael,* 27. The degree to which the younger Raphael had himself absorbed this native Florentine version of *sfumato* and chiaroscuro is rendered somewhat ambiguous by the state of preservation of some of his *Madonnas* with dark backgrounds. See above, n. 9.

163. C. Gamba, *Contributo alla conoscenza del Pontormo,* Florence, 1956, 9. For indications of Roman influence somewhat later, about 1520, see the discussion by Maurer, "Pontormo und Michelangelo," 143-144; Cox Rearick, *Pontormo,* 37; Forster, *Pontormo,* 45.

164. For example, see Freedberg, *High Renaissance,* 519.

165. Smyth, *Mannerism,* 20, 29, 71, n. 139, in fact, sees the *Visdomini* altar as a source of *"maniera* conventions." See below, n. 222.

166. For a differing interpretation, see Freedberg, *High Renaissance,* 521.

167. This relationship was already noted by W. F. Friedlaender, *Mannerism and Anti-Mannerism in Italian Painting* (1925), New York, 1965, 21. These Leonardesque elements, which recall the London National Gallery Cartoon, were also transmitted to Pontormo through intermediary sources of the *Visdomini* composition such as Fra Bartolommeo's *Pitti Altar* of 1512, Sarto's *Dresden Altar* and Raphael's *Madonna dell'Impannata.*

168. Smyth, *Mannerism,* 10.

169. This work is an especially interesting example since, as Smyth, *Bronzino As Draughtsman, An Introduction,* Locust Valley, N. Y., 1971, 42-43, has shown, there is a direct linkage between Bronzino's

picture and Raphael's unexecuted *Resurrection* which Hirst, "S. M. della Pace," 172-173, says was also to have been a night piece. Bronzino's *Nativity* in S. Stefano in Pisa of 1565 (Brogi 23576) is a particularly good example of his interest in Raphael's *Transfiguration* and its dark manner.

170. Lomazzo, *Trattato,* I, 406, criticizes those modern painters whose colors are too light. However, Shearman, *Andrea del Sarto,* I, 147, notes the persistence of a fairly dark background foil even in *maniera* pictures whose forms are light in color and plastically conceived and notes the jarring contrasts that may result. See also Smyth, *Mannerism,* 26, 80, n. 180, 85.

171. See, for instance, the dark tonality of the *Resurrections* by Genga, Raffaellino del Colle and Bronzino (Hirst, "S. M. della Pace," 172-173; Smyth, *Bronzino,* 42-43). A particularly interesting case in point is provided by G. Valeriano's altarpiece (Fig. 28) for the Ascension Chapel in Santo Spirito in Sassia, *ca.* 1570 (F. Zeri, *Pittura e controriforma: l'arte senza tempo di Scipione da Gaeta,* Turin, 1957, 62, 63, figs. 55, 56). Zeri uses Baglione's description of the picture to underline the importance of Sebastiano del Piombo in this period. The gigantic figures do have Sebastianesque shapes but it should be noted that the picture is in all ways an astonishingly close paraphrase of Raphael's *Transfiguration* and a resolution of its internal contrasts. (Valeriano seems also to have used engravings after the *Transfiguration* such as Beatrizet's print of 1541 [B.XV.250, 21] as well as the *Assumption* print by the Master of the Die.) Valeriano's *Ascension* is so close to Raphael's picture that Baglione could mistake the subject of Valeriano's painting for a *Transfiguration*. What is more, it takes over and exploits both the dark manner and the specific dawn lighting from the *Transfiguration* even though the latter is not specially appropriate to the *Ascension*. (On iconographical grounds, Zeri probably errs in calling the time of day "tramonto." See Appendix.) Valeriano's use of a sunrise setting is interesting evidence that the *Seicento* could see Raphael's picture in this way. By the same token, Baglione's account shows that he recognized the early sixteenth-century *oscurità* we have been discussing. Although Baglione saw that the special quality of Valeriano's dark tonality was related to Sebastiano, the idea of making the *Ascension* a dark picture was transmitted along with the compositional structure of the *Transfiguration*. (". . . la Transfigurazione di Christo nel monte Tabor con li suoi Apostoli . . . [Valeriano] l'ha colorita tanto oscura, che a fatica si scorge; e credo, che quest'huomo volesse imitare la maniera di F. Bastianio del Piombo Venetiano, quando pingeva oscuro; e voleva che le sue pitture dessero nel grande con figure assai maggiori del naturale, con far loro grandi teste, mani ampie, e smisurati piedi sí, che restavano tozze piú tosto, che svelte. . . ." G. Baglione, *Le vite de'pittori, scultori et architetti, ecc.* Rome, 1642, 53.)

172. Lomazzo, *Trattato,* I, 342-343, II, 180ff. Barasch, "Licht," 255, emphasizes Lomazzo's identification of light and shadow with life and death, good and evil and rightly stresses that Lomazzo treats light, throughout the *Trattato,* as an emotional element. Lomazzo, *Trattato* I, 408, also associates "ombra" with "dolcezza," as Vasari and Leonardo himself had done (McMahon, *Treatise,* 59, no. 94).

173. S. J. Freedberg, "Observations on the Painting of the *Maniera,*" *Art Bulletin,* XLVII, June, 1965, 194.

174. See Shearman, *Mannerism,* 158-159. Atmospheric darkness in a picture could also affect its illusionistic relation to the surrounding frame and thus to the space in which the spectator stands. C. deTolnay, "Les conceptions artistiques de Léonard de Vinci et leur origine," *L'Art et la Pensée de Léonard de Vinci,* 384, makes this point in relation to Leonardo's chiaroscuro. For this factor in Giulio's *Anima Madonna,* K. W. G. Posner, "Notes on S. Maria dell'Anima," *Storia dell'arte,* 1970, n. 6, 137-138.

175. Pontormo's *Resurrection* fresco in the Certosa, with all its Dürerian reference, possibly already reflects either the *Transfiguration* itself or, perhaps, the S. Maria della Pace *Resurrection* which Hirst ("S. M. della Pace," 173) also associates with Dürer's woodcuts of the theme. See above, n. 68. Dolce, in Roskill, *Dolce's "Aretino,"* 121, reports that Raphael kept prints by Dürer tacked up on the wall and admired them.

176. Vasari-Milanesi, *Vite,* VI, 267-268. The *Resurrection* is a dawn scene. Vasari also mentions the *Agony in the Garden* at the Certosa and a lost *Nativity* which was also done as a *notte.* In each case, Pontormo's use of the *maniera tedesca* is stressed.

Notes

177. The role of Leonardo's *grazia* or *dolcezza* in the creation of the aesthetic ideals of mannerism is often mentioned in the literature. Important observations and insights are provided by critics such as Shearman, *"Maniera,"* 213; Smyth, *Mannerism,* 53-55, 177; Gombrich, "Artistic Progress," *Norm and Form,* 9 and, by the same author, "Leonardo's Method for Working Out Compositions," *Norm and Form,* 62; also D. Summers, *"Maniera* and Movement: the *Figura Serpentinata," Art Quarterly,* XXXV, 1972, 280.

178. Compare Smyth, *Mannerism,* 17-20, and Clark, "Leonardo and the Antique," 2ff.

179. For classification of relief types in the Renaissance, see Vasari-Milanesi, "della scultura," *Vite,* I, 156. Although Vasari called *mezzo rilievo* the mode of the ancients, Michelangelo does not precisely follow Vasari's description of it (see A. Parronchi, *Opere giovanili di Michelangelo,* Florence, 1968, 76). Michelangelo's mode of arranging the figures in space seems as close to that of Leonardo's *Adoration* as to prototypes of relief sculpture ancient or modern. Parronchi and others have, however, made interesting references to the relief sculpture of the Pisani.

180. Condivi also understood the work to be a *mezzo rilievo.* Vasari says that the *Battle* appeared to contemporaries like the work done "non per mano di giovane, ma di maestro pregiato e consumato negli studi e pratico in quell'arte." This would seem to be the place for Vasari to mention that the work was unfinished if he had thought so; especially since he readily makes this kind of distinction in describing the two early *tondi:* "abozzò et non finì due tondi di marmo: . . . le quali opere furono tenute egregie e mirabili." These sources are brought ·together by J. Pope-Hennessy, in *Italian High Renaissance and Baroque Sculpture,* 2nd ed., London, 1970, 302-303. The suggestion by Tolnay *(Michelangelo,* Princeton, 1947, I, 136), that the death of Lorenzo the Magnificent put a halt to work on the relief seems reasonable; however, see Parronchi, *Opere giovanili,* 76-77.

181. A similar suggestion was made by Parronchi, *Opere giovanili,* 76. Leonardo's *Adoration* could have been an especially stimulating source for the linkage between *non-finito* and *sfumato* since the painting was an outstandingly prestigious example of incompleteness and veiled forms. (See also, M. V. Brugnoli, "Note sul rapporto Leonardo-Michelangelo," *Bollettino d'arte,* XL, 1955, 132-135, and C. Brandi, "Forma e compiutezza in Michelango," *Stil und Überlieferung,* II, 93.) The concept of the surrounding stone as the sculptor's *sfumato* is only apparently challenged by Michelangelo's often repeated simile of the image released from the prison of the inchoate mass of the stone. *Sfumato* is not only a veil on the surface of a form but clearly implies the extention of the form *through* the atmosphere: it is the formless space made visible.

182. The antique subject matter of the relief might also encourage speculation that the *non-finito/sfumato* had associations with antiquity for Michelangelo as well as for Leonardo.

183. C. R. Ashbee, Tr., *The Treatises of Benvenuto Cellini on Goldsmithing and Sculpture,* [1888] New York, 1967, 136. However, as Pope-Hennessy, "The Palestrina *Pietà," Stil und Überlieferung,* II, 108, points out, this was not always true of Michelangelo's sculpture. Nonetheless, the principle of organization of the three-dimensional image on a single plane remained dominant. This was evidently recognized by Vasari (Vasari-Milanesi, *Vite,* I, 54, VII, 273), when he said that the figures being carved should emerge from the stone the way a wax model, lifted out of a basin of water, would emerge through the surface of the water.

184. For the relation of this practice to the *non-finito:* P. Barocchi, "Finito e non-finito nella critica vasariana," *Arte antica e moderna,* 1958, 223, 230, 235.

185. For Michelangelo's early polemical partisanship of sculpture at the expense of painting and his later reconciliation of the polarities between the two arts, see the famous response to the letter of Benedetto Varchi in Barocchi, ed., *Trattati,* I, 82. It is worth remembering that there were no contemporary sculptors of the very first rank in Florence (Leonardo included) on whom an ambitious young artist could model himself in the way that a painter could emulate Leonardo, if only through his work. Moreover, it was Leonardo himself who had given the most vigorous expression to social and artistic ideals which Alberti had established for the Renaissance artist. This situation would have made it necessary for the young Michelangelo to act with special vigor and definition to create a new role for himself, as sculptor.

186. This polarity is exemplified by the battle frescos which the two artists were commissioned to paint in the great hall of the Palazzo Vecchio in Florence during the period from 1503 to 1506. It is worth noting, however, that Vasari makes a point of praising the rich *sfumato* effects in Michelangelo's Cartoon for the *Battle of Cascina* (Vasari-Milanesi, *Vite,* VII, 160). No hint of these effects remains in surviving partial copies of the design, but Michelangelo was, apparently, still concerned to challenge the specifically pictorial and optical elements of Leonardo's painting even while emphasizing the contrast between their approaches to art.

187. Vasari-Milanesi, *Vite,* IV, 47. See also Frey, *Il Codice Magliabechiano,* 115, for Michelangelo's quarrelsome attitude toward Leonardo, earlier.

188. For the problem of the priority of these ideas and the opportunities for contact in the crucial years, see Pedretti, *Chronology,* 61-64; also Clark, Pedretti, *Windsor Drawings,* I, 42, 205, for other Michelangelesque motifs recorded by Leonardo; and Brugnoli, "Leonardo-Michelangelo," 124-140. See Gombrich, "Water and Air," 201-203, for Leonardo's polemical reaction to Michelangelo in Rome.

189. See, for example, Shearman, *Mannerism,* 54. Shearman, "*Maniera,*" 213, speaks of the *grazia* of Michelangelo's drawings of the teens. Shearman believes that Michelangelo "gave the essential impulse" to the *maniera* in the second decade. Clark, Pedretti, *Windsor Drawings,* cat. no. 12570, makes the interesting suggestion that some of Leonardo's drawings inspired Michelangelo's elegant presentation drawings of the 1520's.

190. Tolnay *(Michelangelo* IV, Princeton, 1954, 28, 100, 371), where the author derives the pose of the *Slave* from that of a son of *Laocoon* but notes that Michelangelo's statue possesses the "moto spirituale" of Leonardo's figures. Tolnay also believes that Leonardo's Trivulsio *Slaves* influenced the sculptor. Heydenreich, *Leonardo,* 53, sees the influence of Leonardo's *Leda* on the early figures of the *Julius Tomb* and on the *St. Matthew.* For the impact of Leonardo's *St. Sebastian* designs see above, n. 188, also, M. Lissner, "Das Quattrocento und Michelangelo," *Stil und Überlieferung,* II, 88, who already sees reflections of the *St. Sebastian* in Michelangelo's figure of the Satyr accompanying the *Bacchus* as well as in the *Rebellious Slave.* She suggests that Leonardo might have had a commission for a *St. Sebastian* while he was in Florence. She also sees generally Leonardesque form and proportion in the *Crucifix* from Sto. Spirito. Michelangelo's *Minerva Christ* is also close in pose to the *Leda* (H. von Einem, *Michelangelo,* 1959, 104-107), but it is hard to know whether Michelangelo responded to it or to Raphael's *Galatea* (see Oberhuber, "Raphael und Michelangelo," 156), which is also based on Leonardo's figure. Shearman, *Mannerism,* 55, however, makes an analysis of the relation of form to content in the *Christ* which distinguishes it from the other works in the graceful mode mentioned here. The pose has a long history in Michelangelo's own work (Tolnay, *Michelangelo,* I, 199) and is, in any event, founded on antique models. See also V. Mariani, *Leonardo e Michelangelo,* Naples, 1965, 150-167, for a problematic later dating of Leonardo's *Leda* and a comparison of the two works in terms of their contrasts. Summers, "*Serpentinata,*" especially, 280-284, defines the differences between various kinds of *contrapposti* used in these works.

191. Contemporaries were well aware of this contrast and its implications. See Battisti, "La Critica di Michelangelo prima del Vasari," 120-121; Roskill, in Dolce, *Aretino,* 90, 228-229; Barocchi, ed., *Trattati,* I, 149, 440-441; A. Chastel, *Crisis,* 91. See below, n. 217.

192. Apart from the early Vatican *Pietà,* a mode of deliberate *grazia* is apparent in some of the *Sibyls* of the Sistine Ceiling (Freedberg, *High Renaissance,* I, 107, II, Pls. 35, 134). Surviving indications of the early projects for the *Julius Tomb* also suggest that some of the niche figures may have had this character. It is also possible that Michelangelo's commission for the facade of S. Lorenzo in Florence, with its large areas of pictorial relief, might have suggested the use of this mode.

193. Clark, Pedretti, *Windsor Drawings,* cat. nos. 12515-12518, dated 1509-1510. The problem of how Michelangelo could have had access to Leonardo's materials cannot be solved here. I suppose that Michelangelo saw a drawing or copy of a drawing like the Windsor sheets related to the *Leda* series. Also, Leonardo's painted verion of the *Leda,* which some critics date in the Roman period (Ettinger, Ottina della Chiesa, *Leonardo,* 107, 108), could have been influential.

194. Tolnay, *Michelangelo,* III, 138, notes that the head of the *Night* resembles a maenad on an ancient gem which was well known in the fifteenth century (Furtwängler, *Die Antike Gemmen,* Leipzig, 1901, II, 197, Pl. XLI). However, this prototype does not account for the similarities between Leonardo's drawings and the head of the *Night.* For suggestions of Etruscan sources for the *Allegories,* see K. W. G. Posner, "Comments on the Medici Chapel and Pontormo's fresco at Poggio a Caiano," *Burlington Magazine,* CXV, 1973, 648-649.

195. Tolnay, *Michelangelo,* III, 136-138, 192; J. Wilde, "Notes on the Genesis of Michelangelo's *Leda,"* in D. J. Gordon, ed., *Fritz Saxl: A Volume of Memorial Essays from His Friends in England,* London, 1957, 273-274; E. Battisti, "Classical Models in the Sculpture of Michelangelo," *Stil und Überlieferung,* II, 74. The motif was known through a sarophagus in Rome but also through gems such as an onyx-sardonyx cameo in Naples (inv. no. 25967) which comes from the collection of Lorenzo de' Medici. I am grateful to J. Shearman for this reference. For an extended discussion of the role of cameos and other gems in the design of the reclining *Leda* by Michelangelo and others, see E. R. Knauer, "Leda," *Jahrbuch der Berliner Museen,* XI, 1969, 5-35.

196. Tolnay, *Michelangelo,* III, 137, also points to thematic associations between the two subjects that would also have made Leonardo's example relevant. Michelangelo may have been interested in Leonardo's *Leda* even earlier (see above, n. 190). Certainly a number of artists, beginning with Raphael in the *Galatea,* made Leonardesque *Leda*-like images in the second and third decades which exploited the stylistic values which Michelangelo seems to have seen in the design (e.g. Shearman, *Andrea del Sarto,* I, 30, II, 216; Summers *"Serpentinata," passim.*).

197. K. Clark, "Leonardo and the Antique," 18-24. Heydenreich, *Leonardo,* 53, also sees the *Leda* as "the archetype of the ideal manneristic figure—the famous *figura serpentinata."* However, see Summers, *"Serpentinata,"* 273.

198. The Mother-like qualities of the *Night* were already noted by Bocchi-Cinelli while both Borghini and Lomazzo noted that Michelangelo's representation was not like those of antiquity (Tolnay, *Michelangelo,* III, 67, 134-138).

199. J. Wilde, "Michelangelo's *Leda,"* 272, n. 2, also notes the kinship of the *Dawn* with the antique *Leda* relief.

200. If Leonardo's influence was important for the *Night* and the *Dawn,* and if Brugnoli, "Leonardo-Michelangelo," 138, also saw Leonardesque characteristics in the *Medici Madonna,* one may ask why it is not equally apparent in the male *Allegories.* Possibly Leonardesque prototypes were not equally applicable to all the figures. If Michelangelo's bodily ideal is based on the heroic male form in his representations both of men and of women, a more androgynous image, with its possibilities for long, uninterrupted flexible contours and fluid rhythmic gestures, came closest to Leonardo's ideal of beauty. Even his representations of the male figure in poses of violent torsion and conflict

(e.g. the left-hand rider in the *Battle of Anghiari*) display the body primarily as a conductor of rhythmic motion, rather than as the bulky knot of conflicting pressures that Michelangelo makes of the *Day*.

201. For all its initial visual impact, this juxtaposition also reveals the limits of this approach. The heroic, highly expressive faces of both images share a common reminiscence of antique art and the type already appears on the *Sistine Ceiling*. Nonetheless, it seems likely that Leonardo's version of the type could have been fruitful for Michelangelo on several occasions. The physiognomical type of the *Victory* (and of the *Medici Madonna*) is also disconcertingly, though perhaps fortuitously, similar to that of the copy of the *Madonna of the Yarnwinder* in the collection of the Duke of Buccleuch (Tolnay, *Michelangelo*, IV, Pl. 32, III, Pl. 54; Ettlinger, Ottina della Chiesa, *Leonardo*, 106).

202. For the relation of the *Night* to the *Leda*, see Tolnay, *Michelangelo*, III, 43, Pls. 250-251, 279-280; Wilde, "Michelangelo's *Leda*," 270-281.

203. See J. Wasserman, "Michelangelo's Virgin and Child with St. Anne at Oxford," *Burlington Magazine*, CXI, March, 1969, 122-131, specially 130, where he proposes the influence of the kneeling *Leda* on Michelangelo's *St. Anne*.

204. Heydenreich, *Leonardo*, 53. For Lomazzo's connection of the *figura serpentinata* with antiquity, see Shearman, *Mannerism*, 81-86, Summers, "*Serpentinata*," especially 294.

205. Leonardo's intricately coiffed heads are also sources for Michelangelo's *teste divine* of the twenties and thirties (see Shearman, *Mannerism*, 57-58), which are, in turn, closely allied to the head of the *Night*. These images became deeply fixed in the minds of contemporaries as epitomes of luxurious grace and elegance. Thus, in Bronzino's Besançon *Deposition*, the beautiful mourner on the left is, as J. Cox Rearick kindly pointed out to me, a recollection of the *Night*. By the same token, Smyth, *Bronzino*, 9, Fig. 9, emphasizes the direct link with Leonardo in Bronzino's drawing for the *Moses* fresco of the Eleanora Chapel. The same sort of motif was already used by Bandinelli in his Loreto relief of 1518, where his source is patently Leonardo more than Michelangelo. (For the relation of the *teste divine* to Raphael, see Oberhuber, "Raphael und Michelangelo," 158.)

206. Vasari-Milanesi, *Vite*, VII, 193.

207. Vincenzo Danti, "Trattato delle Perfette Proporzioni," [1567], in Barocchi, ed., *Trattati*, I, 237-238. See the important article by D. Summers, "Michelangelo on Architecture," in the *Art Bulletin*, LIV, 1972, 146-157.

208. Roskill, *Dolce's "Aretino,"* 141. See also W. Weisbach, "Zum Problem des Manierismus," *Studien Zur Deutschen Kunstgeschichte*, Strassburg, 1934, and Smyth, *Mannerism*, 17, 61, n. 105.

209. Roskill, *Dolce's "Aretino,"* 293-294; Jex-Blake, Sellers, *Pliny*, 51-53. Ghiberti (J. von Schlosser, *Ghibertis Denkwurdigkeiten*, Berlin, 1912, I, 16) already praises Lysippic proportions, as Gombrich, "Artistic Progress," 6-7, has pointed out. Adriani in Vasari-Milanesi, *Vite*, I, 63, 64, says of Lysippus that "inanzi a lui i maestri [of sculpture] avevano fatte le figure secondo che elle erano ed egli [Lysippus] secondo elle parevano." Lomazzo, *Tempio*, 15, describes the Lysippic canon much as Adriani had done, as a treatise in which the sculptor showed how to "fare le braccia, e le mani lunghi, i piedi e la testa picciola, che da gli altri stati inanzi lui era fatta grossa si come il naturale, e cotal picciolezza è stata riputata da i più grandi artefici, la più bella inventione che sia mai stata ritrovata."

210. Vasari-Milanesi, *Vite*, VII, 193; C. L. Frommel, "S. Eligio und die Kuppel der Cappella Medici," *Stil und Überlieferung*, II, 51-54.

211. Ackerman, *Michelangelo*, Cat. 21-28, for the successive stages in the vericalization of the chapel design. Ackerman traces the chapel articulation to late Quattrocento models in the nave of S. Lorenzo. Their Florentine slimness, as opposed to Roman norms, would itself have been stimulating to Michelangelo's imagination. However see also C. L. Frommel, "Cappella Medici," 53, 54.

212. For Michelangelo's interpetation of the Vitruvian idea of the relation between architectural and human forms, see Ackerman, *Michelangelo*, I, 1-10. Slimness in the architectural members might also

suggest slimness of figural proportion on the model of the Vitruvian description of the proportions of the architectural orders.

213. F. Hartt, "The Meaning of Michelangelo's Medici Chapel," *Essays in Honor of Georg Schwarzenski,* Chicago, 1951, 145-155; C. Gilbert, "Texts and Contexts in the Medici Chapel," *Art Quarterly,* XXXIV, 1971, 391-408; Shearman, *Andrea del Sarto,* 79. It may be that the affirmation of dynastic power took on new meaning in the chapel as emphasizing the Florentine origin of the reigning Roman Popes and also of the legitimacy of papal dominion over the Florentines. This hypothesis is supported by the plan of Clement VII to provide tombs for the Medici Popes themselves in the Florentine chapel rather than in Rome. (For details of the commission, see Tolnay, *Michelangelo,* III, 76-77). It is certainly true that the death of the last legitimate male heir of the Medici left the family in an especially vulnerable position as regards their relation to Florence, as Hartt also implies. Most recently, see M. Winner, "Pontormos Fresko in Poggio a Caiano: Hinweise zu seiner Deutung," *Zeitschrift für Kunstgeschichte,* XXV, 1972, heft 3, 153-197; and Posner, "Comments," 641-649.

214. For the opposed view, that the architecture is in a sense secondary to the sculpture, see Ackerman, *Michelangelo,* 26-30. It seems to me that this view cannot be maintained if credence is given to Vasari's statement that the New Sacristy was to resemble the Old. In that case the *pietra serena* articulation was an original element of the commission and, once Michelangelo had decided to interpret that element in terms of greater verticality, the adoption of a harmonizing body canon was a logical consequence, even if the decision was spurred by reacquaintance with Ghibertian and other Florentine figural examples. It seems to me that the opposite position: that a new figural ideal led to the adoption of a more vertical architecture, is more difficult to sustain. Indeed, drawings for the chapel show how the figures took shape only as designs for the architecture progressed.

215. Also see Tolnay, *Michelangelo,* III, 45.

216. See Smyth, *Mannerism,* 16-19, for late fifteenth-century components in *maniera* taste, *ca.* 1540. For Ghibertian elements in the Medici Chapel, see for instance, M. Weinberger, *Michelangelo the Sculptor,* New York, 1967, 310-311. Michelangelo was, of course, not alone in his heightened appreciation of the modern relevance of Ghiberti and it is certainly significant that Pontormo became indebted to Ghiberti in the second decade as well. The Baptistry Doors are, in fact, the same kind of source of *grazia* that Leonardo's work provides, and Vasari specifically attributes *maniera* to them (Vasari-Milanesi, *Vite,* II, 105-106). A particularly clear demonstration of contemporary awareness of Michelangelo's debt to Ghiberti is found in Cellini's *Salt Cellar* where variants of the Medici *Times of Day* recline in oval riches taken from Ghiberti's doors.

217. I would suggest that this development in Michelangelo's art was another application of the "licenza nella regola" which Vasari had seen in his Medici Chapel architecture and which Vasari parallels elsewhere with "una grazia che eccedesse la misura." (Vasari-Milanesi, *Vite,* IV, 9. This passage is discussed by Smyth, *Mannerism,* 7, 22, and Summers, "Michelangelo"). Both the rule and the possibility of license within it could be found in Leonardo's example as well as in Raphael. Vasari also attributes *grazia* to Michelangelo but he contrasts the sculptor's *terribilità* with the easier beauty of the other two artists. The contrast that he and his contemporaries made between *venustà* and *terribilità* goes back through authors like Castiglione to Pliny and ultimately to the Ciceronian rhetorical distinctions in the grand manner between *cultus:* "Feinheit und Volkommenheit" and *vis:* "Gewalt und Leidenschaft" (J. Bialostoki, "Das Modus Problem in der bildenden Kunst," *Stil und Ikonographie,* Dresden, 1965, 13). See above, n. 191.

218. See Shearman, *Mannerism,* 15-30. For the role of Perino del Vaga in transplanting the stylish style to Florence, compare B. Davidson, "Early Drawings by Perino del Vaga, II," *Master Drawings* 196, 19-22, and Shearman, *"Maniera,"* 216.

219. See Oberhuber, "Raphael und Michelangelo."

220. Gilbert, "Texts," 406, also makes a special point of the "courtliness" of Michelangelo's Medici

architectural commissions; of the fact that the decoration of the floor and ceiling of the Laurentian Library is "far from the familiar Michelangelesque *terribilità*," and of the circumstance that it was Giovanni da Udine who decorated the garlands inside the dome of the Medici Chapel.

221. Gombrich, "Leonardo's Method for Working Out Compositions," *Norm and Form,* 62, and Shearman, *Mannerism,* 53, rightly emphasize what Gombrich calls the "divorce between motif and meaning . . . (and the) persistence of images" as well as the "aesthetic autonomy" of Leonardo as specially important for mannerism.

222. See Cox Rearick, *Pontormo,* 59-62; Freedberg, *Painting in Italy,* 122-123. A. Vallentin, "Léonard et les Maniéristes toscanes," *L'Art et la Pensée de Léonard de Vinci,* 399, 400, emphasizes the importance of Leonardo for the creation of Pontormo's *maniera.*

223. The seventeenth century saw precisely these aspects of Leonardo and objected to them. D. Posner kindly pointed out to me the passage in A. Felibien, *Entretiens sur les Vies et sur les Ouvrages des plus excellents Peintres Anciens et Moderns avec la Vie des Architectes,* Trevoux, 1725, I, 263-264. (Note the Plinian commonplace of the artist who does not know when to stop work, which now gives a negative cast to Vasari's praise of Leonardo's finish. For this high finish see also Smyth, *Mannerism,* 13, 19, 67, n. 121, n. 122.) "Il est vrai aussi que ces grandes ideés qu'il avoit de la perfection et de la beauté des choses, a été cause que voulant terminer ses ouvrages au-delà de ce que peut l'Art, il a fait des figures qui ne sont pas tout-à-fait naturelles. Il en marquoit beaucoup les contours. Il s'arrêtoit à finir les plus petites choses & mettoit trop de noir dans les ombres. En cela il ne laissoit pas de faire connoître sa science dans le dessein & dans l'entente des lumieres, par le moyen desquelles il donnoit à tous les corps un relief qui trompe la vûë. Mais sa maniere de travailler les carnations ne represente point une veritable chair, comme le Titien faisoit dans ses tableaux. On voit plûtôt qu'à force de finir son ouvrage, et d'y arrêter le pinceau trop long-tems, il a fait des choses si achevées et si polies, qu'elles semblent de marbre."

224. This picture was not, however, available in Florence (Ettlinger, Ottina dell Chiesa, *Leonardo,* 109, no. 35). This fact is mentioned by Shearman, "Colour," 28.

225. L. Becherucci, *Manieristi toscani,* Bergamo, 1944, 19. Also Cox Rearick, *Pontormo,* 269, who notes that the *St. Jerome* is a reflection of Leonardo's kneeling *Leda.* This observation would seem to reinforce my proposals on the sources of the *Night* and *Dawn* since Pontormo's painting also transmits experience of Michelangelo's statues. Cox Rearick also notes the frequent reabsorptions, by Pontormo, of Leonardo's art in the late twenties and thirties as well as Jacopo's "mannerist inversion and elaboration of Leonardo's compositions." Elsewhere (Cox Rearick, *Pontormo,* 60-61) she links this new appreciation of Leonardo's qualities to a recognition of them in Michelangelo's work.

226. For the subject of the painting, see J. Shearman, *Pontormo's Altarpiece in S. Felicita,* Newcastle-upon-Tyne, 1971.

227. Maurer, "Pontormo und Michelangelo," 145, recognizes the "absolute eurythmie" of these images but does not mention the classic source (Leonardo) of this characteristic. However, see Cox Rearick, *Pontormo,* 59-62, 265, 269; Freedberg, *Painting in Italy,* 123. Significantly, the influence of Leonardo is now joined to a much stronger reference to Raphael as well as to Michelangelo's *Pietà.* The work, which is one of the most balanced and integrated of Pontormo's career, appears to strive consciously for reanimation of High Renaissance values. (See Shearman, *Pontormo's Altarpiece,* specially 24-25.)

228. A. Colasanti, "Il Memoriale di Baccio Bandinelli," *Repertorium für Kunstwissenschaft,* XVIII, 1905, 422; Vasari-Milanesi, *Vite,* VI, 136.

229. E. Solmi, "Fonti," 301. Vasari-Milanesi, *Vite,* IV, 50, VI, 136, 604. Frey, *Il Codice Magliabechiano,* 110, 111, claims that Leonardo stayed for 6 months in the house of Rustici. This would have been from late 1507 or early 1508 onward. He was still in Florence on 22 March, 1508, and was back in Milan in September of that year (Ettlinger, Ottina della Chiesa, *Leonardo,* 86, also Pope-Hennessy, *Italian High Renaissance,* 340-342, for the problems related to Leonardo's intervention in Rustici's group). It is unique in Rustici's *oeuvre* both in quality and in the degree and character of its absorption of

Leonardesque principles and motifs. Leonardo must have been profoundly implicated, not only in the technical execution but in the final design itself.

230. Richter, *The Literary Works,* I, 93-94.

231. Rustici's special interest in reliefs may well have had the same source.

232. Vasari-Milanesi, *Vite,* VI, 136-137. Leonardo's own early involvement with the school of the Medici garden and with Poliziano is discussed by Solmi, "Fonti," 340, (Codex Atlanticus, f. 147r, 288v); L. Beltrami, *Documenti e memorie riguardanti la vita e le opere di Leonardo da Vinci in ordine cronologico,* Milan-Treves, 1919, doc. 161; Frey, *Il Codice Magliabechiano,* XVII, 110; Castelfranco, "Momenti della Critica," 443.

233. See also Bandinelli's *Leda*-like figures in designs for engravings such as the *Apollo and Dafne,* as well as the figure on the far right of the Loreto *Birth of the Virgin* relief (Fig. 49). However, Raphael's *Galatea* and prints like his *Lucretia* were also extremely influential.

234. For Baccio's brief Roman stay in 1514, see G. Gaye, *Carteggio inedito d'artisti dei secoli, XIV, XV, XVI,* Florence, 1840, II, 138. He was there again in 1517 prior to his transfer to Loreto.

235. Ex. Nevins Collection, present location unknown. The attribution seems to have been made originally by J. Wilde. The picture and drawings for it were published by P. Pouncey, "Di alcuni disegni del Bandinelli e un dipinto smarrito," *Bollettino d'arte,* IV, Oct.-Dec. 1961, 323-325, who dated the composition ca. 1517 based on the chronology implied by Vasari's description of the painting. This dating is uncertain but plausible on grounds of style, as Pouncey points out. Nonetheless, Bandinelli received a commission to do a fresco in the cloister of the SS. Annunziata as early as 1513 and therefore must already have been at least a competent fresco painter by this date. (See J. Shearman, "Rosso, Pontormo, Bandinelli and Others at SS. Annunziata," *Burlington Magazine,* CII, 1960, 152-156.)

236. It is difficult to make out the background scenes. It seems, however, as though the scene on the left might represent the judgment of Paris while the fighting youths on the right may refer either to the exploits of Paris or of Castor and Pollux. The women on the left resemble draped figures attributed to Rosso, such as the red chalk drawing in Chatsworth (T. S. Wragg, *Old Master Drawings from Chatsworth 1962-1963,* loan exhibition, n. 66, 32). The fighting youths include a variety of antique poses and may be compared to the figures of the boxers, Entellus and Dares, engraved by Marco Dente (B.XIV.195) and others. (See *Drawings and Prints of the First Maniera,* Providence, R.I., 1973, no. 89, 82.) The style of the drawing for this scene in the British Museum and which is published by Pouncey, "alcuni disegni," 323, reveals Baccio's early relation to Granacci to whom Berenson attributed the drawing. The multiplicity of sources that can be traced in the *Leda* is characteristic of Bandinelli's early style.

237. Bandinelli places his figures against a background of antique ruins to stress the Roman connection as can be seen even more clearly in the preparatory drawing in the Uffizi published by Pouncey, "alcuni disegni," 323. The composition of the drawing suggests that the sculptor may have known Filippino Lippi's composition for the unfinished fresco of the Punishment of Laocoon at Poggio a Caiano. See for instance, M. Fossi-Todorow, *Mostra di disegni di Filippino Lippi e Piero di Cosimo,* Florence, 1955, no. 48, pl. 16. The bent, raised arm of Bandinelli's *Leda* is also interesting for the early reconstruction of the statue's missing right arm and generally resembles Bandinelli's reconstruction in his marble copy after the statue. For this problem see H. H. Brummer, *The Statue Court in the Vatican Belvedere,* Stockholm, 1970, 75-119, especially 107-108. Bandinelli would also have known the pose of the standing Hellenistic *Leda* type attributed to Timotheus. An example of the type was known in Florence by the middle of the century (G. Mansueli, *Galleria degli Uffizi: Le Sculture,* Rome, 1958, I, n. 34).

238. Richter, *The Literary Works,* I, 91-94.

239. Sold at Christies, July 1st, 1969, no. 119, pen and ink, 356 x 265 mm. I am indebted to John Shearman, who kindly brought this drawing to my attention. The manner of hatching is close to that of the Uffizi

Leda drawing and is comparable to the handling suggested by Agostino Veneziano's so-called *Olympian Scene* engraved after Bandinelli in 1516 (B.XIV. 193.241). The awkward facial expression is similar to a number of drawings by Baccio of female heads in this period, but it would not be surprising if this deliberate and somewhat stilted interpretation of Leonardo were among Bandinelli's earliest surviving works.

240. See Ettlinger, Ottina della Chiesa, *Leonardo,* 110, for the chronology of Leonardo's concern with the Angel-Baptist theme, and Clark, Pedretti, *Windsor Drawings,* 27-28, 12328r.

241. Vasari-Milanesi, *Vite,* VI, 136.

242. See K. W. G. Posner, *Problems in Cinquecento Sculpture: The Santa Casa di Loreto,* unpublished dissertation, Harvard University, 1965.

243. Smyth, *Mannerism,* 57, n. 84. notes that Vasari (Vasari-Milanesi, *Vite,* I, 172), sees the Renaissance as arising from the imitation of antique reliefs. In this sense, the deep interest of Bandinelli and other *maniera* artists in this form of ancient art may have been an attempt to continue the traditions of the High Renaissance.

244. For the history, meaning and bibliography of the *Hercules and Cacus,* see Pope-Hennessy, *Italian High Renaissance,* 45-46, 363-364, and L. D. Ettlinger, "Hercules Florentinus," *Mitteilungen des Kunsthistorisches Institutes in Florenz,* XVI, 1972, 119-142.

245. Clark, Pedretti, *Windsor Drawings,* cat. no. 12594; also see 12586. See C. Pedretti, "L'Ercole di Leonardo," *L'Arte* Anno LVII, 1958, 163-172. Michelangelo himself had thought about a *Hercules* as early as 1508. Bandinelli had also experimented with the type of figure represented by his *Hercules and Cacus* in his stucco *Hercules* produced for the Florentine festivities for Leo X in 1515 (see J. Holderbaum, "The Birth Date and a Destroyed Early Work of Baccio Bandinelli," in D. Fraser, H. Hibbard and M. Lewine, eds., *Essays in the History of Art Presented to Rudolf Wittkower,* London, 1967, 93-97). A similar type of figure and pose is used in his pair of *Colossi* for the Villa Madama (see D. Heikamp, "In margine alla 'Vita di Baccio Bandinelli' del Vasari," *Paragone,* no. 191, January 1966, 52-54).

246. Vasari-Milanesi, *Vite,* VI, 160. The notion that muscles should look "dolce" and the implied criticism of the dry, emphatic muscularity of Michelangelo's nudes in the *Battle of Cascina* is discussed by Chastel in "Les notes de Léonard," 15. It is ironic that Bandinelli's figures, in their final state, were criticized for resembling "un sacco di noci"; that is, the very term used by Leonardo to criticize Michelangelo. Possibly Baccio was really trying to make the *Hercules* more Michelangelesque when he recut it. Bandinelli had made modeled both a *Hercules* and a *David* in his youth.

247. A drawing in the Uffizi, 714E *recto,* (Venturi, *Storia dell'Arte* X², 203, fig. 171) shows this source clearly. Uffizi no. 6942F *verso,* a chalk drawing, gives the face of *Cacus.* Bandinelli was particularly deft in interrelating the poses of the two figures stemming from quite different sources. It is likely that the solution of this problem was suggested to him by the pose of Donatello's *Abraham and Isaac* from the campanile of the Florentine Cathedral; a source which Michelangelo had also used for the pose of his *St. Matthew* at an earlier moment (see H. W. Janson, *Donatello,* Princeton, N.J., 1957, pl. 43a). However, the *Knife Grinder's* pose can be found in connection with an active, standing male nude in antique *Marsyas* sarcophagi that Bandinelli could have known in Rome, such as the restored relief formerly at the Villa Borghese or the fragment from S. Paolo f.l.m. (C. Robert, *Die Antiken Sarkophag-Reliefs,* Rome 1969, III, 2, nos. 199 and 212). A source in antique relief would help to explain the special flatness of the two-figure composition as it is used both by Donatello and by Bandinelli. The famous statue of the *Scythian,* now in Florence, would have been in Rome during Bandinelli's life. (See Mansueli, *Galleria degli Uffizi: Le Sculture,* I, 84-86, cat. no. 55.)

248. The positive interpretation of Bandinelli's art as "alternative" to that of Michelangelo was pioneered by Rudolf Wittkower, by Hei Kany's numerous articles, and by J. Holderbaum in "The Birth Date of Baccio Bandinelli," 93-97. The more traditional assessment of Bandinelli is given by Pope-Hennessy, *Italian High Renaissance,* 44-46, 68, 74-75.

249. Smyth, *Bronzino,* 8-9, 36-38, 58, n. 48, points to Leonardo's importance for Bronzino. Bronzino also copied a *Madonna* by Leonardo for the Duchess Eleonora in 1563. In addition, one might mention the figure of Envy in the London National Gallery *Allegory* which recalls the screaming man of the *Battle of Anghiari,* although the theme can be traced back into the fifteenth century and the antique (see Oberhuber, "Raphael und Michelangelo," 158). M. Levey, "Sacred and Profane Significance in Two Paintings by Bronzino," *Studies in Renaissance and Baroque Art Presented to Anthony Blunt,* London-New York, 1967, 30-31, emphasizes the importance of Leonardo's compositions and lighting for Bronzino's *Holy Family* in the London National Gallery. Also see above, n. 205.

250. Most recently by M. Levey, *Painting at Court,* New York, 1971, 105.

251. This source is revealed even more clearly in the pose of the Wallace Collection portrait of the duchess (Fig. 56) which, however, was probably posthumous and re-uses Bronzino's Uffizi formula. (Levey, *Painting at Court,* 107; A. Emiliani, *Bronzino,* Busto Arsizio, 1960, 68; see also *Wallace Collection Catalogues: Pictures and Drawings,* London, 1968, 45.) In that case, the pose indicates that the painter was aware of the Leonardesque reference in Bronzino's work.

252. Levey, *Painting at Court,* 105, rightly notes that the *Eleonora* also has a landscape background. Since Bronzino habitually represents female sitters indoors, it is all the more likely that he was referring specifically to the *Mona Lisa.*

253. McMahon, *Treatise,* No. 436, 162. Compare this with Bronzino's definition of painting in his letter to B. Varchi in Barocchi, ed., *Trattati* I, 66-67.

254. Caravaggio's early experiences with the Leonardesque *tenebroso* tradition could be explored further, as should be M. A. Lavin's important suggestion that a revival of Leonardo's color theories was involved in Barocci's coloristic innovations (review of H. Olsen, *Federico Barocci,* in *Art Bulletin,* XLVI, June 1964, 252).

255. See above, n. 223.

Notes

APPENDIX

1. These proposals are well analyzed by von Einem, "Verklärung," 311-314.

2. Vasari-Milanesi, *Vite,* IV, 372.

3. Von Einem, "Verklärung," 303, cites this text in relation to the brightness of Christ's image in the painting.

4. The implication that the Transfiguration takes place as night gives way to dawn and as the Passion is followed by the Resurrection is specially marked in the Gospel of Luke (IX:30-32): "And, behold, there talked with him two men, which were Moses and Elias who appeared in Glory and spake of his decease which he should accomplish at Jerusalem. But Peter and they that were with him were heavy with sleep, and when they were awake, they saw his glory, and the two men that stood with him." The Apostles also descend from the mountain "on the next day" (IX: 37), implying that night has passed.

5. The arguments are summarized in von Einem, "Verklärung," 323-324. The fact that the Deacons already appear in the drawings thought to show earlier stages of the design of the painting strengthens the hypothesis that these figures have a significant part in the meaning of the picture. The suggestions made repeatedly (Lütgens, *Transfiguration,* 60-63), that Cardinal Giulio de'Medici, donor of the picture, is represented as the saint on the right, seems to be correct. His face, only dimly visible in photographs but distinct in the original, is perfectly congruent with Raphael's representation of the Cardinal in the portrait of *Leo X with his Nephews.* The pose of the saint, with his hands joined in prayer, is entirely traditional for donor portraits.

6. "... unde etiam Salvatorem expectamus Dominum nostrum Iesum Christum qui reformabit corpus humilitatis nostrae, configuratum corpori claritatis suae secundum operationem, qua etiam possit sublicere sibi omnia" (Philippians III:20-21). In the West, the Feast of the Transfiguration was composed and instituted by Pope Calixtus III in 1456, to commemorate the victory at Belgrade over the Turks. For the early history of the Transfiguration liturgy see von Einem, "Verklärung," 300, n. 2, and 315-316, for a summary of iconographical theories based on the original significance of the Feast.

7. St. Augustine, Sermo LXXIX, J.P. Migne, *Patrologia Latina,* Paris, 1841, XXXVIII, col. 493. J. Shearman, *Raphael's Cartoons in the Collection of Her Majesty the Queen and the Tapestries for the Sistine Chapel,* London, 1972, 34, n. 90, adduces this sermon and its reference to the Transfiguration in his analysis of *Christ's Charge to Peter* where Christ's robe is also "candida sicut nix." Augustine, however, also uses the whiteness of Christ's garment as a metaphor for the purity of the Church.

8. R. Arbesmann, O.S.A., "The Concept of 'Christus Medicus' in Saint Augustine," *Traditio,* X, 1954, 9ff., as cited by Shearman, *Raphael's Cartoons,* 50, n. 32. See below, n. 9.

9. I am indebted to Professor Shearman's discussion of the *Christus medicus* theme in *Raphael's Cartoons,* 17, 50, 77-78, 80, and to conversations with him which encouraged me to investigate whether the *Transfiguration* might be understood in this way as well.

10. Shearman, *Raphael's Cartoons,* 84, n. 218.

11. Shearman, *Raphael's Cartoons,* 45-90, especially 50, 77-78. Madness was a metaphor for war (e.g. Leonardo's "pazzia bestialissima") as pestilence was for schism. Christ's healing of this madness may,

then, be equivalent to his role as *Rex pacificus;* a role which Leo X and his panegyrists were most anxious to apply to the new Medici Papacy. Shearman, *Raphael's Cartoons,* 76-77, n. 178, notes the relation between the *medicina Dei* and *Manifestio Pacis* when applied to Christ's Healing of the Leper.

12. In a forthcoming article, I hope to show more extensively that liturgical and papal metaphors explain the unique iconography of the *Transfiguration* and probably also its relationship to Sebastiano's *Raising of Lazarus.*

13. This mythology is characterized in detail by Shearman in *Raphael's Cartoons,* 76 *et passim.*

Selected Bibliography

Ackerman, J.S., *The Architecture of Michelangelo,* 2nd ed., 2 vols., London, 1964.

Barocchi, P., ed., *Trattati d'arte del Cinquecento,* Florence, 1960, I.

Becherucci, L., Forlani-Tempesti, A., *et. al., Raffaello,* 2 vols., Novara, 1968.

Brown, D.A., "Correggio's 'Virgin and Child with the Infant St. John'," *Museum Studies,* no. 7, Chicago, 1972, 7-33.

Bock von Wülfingen, O., *Raffael, Die Verklärung Christi,* Neubearbeitung des 1946 erschienen Kunstbriefes, Werkmonografien zur bildenden Kunst, no. 9, Stuttgart, 1956.

Chastel, A., "Les notes de Léonard de Vinci sur la peinture d'après le nouveau manuscrit de Madrid," *Revue de l'Art,* XV, 1972, 9-28.

Cian, V., ed., *Il Cortegiano del Conte Baldesar Castiglione,* Florence, 1929.

Cian, V., *Un illustre nunzio pontificio del Rinascimento: Baldassar Castiglione,* Vatican City, 1951.

Clark, K., "Leonardo and the Antique," in C.D. O'Malley, ed., *Leonardo's Legacy,* Berkeley and Los Angeles, 1969, 1-34.

Clark, K. Pedretti, C., *Leonardo da Vinci Drawings at Windsor Castle,* 2 vols., London, 1968

Cox Rearick, J., *The Drawings of Pontormo,* 2 vols., Cambridge, Mass., 1964.

Dussler, L., *Raffael: Kritisches Verzeichnis der Gemälde, Wandbilder und Bildteppiche,* Munich, 1966.

Dussler, L., *Sebastiano del Piombo,* Basel, 1942.

Eastlake, C., *Methods and Materials of Painting of the Great Schools and Masters* [1869], New York, 1960, II.

von Einem, H., "Die 'Verlärung Christi' und die 'Heilung des Besessenen' von Raffael," *Abhandlungen der Akademie der Wissenschaften und der Literatur in Mainz,* Wiesbaden, 1966, 299-327.

Ettlinger, L.D., Ottina della Chiesa, A., *L'Opera completa di Leonardo da Vinci,* Milan, New York, 1967.

Fairbanks, A., tr. and ed., *Philostratus, Imagines,* London, 1931.

Flora, F., ed., *Tutte le opere di Matteo Bandello,* 3rd ed., Verona, 1952.

Forster, K., *Pontormo,* Munich, 1966.

Freedberg, S. J., *Painting in Italy 1500-1600,* Harmondsworth, 1971.

Freedberg, S. J., *Painting of the High Renaissance in Rome and Florence,* 2 vols., Cambridge, Mass., 1961.

Freedberg, S. J., *Parmigianino, his Works in Painting,* Cambridge, Mass., 1950.

Frey, C., ed., *Il Codice Magliabechiano,* Berlin, 1892.

Gombrich, E.H., "Controversial Methods and Methods of Controversy," *The Burlington Magazine,* CV, 1963, 90-93.

Gombrich, E.H., *Norm and Form,* London, 1966.

Gombrich, E.H., "The Form of Movement in Water and Air," in C.D. O'Malley, ed., *Leonardo's Legacy,* Berkeley and Los Angeles, 1969, 171-204.

Grayson, C., tr. and ed., *Leon Battista Alberti, On Painting and On Sculpture,* London, 1972.

Hartt, F., *Giulio Romano,* 2 vols., New Haven, 1958.

Heydenreich, L.H., *Leonardo da Vinci,* 2 Vols, New York, 1954.

Hirst, M., "The Chigi Chapel in S. Maria della Pace," *Journal of the Warburg and Courtauld Institutes,* XXIV, 1961, 161-185.

Jex-Blake, K., Sellers, E., *The Elder Pliny's Chapters on the History of Art,* London, 1896.

Levey, M., *Painting at Court,* New York, 1971.

Lomazzo, G.P., *Idea del tempio della pittura* [1590], Hildesheim, 1965.

Lomazzo, G.P., *Trattato dell'arte della pittura* [1584], Rome, 1844.

Lütgens, H., *Raffaels "Transfiguration" in der Kunstliteratur der letzten Vier Jahrhunderte,* (Diss.), Göttingen, 1929.

Marazza, A., ed., *Leonardo: Saggi e ricerche,* Rome, 1954.

Marucchi, A., Salerno, A., eds., G. Mancini, *Considerazioni sulla pittura (1614-1630),* Rome, 1956.

Maurer, E., "Pontormo und Michelangelo," *Stil und Überlieferung in der Kunst des Abendlandes: Acts of the Twenty-First International Congress of the History of Art, 1964,* Berlin, 1967, II, 141-149.

McMahon, A.P., tr. and ed., *Treatise on Painting by Leonardo da Vinci,* 2 Vols., Princeton, 1956.

Milanesi, G., ed., G. Vasari, *Le Vite de' più eccellenti pittori, scultori ed architettori* [1568], 9 Vols., Florence, 1878-1885.

Oberhuber, K., "Raphael und Michelangelo," *Stil und Überlieferung in der Kunst des Abendlandes: Acts of the Twenty-First International Congress of the History of Art, 1964,* Berlin, 1967, II, 156-164.

Oberhuber, K., "Vorzeichnungen zu Raffaels 'Transfiguration'," *Jahrbuch der Berliner Museen,* n.f. IV, 1962, 116-149.

O'Malley, C.D., *Leonardo's Legacy,* Berkeley and Los Angeles, 1969.

Parronchi, A., *Opere Giovanili di Michelangelo,* Florence, 1968.

Pedretti, C., *A Chronology of Leonardo da Vinci's Architectural Studies after 1510,* Geneva, 1962.

Pope-Hennessy, J., *Italian High Renaissance and Baroque Sculpture,* 2nd ed., London, 1970.

Pope-Hennessy, J., *Raphael,* London, 1971.

Pouncey, P., "Di alcuni disegni del Bandinelli e un dipinto smarrito," *Bollettino d'arte,* IV, 1961, 323-325.

Pouncey, P., Gere, J.A., *Italian Drawings in the Department of Prints and Drawings in the British Museum: Raphael and His Circle,* 2 Vols., London, 1962.

Richter, G., *The Literary Works of Leonardo da Vinci,* London, 1939, II.

Roskill, M.W., *Dolce's "Aretino" and Venetian Art Theory of the Cinquecento,* New York, 1968.

Shearman, J., *Andrea del Sarto,* 2 Vols., Oxford, 1965.

Shearman, J., "Leonardo's Colour and Chiaroscuro," *Zeitschrift für Kunstgeschichte,* XXV, 1962, 13-47.

Shearman, J., "*Maniera* as an Aesthetic Ideal," *Studies in Western Art. The Renaissance and Mannerism: Acts of the Twentieth International Congress of the History of Art, 1961,* Princeton, 1963, II, 200-222.

Shearman, J., *Mannerism,* Harmondsworth, 1967.

Shearman, J., *Raphael's Cartoons in the Collection of Her Majesty the Queen and the Tapestries for the Sistine Chapel,* London, 1972.

Smyth, C.H., *Bronzino As Draughtsman, An Introduction,* Locust Valley, N.Y., 1971.

Smyth, C.H., *Mannerism and "Maniera",* Locust Valley, N.Y., 1963.

Solmi, E., "Le fonti dei manoscritti di Leonardo da Vinci," *Giornale storico della letteratura italiana,* suppl. 10-11, 1908, 1-344.

Stil und Überlieferung in der Kunst des Abendlandes: Acts of the Twenty-First International Congress of the History of Art, 1964, Berlin, 1967, II.

Stridbeck, C.G., *Raphael Studies II: Raphael and Tradition,* Stockholm, 1963.

Summers, D., "*Maniera* and Movement: the *Figura Serpentinata,*" *The Art Quarterly,* XXXV, 1972, 269-301.

Tiraboschi, G., ed., P. Giovio, "Leonardi Vincii Vita," *Storia della letteratura italiana,* Rome, 1785, IX, 120-121.

de Tolnay, C., *Michelangelo,* 5 Vols., Princeton, 1943-60.

Wilde, J., "Notes on the Genesis of Michelangelo's *Leda,*" in D.J. Gordon, ed., *Fritz Saxl: A Volume of Memorial Essays from His Friends in England,* London, 1957.

List of Illustrations

1. Leonardo, *Mona Lisa,* Paris, Louvre (photo Anderson)
2. Raphael, *Donna Velata,* Florence, Pitti Palace (photo Alinari)
3. Raphael, *Baldassare Castiglione,* Paris, Louvre (photo Alinari)
4. After Leonardo, *Adoration of the Magi* (after P. Müller-Walde, *Leonardo da Vinci*)
5. Cornelis Cort, after Raphael, *Transfiguration,* engraving, Vienna, Albertina (photo Albertina)
6. Raphael, *Transfiguration,* Rome, Vatican Museum (photo Vatican)
7. Raphael, *Transfiguration* (detail) (photo Alinari)
8. Raphael, *Transfiguration* (detail) (photo Alinari)
9. Leonardo, *Adoration of the Magi,* Florence, Uffizi (photo G.F.S.G. Firenze)
10. Leonardo, *Adoration of the Magi* (detail) (photo G.F.S.G. Firenze)
11. Master of the Die, after Raphael, *Assumption of the Virgin,* engraving (photo Institute of Fine Arts, the Illustrated Bartsch)
12. Raphael, *Disputa,* Vatican, Stanza della Segnatura (photo Alinari)
13. Raphael, *Way to Calvary (Lo Spasimo di Sicilia),* Madrid, Prado (photo Anderson)
14. Sebastiano del Piombo, *Raising of Lazarus,* London, National Gallery (photo National Gallery)
15. Raphael, *St. Michael,* Paris, Louvre (photo Alinari)
16. Sebastiano del Piombo, *Pietà,* Viterbo, Museum (photo G.F.N. Rome)
17. Giulio Romano, *Madonna and Child with Saints,* Rome, S. Maria dell'Anima (photo Anderson)
18. Leonardo, *St. John the Baptist,* Paris, Louvre (photo Alinari)

19. Leonardo, *The Madonna and Child with St. Anne and St. John the Baptist*, cartoon, London, National Gallery (Photo National Gallery)
20. Giulio Romano, *Holy Family ("La Perla")*, Madrid, Prado (photo Prado)
21. Giulio Romano, *Stoning of St. Stephen*, Genoa, S. Stefano (photo Alinari)
22. Polidoro da Caravaggio, *Entombment*, drawing, Paris, Louvre, Cabinet des Dessins, (photo Cabinet des Dessins, Musée du Louvre, Cliché Musées Nationaux)
23. G.F. Penni and the Raphael School, *Adoration of the Magi*, tapestry, Rome, Vatican Museum (photo Alinari)
24. Parmigianino, *Vision of St. Jerome*, London, National Gallery (photo National Gallery)
25. Pontormo, *Madonna and Child with Saints*, Florence, S. Michele Visdomini (photo Alinari)
26. Raphael, *Holy Family (Madonna dell'Impannata)*, Florence, Pitti Palace (photo Alinari)
27. G. Vasari, *Allegory of the Conception*, Florence, SS. Apostoli (photo Alinari)
28. G. Valeriano, *Ascension*, Palidoro, SS Giacomo e Filippo (photo G.F.N. Rome)
29. Michelangelo, *Battle of the Centaurs*, marble relief, Florence, Casa Buonarotti (photo Alinari)
30. Michelangelo, *"Dying Slave,"* Paris, Louvre (photo Alinari)
31. After Leonardo, *Leda and the Swan*, Rome, Borghese Gallery (photo Anderson)
32. Leonardo, Study for a *Kneeling Leda*, drawing, Rotterdam, Boymans-van Beuningen Museum (photo Boymans-van Beuningen Museum)
33. Leonardo, Study for a *Kneeling Leda*, drawing, Windsor, Royal Library (reproduced by gracious permission of Her Majesty the Queen)
34. Sixteenth-Century Drawing after an ancient *Leda* Relief, Berlin, Staatsbibliothek, Codex Pighianus (after Tolnay, *Michelangelo*, III, pl. 250)
35. Leonardo, Studies for the Head of *Leda* (detail), Windsor, Royal Library (reproduced by gracious permission of Her Majesty the Queen)
36. Michelangelo, *Night* (detail), Florence, S. Lorenzo, Medici Chapel (photo Brogi)
37. Michelangelo, *Night*, Florence, S. Lorenzo, Medici Chapel (photo Brogi)
38. Michelangelo, *Dawn*, Florence, S. Lorenzo, Medici Chapel (photo Alinari)
39. Leonardo, *Last Supper* (detail), Milan, S. Maria delle Grazie (photo Alinari)
40. Michelangelo, *Dawn* (detail), Florence, S. Lorenzo, Medici Chapel (photo Brogi)

Plates

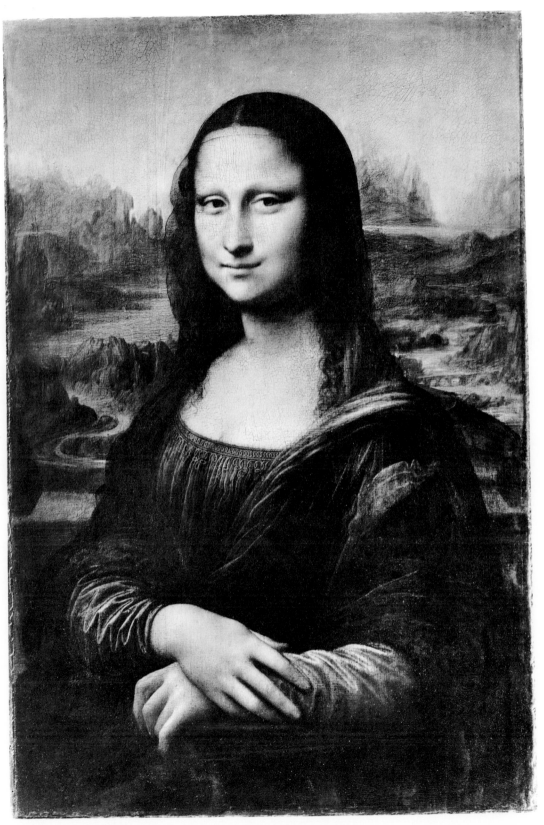

1. Leonardo, *Mona Lisa*.

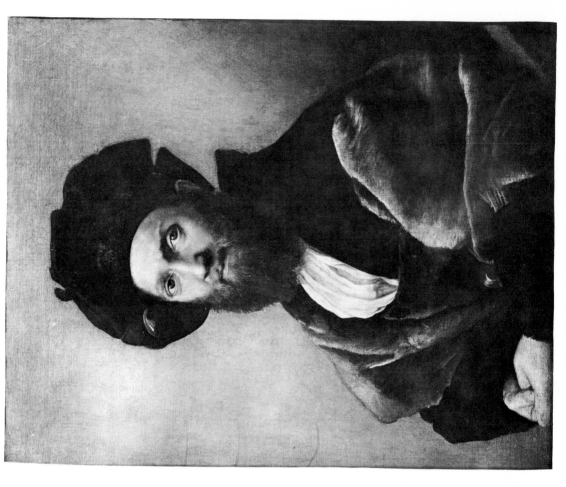

3. Raphael, *Baldassare Castiglione.*

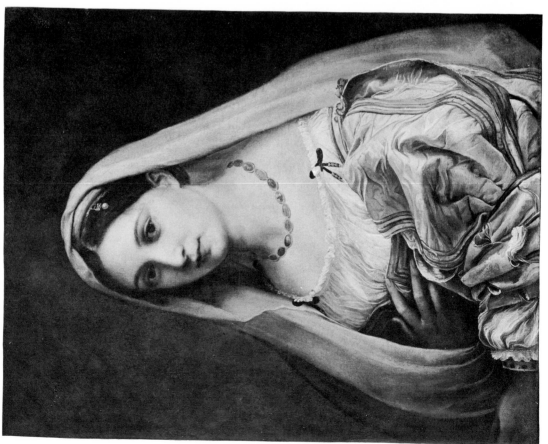

2. Raphael, *Donna Velata.*

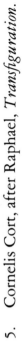

5. Cornelis Cort, after Raphael, *Transfiguration.*

4. After Leonardo, *Adoration of the Magi.*

6. Raphael, *Transfiguration*.

7. Raphael, *Transfiguration* (detail).

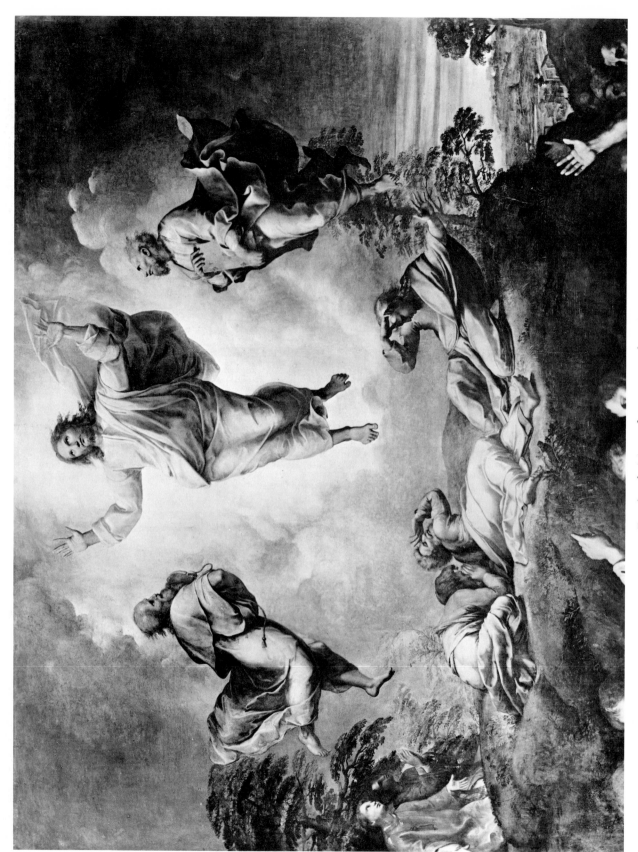

8. Raphael, *Transfiguration* (detail).

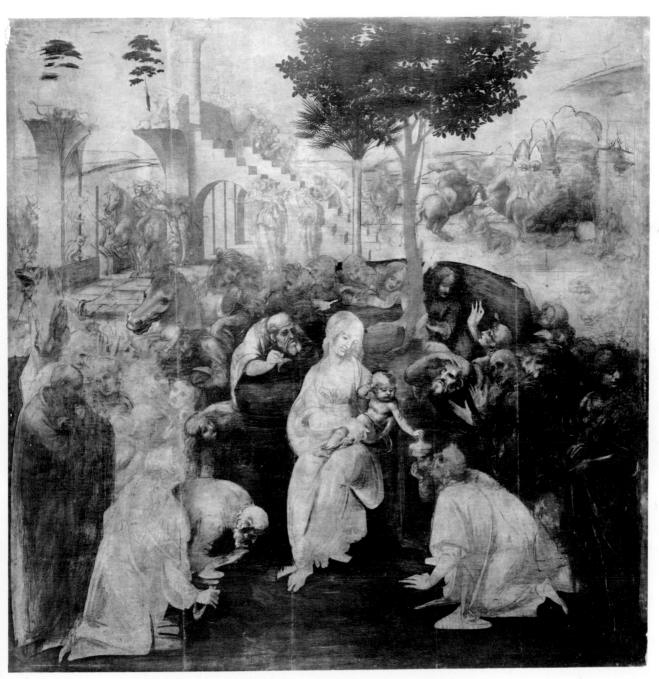

9. Leonardo, *Adoration of the Magi*.

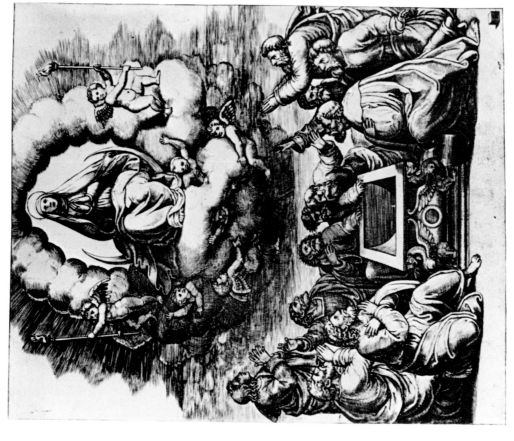

11. Master of the Die, after Raphael, *Assumption of the Virgin.*

10. Leonardo, *Adoration of the Magi* (detail).

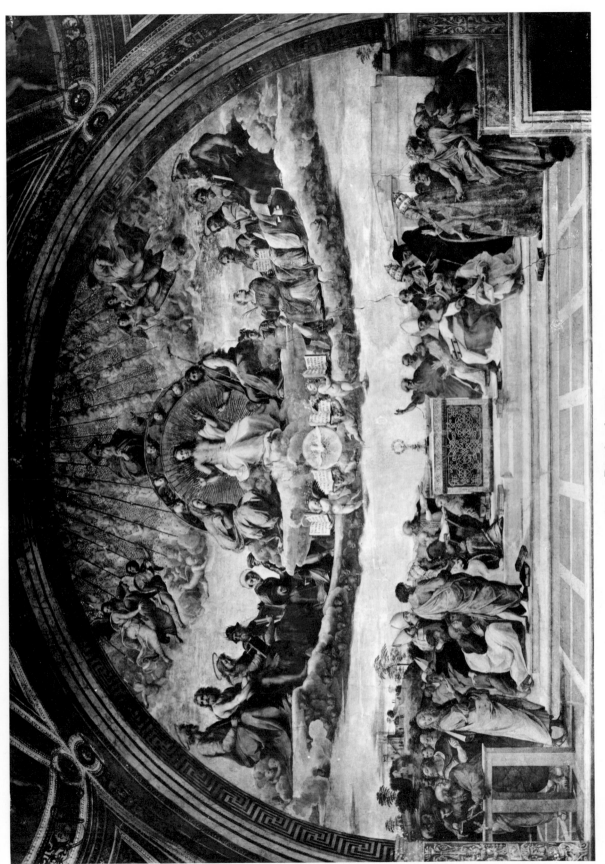

12. Raphael, *Disputa*.

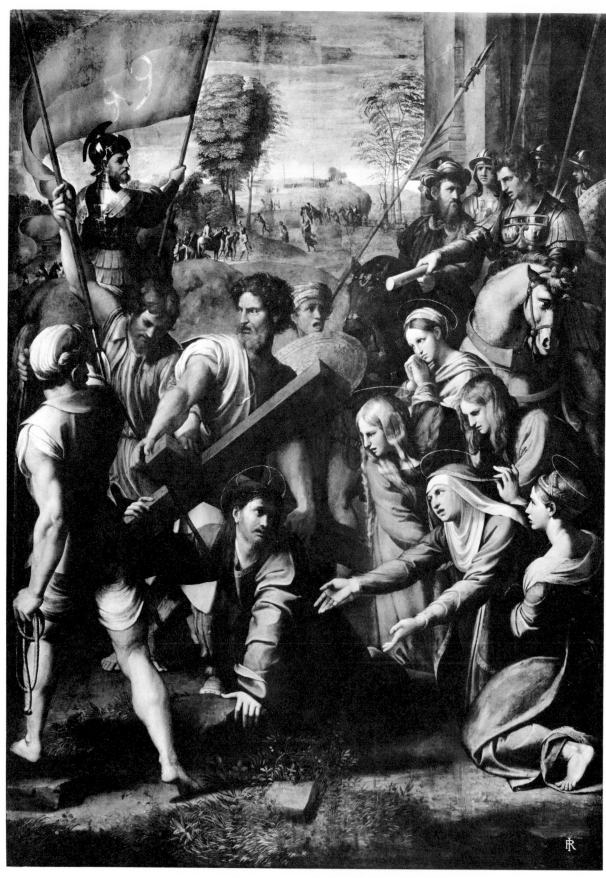

13. Raphael, *Way to Calvary (Lo Spasimo di Sicilia)*.

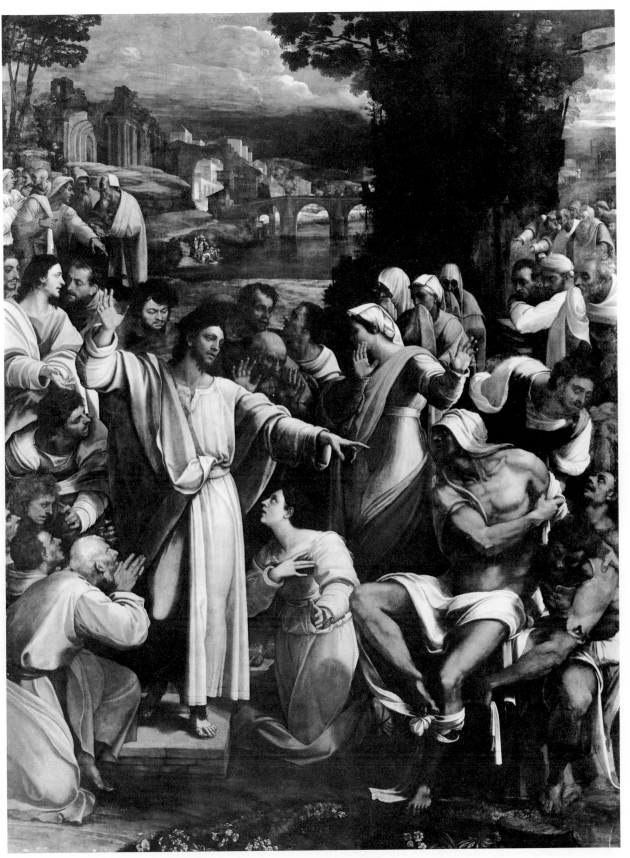

14. Sebastiano del Piombo, *Raising of Lazarus*.

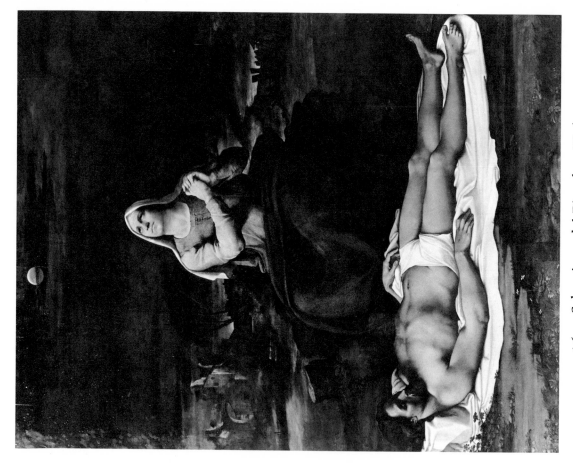

16. Sebastiano del Piombo, *Pietà*.

15. Raphael, *St. Michael*.

18. Leonardo, *St. John the Baptist.*

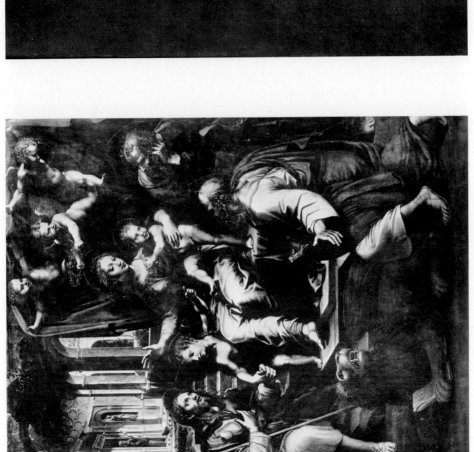

17. *Giulio Romano, Madonna and Child with Saints.*

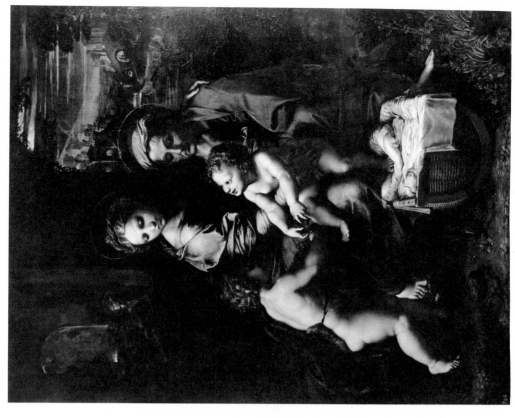

20. Giulio Romano, *Holy Family ("La Perla")*.

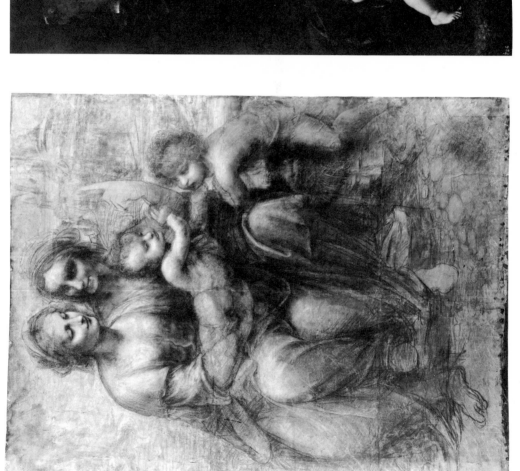

19. Leonardo, *The Madonna and Child with St. Anne and St. John the Baptist.*

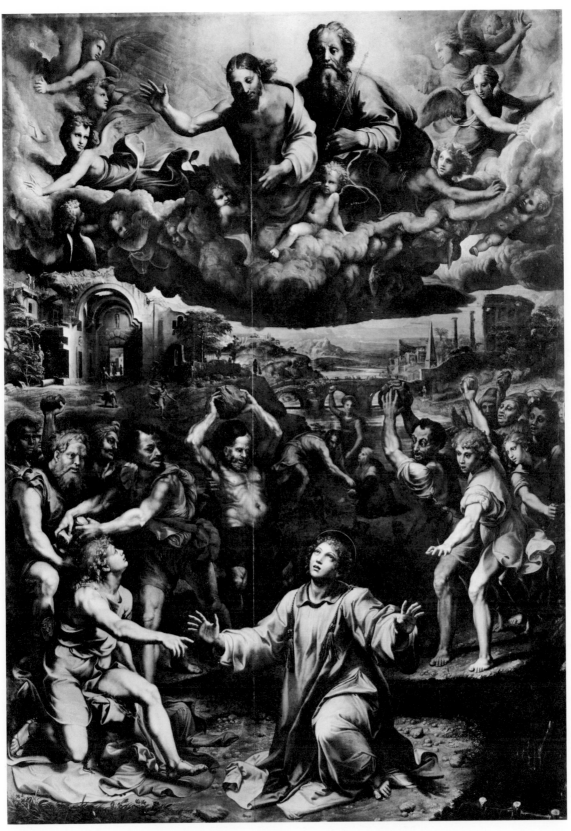

21. Giulio Romano, *Stoning of St. Stephen*.

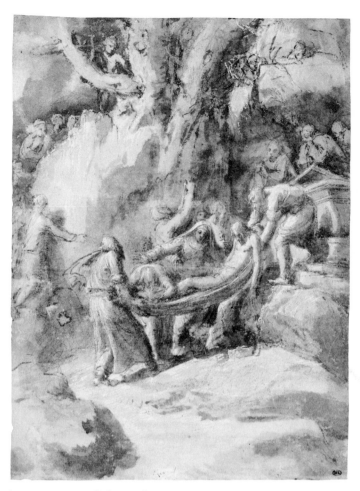

22. Polidoro da Caravaggio, *Entombment*.

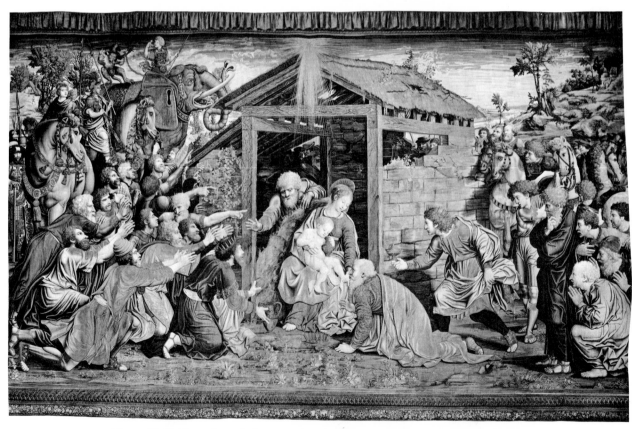

23. G.F. Penni and the Raphael School, *Adoration of the Magi*.

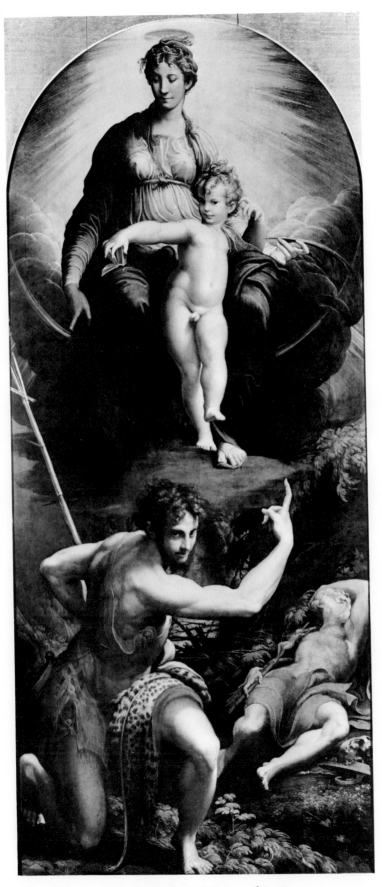

24. Parmigianino, *Vision of St. Jerome*.

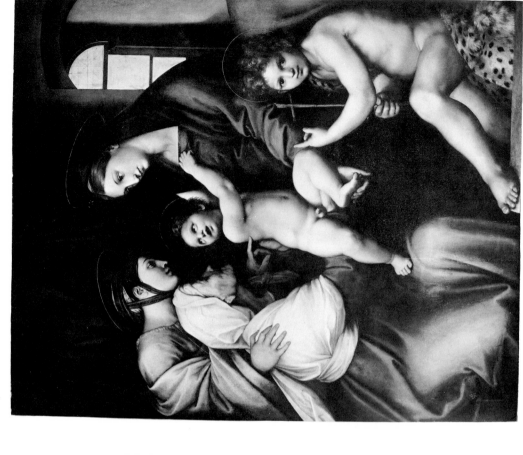

26. Raphael, *Holy Family (Madonna dell'Impannata)*.

25. Pontormo, *Madonna and Child with Saints*.

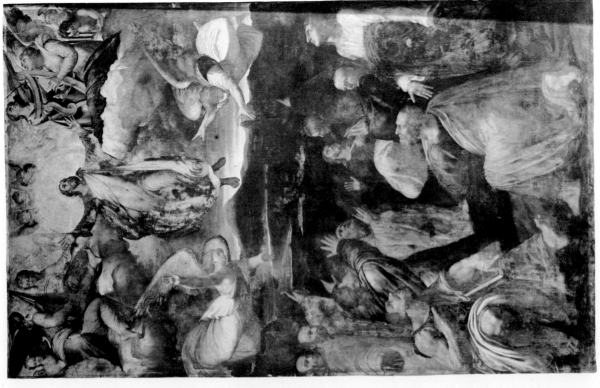

28. G. Valeriano, *Ascension.*

27. G. Vasari, *Allegory of the Conception.*

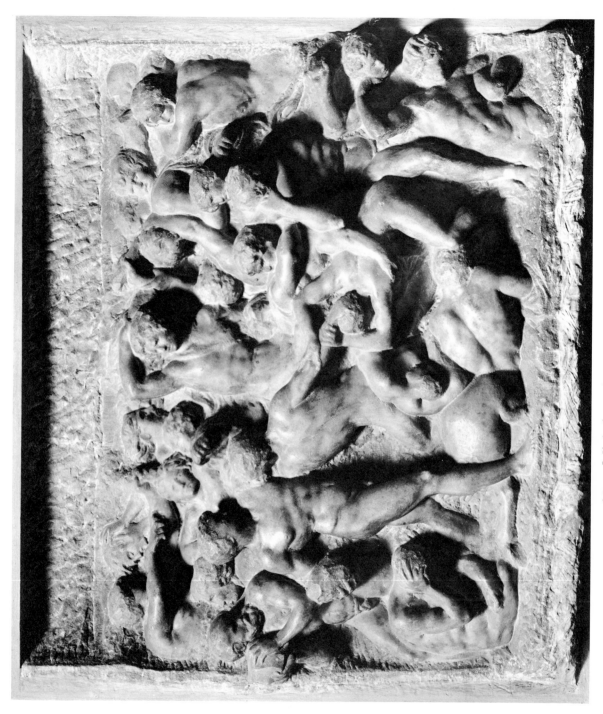

29. Michelangelo, *Battle of the Centaurs.*

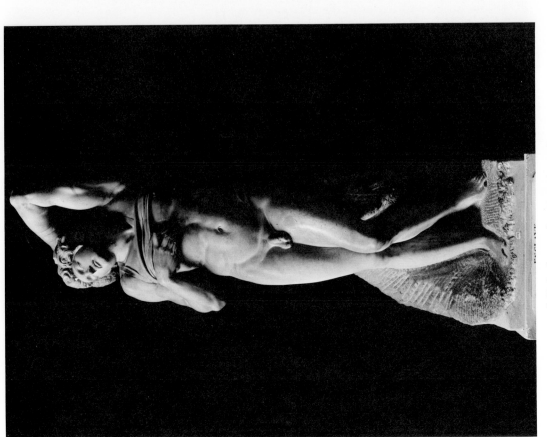

31. After Leonardo, *Leda and the Swan.*

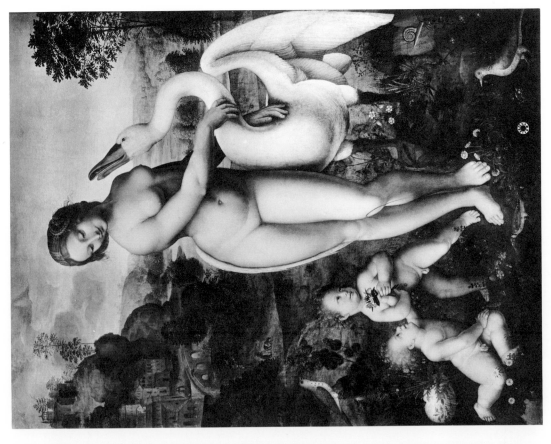

30. Michelangelo, "*Dying Slave.*"

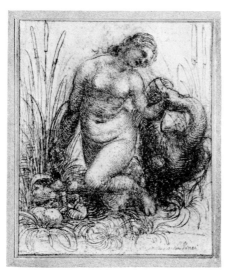
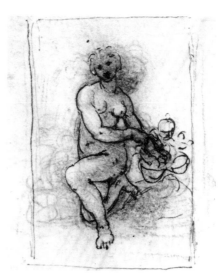

32. Leonardo, Study for a *Kneeling Leda*. 33. Leonardo, Study for a *Kneeling Leda*.

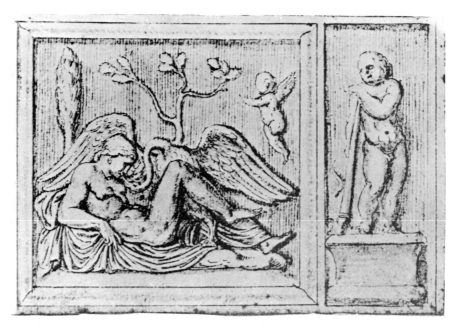

34. Sixteenth-Century Drawing after an ancient *Leda* Relief.

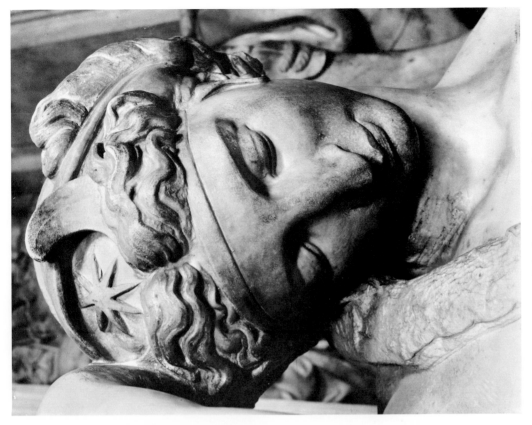

36. Michelangelo, *Night* (detail).

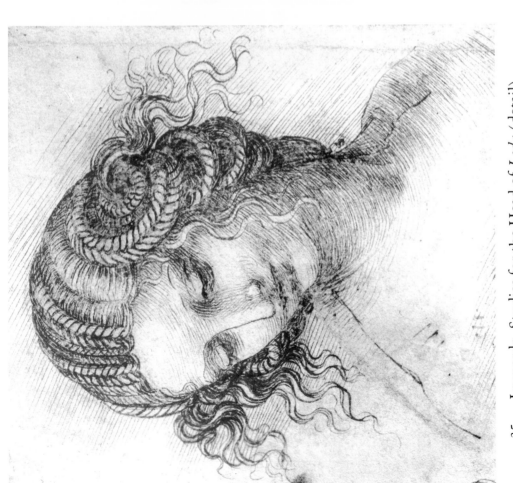

35. Leonardo, Studies for the Head of *Leda* (detail).

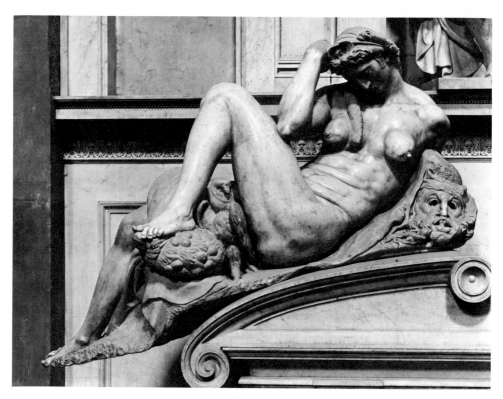

37. Michelangelo, *Night*.

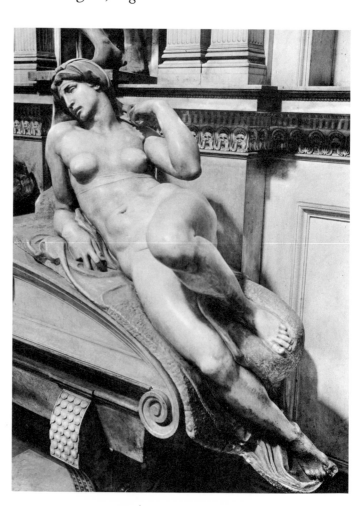

38. Michelangelo, *Dawn*.

39. Leonardo, *Last Supper* (detail).

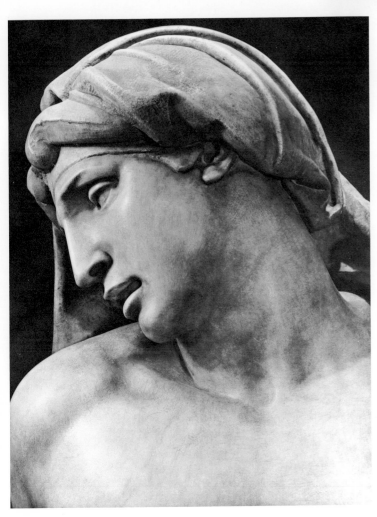

40. Michelangelo, *Dawn* (detail).

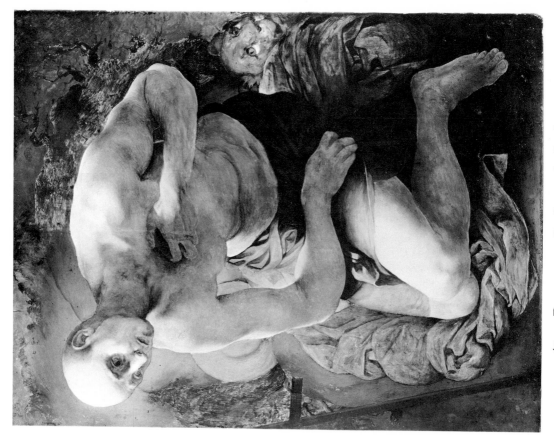

42. Pontormo, *St. Jerome in Penitence.*

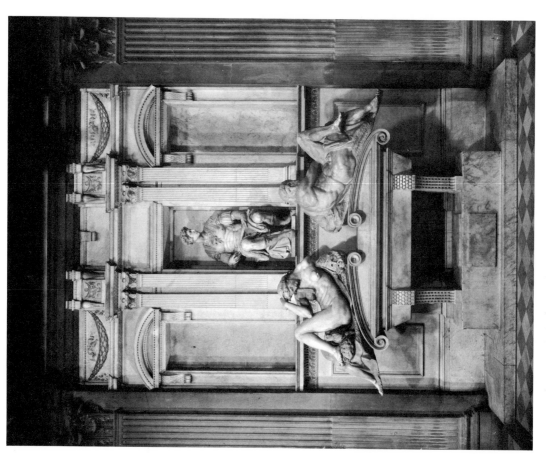

41. Michelangelo, *Tomb of Giuliano de' Medici.*

44. Pontormo *Madonna and Child with St. Anne.*

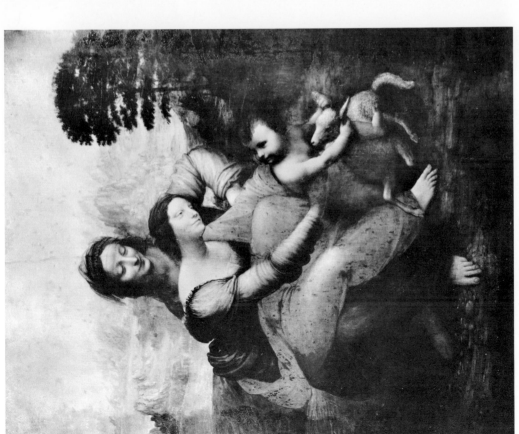

43. Leonardo, *Madonna and Child with St. Anne and St. John the Baptist.*

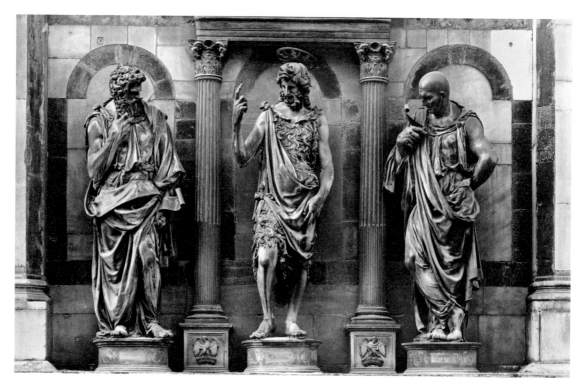

45. G.F. Rustici, *Baptism of Christ*.

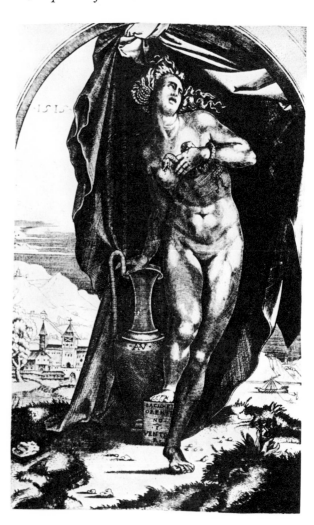

46. A. Veneziano (after Bandinelli), *Cleopatra*.

47. B. Bandinelli, *Leda and the Swan.*

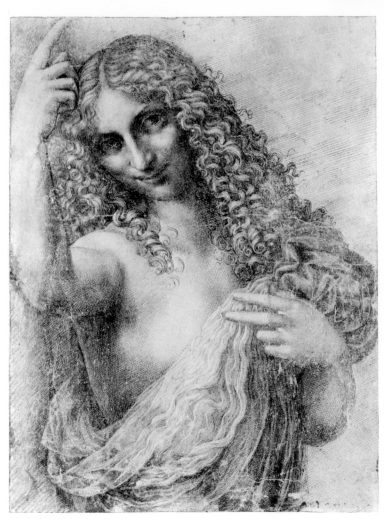

48. B. Bandinelli, *Angel of the Annunciation.*

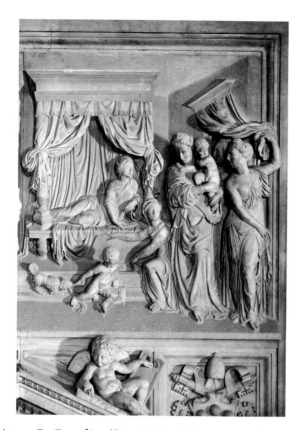

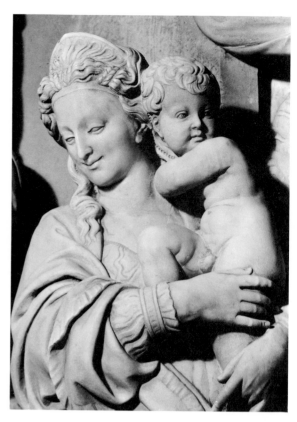

49. B. Bandinelli, *Birth of the Virgin* (detail). 50. B. Bandinelli, *Birth of the Virgin* (detail).

51. B. Bandinelli, *Hercules and Cacus*. 52. Leonardo, *Standing Male Nude*.

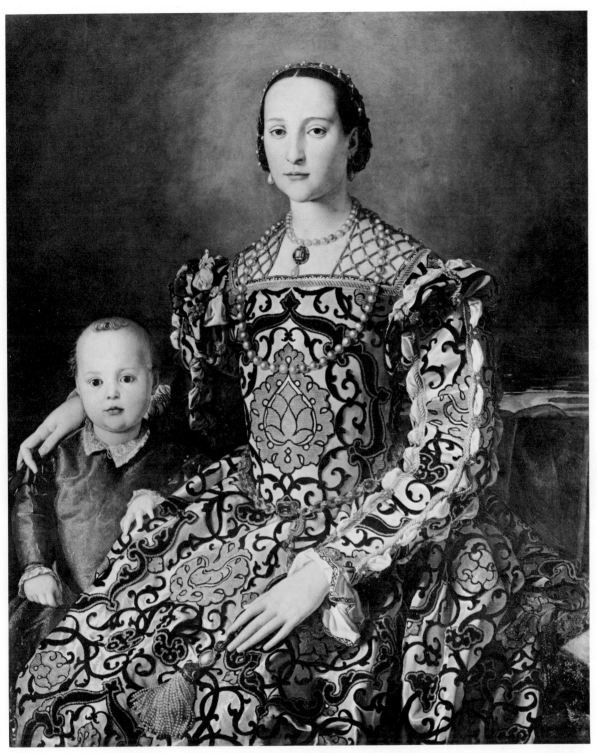

53. Bronzino, *Eleonora di Toledo*.

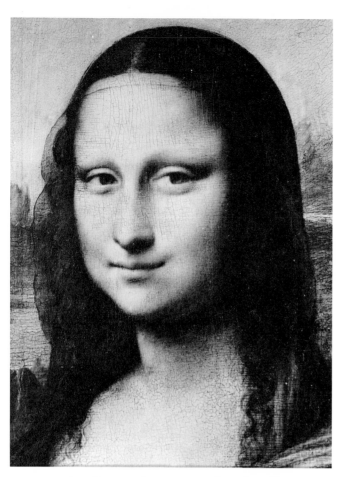

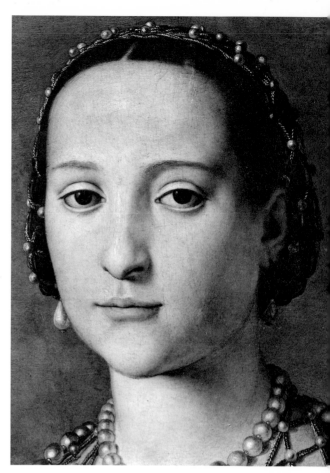

54. Leonardo, *Mona Lisa* (detail).

55. Bronzino, *Eleonora di Toledo* (detail).

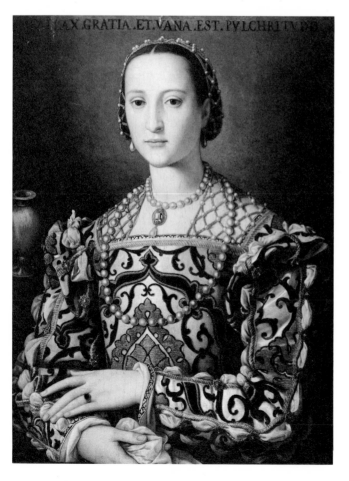

56. Attributed to Bronzino, *Eleonora di Toledo*.